GALLERY
CONFIDENTIAL

GALLERY
CONFIDENTIAL

CONFESSIONS OF AN
ART DEALER

STEVEN MAIER
aka **Sonny Pops**

A TWO-FACED PREFACE

Art is a funny business. If I taped a banana peel to this page you would visually slip on it and that would be funny. But if I tripped on it, that would be hilarious. We all probably do a double-take and quietly smirk when a banana, duct-taped to a wall in an art fair, sells for $120,000.00, thinking in the back of our minds that the buyer is monetarily tripping on that banana.

Titled "Comedian," that duct-taped banana actually joined the art historical process by becoming a commodified conceptual art piece and is now part of the Guggenheim Museum's collection. Along with a nice tax write-off, the donors clinched their place in art history. What a beautiful business. Not one for prat-falling monkeys.

There is a classic James Thurber cartoon of an erudite-looking man standing on a chair in an art gallery, head-cocked, intently inspecting a painting. Three figures are off to the side, looking at him, and one says: "He knows everything about art, but doesn't know what he likes."

Thurber defined the irony of expertise. It's easy to squeeze the joy out of looking and seeing. To overthink the experience instead of reveling in it.

Let's revel.

Kissing and telling is not nice, but at times I can't help myself. I aim to titillate. To truthfully tantalize. Taken together, these sketches paint a portrait, sometimes two-faced, of highlights during the pinball trajectory of my topsy-turvy career.

These stories are meant to describe how both buying and selling art actually work. Instead of a tutorial, this is more of a TRUTH-TORIAL—nothing theoretical about it. This is how the mid market works. You can draw, or doodle, your own conclusions.

For me, the last half-century in the art business has been like a torrid romance in a cheap romance novel, and the moral of the story...ambiguous. These recollections pull the skirt up and the curtains back on the gallery business. But generally, the art business is just funny.

These vignettes are not varnished or censored, not chronological or apocryphal. Meant more to entertain than to educate. I hope you enjoy the stories and are amused at the decades-long professional pratfall that partly describes my art career. I am not convinced that we can learn from other people's mistakes, but if we can, there are lessons to be learned here through clucks and chuckles.

If you prefer a scholarly read by a bald bow-tie-wearing proper British expert (like the fellow featured in Thurber's cartoon), a learned treatise, rather than this bumpy ride with arts butt cracks showing, there are good ones to choose from.

Otherwise, reader discretion is recommended.

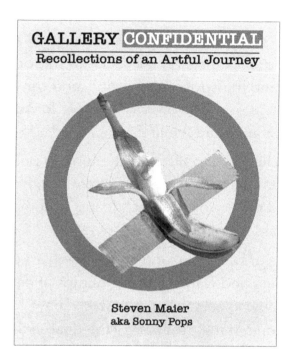

Rejected book cover converted to B&W

GEEZER SHOUT OUT...

Still heading down the boomer highway seven decades in. Mostly in the slow lane, but still enjoying the ride. Tollgate ahead. Looking back through the rearview mirror, some things get distorted and transposed in memory and can appear closer than they really are—you know this if you've looked into a car's rearview mirror and read the fine print.

It can be challenging to discover the turning points in life, the events that send us in unexpected directions. How did an art consultant and gallery director/art dealer become Sonny Pops: Hawaii's Ambassador of Nu'u Pop?

These stories draw from a long and winding art career. A road trip with detours and warning signs: bumps ahead. If this were a seminar on buying and selling art I would have to charge $199 and feel like you got the best part of the deal. If this were stand up comedy the door charge would be ten bucks and I would feel like I got the last laugh.

TABLE OF CONTENTS

100 Stories = 1 Tale

THE PERSISTENCE OF THIS MEMORY

"You could sell wet matches to Eskimos." (That should be illegal, but it isn't). So said a friend of my mother's, a seasoned and perhaps masterful artist and one of the early aloha shirt designers, Johnny Meigs, describing my ability to sell art.

I was and remain offended by his remark. That's not the reputation that I aspired to. Because what you sell and how you sell it matters to me. Johnny made that remark because I was selling limited edition Dali prints to tourists, and, in retrospect, given what I know now, I understand and respect his commentary. If you see me selling matches, get a lighter.

Over the years, I have tried to be honest and to sell with integrity, but an art dealer is only as good as his sources. Even auction houses have made egregious mistakes. Trust but verify was President Reagan's mantra about his arms deals with Russia. It might apply to art as well as nuclear weapons.

The art market is sometimes fraught with ethically questionable practices. An art consultant may run into a dealer who may not be honest about the provenance of a piece of art. Or a publisher may not be straight about the legitimacy of a print. (It took the

experience of the Dali market fiasco for me to understand the necessity of digging into the market to ferret out fakes and frauds.) Or a client may give you something to sell on the secondary market, and he may believe that it is legit, but there could be issues of which he is not aware. It is incumbent on art consultants and dealers to explore the provenance and legitimacy of the art they offer.

When you represent a gallery, you have faith in the integrity of the art. That, and realizing that unscrupulous players prey on unsuspecting collectors, made me wary.

Almost all of my relationships have been mutually beneficial and harmonious, but probably the ones you want to hear about are the ones that weren't.

I'll tell you about both.

A NEW START

Before moving to Waikiki in 1982, I had been a single father living in Sausalito, California. Living in the Bay Area was a good choice; I loved it, but my career was off course. I was a painting and decorating contractor and realized that it was not what I wanted to do.

As my first daughter grew from a toddler to a young child, it became clear that she needed her mother. Her mom, after a rough patch, was finally in a healthy place to care for her. A mother's love is uniquely important in a child's life. Reuniting them was the right thing to do.

Was I having a pre-midlife crisis? I was still at least a decade too young for that. Nonetheless I thought: Why wait? A much-needed life change had been percolating in my mind, so I brewed up plan A.

Hawaii was calling.

After years of round-the-clock work and child care (I gained enormous respect for single parents during that time), I felt that I could finally make a move and change careers. It felt like it was now or never.

I sold everything (by most standards not much) and took nothing except a suitcase of clothes to Hawaii. (If you are at home, without adult supervision, think twice.)

The leap from house painting to selling paintings was a fortuitous brush with destiny that I had not truly anticipated. The art business was one of a few career moves that I thought about. My early career was shaped by the paternal construction side of our family. After giving that a yeoman's effort, I realized that it was not for me. Now I was influenced by the maternal side.

My mother knew Bill Mett, the owner of Center Art Galleries. She had opened the Maltese Trading Company at the oldest hotel in Hawaii, the Moana, for him. She merchandised and managed the business until he sold it. Because she seemed to admire his entrepreneurial spirit, and he was the most successful gallerist in Hawaii, she suggested that I submit my thin resume to him.

I did.

Each time I called the VP, Marvin, to set up a time to meet he told me that he had misplaced my resume. So I sent in a total of three. Apparently, that was key. I was hired on the third spot. It helped that I had the mom connection. It also helped that while I was growing up my father had given me books to read, and talked to me about advertising and sales. There was some early preparation that gave me a leg up.

I think that I was desperate enough to apply myself thoroughly. Failing was a cliff that I did not want to go over. From my time in the construction business, I knew hard work. Hard labor. For years. Honestly, the gallery gig was a skate in the park by comparison. Challenging in ways that I liked.

Over the last forty-plus years living in Hawaii, I have met many famous and well-known people. Some ballers, and lots of bald-headed people. Working in art galleries and doing shows in Waikiki, Lahaina, San Francisco, New York, Hollywood and Hong Kong provided unique venues for meeting and talking with celebrities.

Maui in the early 1980s attracted a cross-section of the jet set and some of the most creative individuals from around the world, along with some colorful weirdos. The art galleries provided a relaxed and interesting place for people to gather. Galleries often offer more than some museums, with a personal docent/art consultant to enhance the experience. Good galleries offer a free show. Sometimes complimentary wine.

It seems almost like a dream now, and I remain grateful that life could have been so simple and full of talented and engaging friends and associates and art-related events that led to new friends.

Shedding my old paint-spattered work clothes to work in a clean, well-lighted environment presenting paintings felt sooo good. That first year I went to the beach every day, rain or shine, before and after work.

Waikiki in the early 1980s was, according to many old-timers, already spoiled. The glory days had passed. But for me, it was fresh and fun and full of opportunities.

And bodysurfing. It was a great place to live, and with work that I loved, it felt like nonstop play—play that always rejuvenated and refreshed.

That first year I was going back and forth between Maui and Oahu. I was on Oahu the first year, then on Maui, but shows and meetings meant lots of inter-island travel.

It was a challenge to learn about all of the art and the artists and the myriad techniques they used, to develop an engaging style to present art to people in a way that felt genuine, informed, and compelling. Before long, the job became a lifestyle.

Soon I learned that there is an inter-island pecking order in Hawaii: Folks on Maui don't want the island to become commercialized like Honolulu/Waikiki. Kauai wants to remain a pristine gem, the garden island, a vision of paradise, and doesn't want to become Maui-fied. Molokai continues to fend off all attempts at development; when Molokai residents go hunting (for feral pigs, axis deer, feral goats, and wild turkeys, and so on), they may be gone for weeks, sometimes months, and they want to keep it the way it is. Lanai, the "pineapple island," became a bargaining chip among billionaires and boasts elite hotels. Oracles Larry Ellison has grand plans to create a Lanai that is a beacon of sustainability—only three thousand people live there. It is an ideal micro-cosm. The Big Island just gets bigger, and residents love it. It boasts the most billionaires, but with its ohana (family) spirit and proud local traditions, it is too diverse to pigeonhole. Oahu is the population center, the capital; Diamond Head is the Hawaii Sphinx.

Maui has more galleries than all of the other islands put together. After a little more than a year on Oahu, I relocated to Maui.

The first time I visited Lahaina, the feeling of being there reminded me of a long- forgotten dream that I had had when

I was about 12 years old. It consisted of a simple enchanting image, infused with deep feeling, that I had forgotten about. Until then. That memory felt like an apparition—the sight of the island in the dream, dimly lit at late dusk, became the island of Lanai seen from Lahaina, which was now to become my actual island home. It felt like a dream coming true.

There was no doubt in my mind. I knew that living there was decided, if not ordained, by that indelible memory, that vivid dream. The art business was booming in Maui, and I was grateful for the gallery job that I had waiting.

At times living in the islands was like being at a big, well-attended social gathering all the time. At others, it was a diet of beautiful days of surf and a job that entailed traveling and parties and working with a cast of talkative characters that now included lifelong friends.

But the parties were actually highly-disciplined sales-focused art events that generated millions of dollars: challenging, competitive, and fun. They taught me a lot about the ups and downs of the art business and life.

If this were a movie in pre-production and I told you who was going to be in the movie, you would throw me out and tell everyone that I'm a bullshitter. Perhaps that's part of the art business; it's politely called hyperbole, but this really is what I remember.

WAIKIKI CIRCA 1980s

In the early 1980s, the thriving art business in Waikiki was a commercial bonanza mostly focused on the still-living "modern masters": Picasso, Miro, Chagall, and Dali.

Inflation was rampant, and people were looking for tangibles that would hold their value. Of course, everyone wanted the next big thing, hoping the prices of the art they bought would go up. The successful galleries catered to that market.

Visitors to the islands had the leisure time to shop, and the lure of owning museum-quality artists was compelling. The cachet of telling friends back home that you acquired the art in Hawaii, on vacation, made it a little sweeter. Never underestimate the power of subtle snob appeal.

There was a maudlin aspect to selling the mod masters: They were all quite old, and the fact that they would pass before long made getting the art now that much more critical. The implication was that the price—AD—would be substantially higher. A premise that, in fact, is not necessarily true, but it's an effective motivator. And one that is best never clearly articulated but oftentimes gauchely implied.

No doubt more important art markets and more serious galleries existed around the country. After all, the "art world" is like an onion with lots of layers and players (not to mention tears when you cut into it), but no art market was more fun than the one in Hawaii.

More egalitarian than elitist, Hawaii was ideal for turning vacationers into art collectors. To someone who works in commercial galleries in tourist spots, the "real" art market is harder to penetrate than a fortified border wall. I was content not to try.

There used to be a colorful landmark sign on the corner of Kalakaua and Kapiolani on Oahu, a directional sign that had the names of cities from around the world and the number of miles away they were from that happy crossroad. There were different colors and shapes. It was funky, and pointed in all directions.

Hawaii is still a crossroads where the paths of people from around the world cross, but it has become more corporate and name brand. That old sign was replaced and even the replacement is gone now.

Now I'm the old guy sounding like the best days are past. They aren't—the best is yet to come....

CHAPTER

4

STORIES SELL

That is an old art gallery axiom.

The art is in the sizzle. It always struck me as crass and slightly craven that training in art galleries is heavier on the sales side, not on the curatorial or insight side. Creating a mood conducive to opening people up to art is important. It can be a fool's errand, but it's fun trying. It is like improvisational jazz, riffing off what you get.

If a picture is worth a thousand words, an art consultant should be concise and let the art do most of the talking. It's not what you say, it's more when you say it. And the tonality, the spirit behind the words. Being in the moment, really connecting with people, and letting them discover what they love can be an exhilarating experience. It is easy to get in the way of that. Don't. It's a dance, and you don't want to step on toes.

The most important story in presenting art is the client's, the collector's, story. Listening and paying attention to their stories tells you how to help lay the tracks for where that art train is going. Attune yourself to the client. I learned more from art-loving clients over the years than I did from books and museums.

The art of presenting art can be crude or refined. It helps to know both approaches because not everyone responds to the esoteric side of art. Art as an object—the tangible display of success, not necessarily a work of artistic merit—is what some people are looking for; in that case, that's the necessary play.

The old saw "beauty is in the eye of the beholder" is true. Schlock is a description sometimes given to describe what is considered bad art. But one man's schlock is another man's treasure.

Good sizzling stories sell. The truer, the better.

These stories are unflattering, but true. A few of the names have been changed to protect me, not the innocent. If confessions of an art dealer leads to a few bridges burning, please know that this is not meant to be a burning bridges book tour.

CHAPTER

5

THE FUCKAH'S GONNA DIE

Dear Reader, there are no deaths in this sketch.

One of my colleagues during my time in Waikiki was a beautiful young Black woman, Jada. Her husband had been in the NBA, and they were well-connected with successful sports figures. She was a successful art consultant. Jada had a winning smile and an upbeat attitude. When she was with one of her clients, she clung to them like a needy barnacle. They loved it.

One day she was on the phone with a star running back for the San Diego Chargers. Jada was urging him to purchase Salvador Dali's The Last Supper Collection, a lithograph coupled with a bas relief sculpture. She was saying, "Chuck, the fuckah's gonna die, the fuckah's gonna die." Chuck took her sophisticated advice and bought the Dali. Before the fuckah died. I should have died laughing. I loved working with her, but still cringed while cracking up at that line.

Jada was so lovable and without guile that she could say anything, and it was okey-dokey. She knew how far she could go with her clients—all the way.

THE SCENE OF THE CRIME

The yellow police tape circling the gallery was not conceptual art.

What a study in contradictions. Trying to figure out Bill Mett is a Rorschach Test. It depends on your focus. Mr. Mett was the owner of Center Art Galleries and one of the most successful gallerists in the history of art in Hawaii. He was a professor of law at the University of Hawaii, and one of his students told me that he was the best prof she had ever had.

Bill Mett was, by most metrics, a huge success. Admired by his loyal employees, sought after and esteemed by artists, respected by collectors, and socially well-connected. Politicians and publicists sought him out and were in his sphere of influence.

Mr. Mett was in his mid-forties, a good-looking, hard-working, articulate individual from Wisconsin. Bill looked vaguely like Rod Serling (the creator of The Twilight Zone), but more handsome. He created a fleet of galleries and employed a cadre of eager and grateful art consultants.

Mett may have harbored larceny in his heart, but that was not clear until it was too late.

His Center Art Galleries had hugely successful blockbuster shows of the modern masters: Picasso, Chagall, Miro, and Dali. He had a Norman Rockwell show with over 70 original paintings and the best limited editions. The Rockwell Museum's curator wrote the introduction to the catalogue and was there for the show.

Center's celebrity artists included Red Skelton, Anthony Quinn, and Tony Curtis. Even the beloved Woody Woodpecker cartoonist, Walter Lantz.

Bill Mett's office featured framed photos of him with Dali, Ronald Reagan, governors, senators, movie stars, etc. Bill was a trusted and true success with a memory like a steel trap and boundless energy. He was living the dream.

So were we. After years of success, things got way too surreal, overnight. it was like the poet Yeats said, "Things fall apart, the center cannot hold...." Center Art Galleries didn't.

We woke up to HEADLINES in the local newspaper, announcing the BUST of Center Art Galleries. There was yellow CRIME tape strung around the closed-down Honolulu galleries, and the business was shut down by the feds. Mett and his partner Marvin Wiseman were charged and eventually convicted of mail and wire fraud. Later we learned that some of the Dali's that we were selling had forged signatures.

The trial became headline news. I was in one of Mett's galleries on Maui; we were not raided. But Mett did ask our secretary to go around the island and buy every newspaper to keep people from reading about the scandal. He became Nixon-esque, maintaining that he was not a crook.

The raid became the scuttlebutt throughout the industry. Dali was known to have signed at least 5000 blank sheets. He allowed dealers to take care of the printmaking. Those in the know had already suspected hanky-panky.

The defense lawyers alleged that the prints were legitimate because the signature was that of the artist and Dali was paid, having contractually agreed to the editions. Even if the prints were pre-signed, the gallery had legally contracted for the rights to publish these editions.

When the prosecution showed two signed lithographs in court, one with the signature partially covered by the image and the other with the signature slightly over the image, the case was closed. Clearly, it was a fraud. At least one of them was signed after the lithograph was printed. Maybe both.

An odd twist to the story came years later when the fake prints were sold at auction by the U.S. Postal Service to cover the trial costs. They were stamped on the back with these words: "Counterfeit, unauthorized, fake." But prints get mounted and framed, and the stamp can't be seen. Unless it was disclosed that they were fakes, the prints could now be resold and a new crime perpetrated. Crazy.

So my first experience in the art business was a HUGE object lesson. It was a once-in-a-lifetime opportunity to work in a booming field, to experience many different artists and styles, and to study art market dynamics. In retrospect, my whole-hearted belief in the company's integrity, and the authenticity of the art we sold, was simply not justified. Sobering.

Since then, I am more cautious and skeptical. Due diligence is the order of the day. Provenance must be established.

Nonetheless, I am still in love with art and interested in how we create, experience, market, and consume it.

On the forever grateful side: I met my lovely and talented wife, Mihoko, at Center Art. Many of the people whom I met at that time are still dear friends. Lifelong relationships were forged that I will always cherish. It stung to be associated with the controversy, but I think that many of us were chastised and awakened by that experience.

Bill Mett and his partner in crime, Marvin Wiseman, paid with seven years in prison for their misdeeds. It felt like a severe and surreal ending. Brilliant entrepreneurs in federal custody. They were paid seventy-five cents an hour and became superstars in the white collar crime facility.

THE FIGHT OVER THE BATTLE OF TETUAN

A broad tough looking guy, a cross between Luca Brasi from The Godfather and Joe Pesci, showed up in the gallery and wanted to pay cash for the best painting in the joint. He was on orders from his big boss. Clearly not a guy to be taken lightly.

Mett owned a 10' x 10' original oil painting by Dali that hung in his home in Kaneohe. He had acquired it from an Italian collector in 1981 for half a million dollars. After he was convicted, that painting was sold at a Sotheby's auction to pay for the judgment against him. It was listed by the auction house as being worth between $2 and $3 million.

Mett had already made his money back on this painting because he had published a limited edition lithograph that sold out. The scene had over a thousand figures, most charging on horses with Dali and his wife, Gala, leading the attack. It was, to describe it in one word, unusual. When finally sold and was being shipped, the local TV news ran a story with the clever caption: "Dali Partin'". Mett had panache.

In retrospect, this incident takes on an interesting significance. One of my associates, an older local lady, told me this story a year or two before the gallery got busted. I believed her then, and still do.

Her client worked for an underworld figure. She described him as being a big burly tough-talking guy. He explained that they wanted to buy the Battle of Tetuan, the 10' x 10' oil on canvas by Dali. Mett had priced it at $5 million. This was years before the painting was auctioned to pay court costs. The tough guy offered four mil, cash. When his offer was rejected, she said that his hand sprung to his mouth, and he bit down, hard. She mimicked the gesture several times while she was telling the story, and it made me laugh every time.

She said that he did not want to go back to his boss without getting that painting. That bites.

BIG-EYED ART

Eyes that would make an owl jealous. Spacey saucers with a hypnotic feel mutely stare into your squinting eyes. Welcome to the wide-eyed experience of Keane's world.

Margaret Keane, an artist that Center Art Galleries promoted, was known for her paintings of big-eyed subjects. Tim Burton's movie Big Eyes was about her. Somehow that fits perfectly in my mind: Saucer eyes and Edward Scissorhands on a blind date.

She was painfully shy, the prototypical shrinking violet. Given her passive personality, the odd and oft-told story of her early career painting attributions made sense. Her husband, Walter, promoted her work from their home in San Francisco in those early days. He told her that the paintings would sell better if people thought they were dealing directly with the artist, and "people don't buy lady art."

So he convinced her to let him sign the work. This was when chauvinist pigs still roamed free. Sales increased.

When they were divorcing, years later, things got interesting. During the court case to determine who the actual painter truly was, she wanted to reclaim her name and set the record straight.

Walter obstinately contended that he was the painter. To settle it once and for all, the judge challenged them to paint something in the courtroom.

The jig was up. That is when she got her name back. Walter couldn't paint. And people do buy lady art. She thrived. The LA Art Show, Littletopia, presented Keane with a Lifetime Achievement Award when she was 90 years old.

Decades before Tim Burton's movie, I went to Ms. Keane's house on Oahu. She was just as uncomfortably shy there as she was at our gallery shows. Her extreme shyness made me feel uncomfortable.

The way she looked and her social stiffness reminded me of the rigid gaunt-looking woman in Grant Wood's painting American Gothic.

While her paintings drew many fans and collectors, moved by the accentuated (stoned?) eyes, I just thought that they were sort of creepy.

In another era, it was campy.

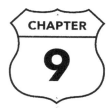

CHAPTER

9

THE SPORTIEST ARTIST

Paintings awash with splashy colors, packed with athletic action, infused with a neon-expressionist sensibility, spotlighting major sports spectacles: LeRoy Neiman became the Howard Cosell of the art business. An art market sensation.

His paintings seemed to always be sprinting to the finish line.

LeRoy was an overnight success in the art business. His paintings featured in Playboy magazines and network TV led to commissions and projects with corporations and sports teams. Neiman had a ringside seat to sports events for decades . He had one of the fastest brushes in the business and covered it all. With notoriety and accessible imagery, LeRoy's art became ubiquitous in galleries from shore to shore.

Neiman's colorful and energetic style was perfect for sports, all action. He became a celebrity in his own right, often featured on television and in magazines. LeRoy was photogenic and could play to the camera with the best of them. Represented in galleries all over the country. He became a bona fide celebrity. Even people that could not name one other artist knew Neiman's name.

For our Maui Neiman show, he arrived in his distinctive all-white suit. With his stylish mustache and unlit cigar, he was a

dashing, urbane figure. One of the most polished artists that we worked with. He lived up to what people expected, he played the part. Leroy's exhibition and sale was one of the highlights of our year. People are comfortable with the familiar, and he had become a media staple.

The author and Neiman

Artists who create images with an aura that defines their particular niche are art market darlings. LeRoy Neiman did that with sports art. He was more panache than painterly, but the mid-market ate it up.

Even when I don't love the art, I respect it. Arguing with success in this business is like spitting in the wind. You end up having to wipe it off your face.

CHAPTER

10

MY FIRST ART TRAINING

Mercifully, my art training didn't require newspapers or diapers.

Before an art consultant was allowed to "be on the floor" of Center Art Galleries, we had to go through a week of training with the company's VP, Marvin. We were told that Marvin used to work in a museum (only decades later did I learn that Marvin had worked in the museum bookstore). It must have been a hell of a good bookstore.

He was a fascinating character, bright, and extremely knowledgeable about art. When he talked, he sounded like someone mimicking, or exaggerating, a cultured, but hard to place, accent. Vaguely Bostonian. He was tall and a bit stooped like the fore bracket in a parenthesis. Mannerisms aside, he really helped everyone get off to a good start with a grounding in the fundamentals of art and the corporate culture of Center Art. His knowledge was encyclopedic. Oddly compelling.

Before and after our all-day sessions at a beautiful Waikiki condo owned by the gallery, we were required to study. We used to say that if you ask Marvin for the time, he will tell you how to build a watch. Brevity was not his forte.

At the end of the week, to qualify to work in the gallery, we had to give a presentation in front of our group of trainees and answer questions about the art we were told to present. I was hoping that the artist I was to cover was someone that I knew something about.

That didn't happen. Marvin chose an obscure North Shore abstract artist whom I knew nothing about. So I winged it, extemporized. At one point, I said, "This work is selling like hotcakes." Marvin interrupted and stopped me right there. He told me, much to my chagrin, never to equate art with hotcakes. He made it fun, and I never forgot that lesson. The laughs were on me.

Marvin's class really was an invaluable introduction to presenting and selling art, and many of the people who took his class are successful gallerists today. And, thanks to Marvin, who ended up serving serious time, I can tell you how to build an artistic melting watch in Dali-esque detail.

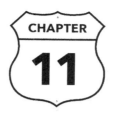

WISHING UPON A MOVIE STAR

Along with the so-called modern masters, we sold celebrity art. People LOVED it.

Fame is seductive, and we exploited that to the max. Center hosted elaborate events with Red Skelton, Anthony Quinn, Tony Curtis, and other lesser-known actors and actresses. The gala art shows were designed to reward the buyers with an up-close and personal experience with the celebrity. It worked like a charm.

The more people spent, the closer they got to the celebrity during our elegant and cleverly designed artful dinners. People would sometimes spend hundreds of thousands of dollars to be seated at the table with the star. The less they spent, the further away they were seated. It was dinner seating Darwinism.

But being there was still exciting wherever you sat and made you feel like you were in with the in-crowd. For many people, the bragging rights back home were priceless. And the stories they might still be telling their friends may have gotten even better over time.

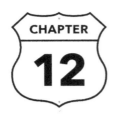

CHAPTER

12

RED NODS OFF

Seeing Red Skelton nod off at dinner opened my eyes.

Growing up in Southern California during the 1950s in a small rural beach town, Portuguese Bend, we had an antenna for our television on our roof because the reception was always bad. We were in the beach boonies, the peninsula, with Rolling Hills blocking good reception.

There were only three channels, all with snow, but one of them had the most popular show, The Red Skelton Hour. Red Skelton was one of the most beloved celebrities of that era. His work harkened back to vaudeville. He was known as a "clean" comic, and his shows were family-friendly. Red's persona was of a lovable clown. His Freddy the Freeloader character was a staple of early TV. The reality behind that image was a bit different.

Getting to meet and work with Red was a thrill, but seeing the actual man behind the scenes was a life lesson. I still admire his ability to move an audience, the brilliance of his pantomimes, and the strength of his performances, but knowing that the affable clown's image masked the man's bitterness and insecurities taught me to question the images that we are fed.

Red's art was promoted so that there was something for every budget. He was, after all, an everyman, and the collection was egalitarian in some ways. You could choose among limited edition reproductions on canvas featuring his most famous characters for as little as $395 framed. Or, you could buy an original painting for many tens of thousands of dollars. There were even hundred-thousand-dollar sales.

Monetizing fame is seductive.

Many of his originals were painted on linen napkins that Red took from restaurants. We sold millions of dollars' worth of this art, and the collectors were moved to tears, not by the prices, but the memories of a favorite and beloved comedian.

After one of the art shows with Red, I was able to engineer a dinner for a special client who had spent hundreds of thousands of dollars, but not on Red's work. The juxtaposition of Red and these clients cracked me up. It was like a clown getting into a getaway car.

The clients were from Vegas and had sketchy backgrounds at best. They paid in cash and said that they owned restaurants. I didn't do a background check, but one of the guys in that group wore a brace for a broken back and had a vibe that suggested it was better to go with the restaurants story. Our party of eight was regaled by Red with stories that definitely did not live up to his clean comic image. Everyone seemed to enjoy that. I did.

At one point, Red nodded off. Unless this was just another great pantomime.

He always worked as if he would starve if he didn't because he grew up so poor. His appetite for public attention seemed insatiable. Red liked to tell the story of making his first paintbrush

from his own cut hair to remind people of his humble early life. He was gracious, and I really appreciated the chance to spend a little time with a true entertainment legend. His humanity made us all a little better.

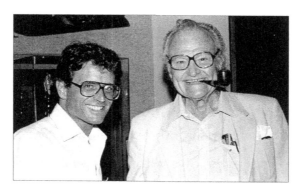

The author and Red Skelton

Red made us laugh to tears; his paintings didn't. The clown paintings were sorrowful on a few different levels.

The folks from Vegas eventually bought one of Red's paintings, so they now have a Skelton in their closet.

IN MY MIND QUINN WAS ZORBA

Zorba the Greek grabbed life with both hands and lived exuberantly. So did Quinn.

Anthony Quinn was my favorite celebrity artist. Not only do I have enormous respect for his acting chops, I really liked a lot of his art. Especially the sculpture.

He was a gifted storyteller and lived up to his image as a larger-than-life star. He was also an incredible draw for Center Art. People literally lined up around the block to meet him during gallery shows.

We needed Quinn to sign posters created for the event. The poster was perfect capturing the spirit of the collection. Perhaps too Picasso-esque, but it's hard to create in that idiom and not be compared to modernism's prolific torchbearer. Quinn had created a bas relief with painted wood. A mixed media painting with sculptural elements, it felt like a modernist totem. The depth and shadows of the original art translated beautifully in the 30" x 40" superbly printed poster.

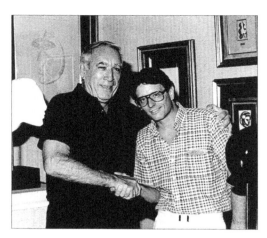

Quinn and the author

I spent a couple of hours in a small viewing room with Mr. Quinn as he graciously signed the posters. We talked. Well I listened more than talked. His voice commands attention, but is delicately modulated. The resonance, the tenor of his voice, along with his robust presence was a rare treat. His ability to spin spellbinding stories left no doubt that he was shaped by the art of his time.

Time flew. I left feeling like I was scratching the surface of life. That there were depths that I had not imagined. We see heroes on the big screen. Quinn played some of them. But his life was heroic - he broke social barriers as an actor. He was poly ethnic and played Indians and cowboys, Popes and fighters on the ropes. A man of the world.

Quinn played Gauguin opposite Kirk Douglas's Van Gogh in Lust for Life. He was a multi-dimensional artist who referenced the modernist aesthetic genuinely and robustly, in real life. He could be profound or referential and could recite and quote the greats, but make the words quintessentially his own. He

repeated: "Small talents borrow, great talents steal. I steal." He had his own very down-to-earth voice that was strong yet vulnerable. Comfortable in his own skin and able to act in many different ethnic skins. He was a transformational artist.

The poster signing was tedious, but time flew in a Hollywood flash. With good cheer. I was there to stack and file the posters and make sure that some of them had dedications for VIP clients. At the end of that chore, he must have been bored and tired, but he was kind throughout, and when we were done he asked if I wanted him to dedicate one to me. He wrote: "To Steven, With affection, Anthony Quinn." I was stoked that in spite of Oscar-winning fame, he was such a gentleman.

Fast forward a year to New York. The Plaza Hotel, owned by one Donald Trump, but more about that later. We had a gala Quinn event at the hotel with a guest list that included Adnan Khashoggi, one of the world's most successful arms dealers, celebrity friends of Quinn's, hotel owners from Europe, and ballers from all over the world.

All the stops were pulled, and that show was destined for success.

CHAPTER

14

QUAALUDES AND QUINN DON'T MIX

Dali once said, "I don't do drugs; I am drugs." My client never said that.

Months before Quinn's NY show, I had promised one of my most loyal collectors, Jerry, to visit his NY penthouse suite to hang his extensive Salvador Dali collection. He was in the penny stock market and was clearly doing well.

I took a subway close to his place, and called him. He said that he would pick me up and get me into his building. He pulled up in his luxury BMW and took me to his well-appointed penthouse.

I had brought tools but realized that his walls were solid concrete; we needed specialized hanging hardware. I suggested that we go to the nearest hardware store. Before leaving, he opened a cabinet, and there were bottles of pills. He asked if I wanted a Quaalude. I didn't. Not only did I have a major show in a few hours, I had never had any desire to take one. He took two. Yikes.

On the way to the hardware store, he wanted to introduce me to his sister, so we stopped at her flower market. She was nice, but I saw him pop his third Quaalude. Enough to put down an

elephant. We didn't stay long. On the way back, he said that he needed gas, so we stopped at a gas station.

Jerry was so stoned, he literally sat on the water bucket used to clean car windows. With a slur, he asks me to drive to his house. I had no idea where it was at this point and was not comfortable driving his car. But he was in no shape to do it.

When I pulled up to the first stoplight, he was slumped over with his tongue hanging out of his mouth. He looked dead. I could see the driver in the car next to us staring at him with a concerned expression. After multiple stops to ask for directions along the way, we made it back to his building. I asked the doorman to help me get him into the elevator.

Several people got on the elevator with us and were totally pissed when Jerry proceeded to hit every button on every floor as if he were Jerry Lee Lewis hitting all of the piano keys at the end of "Great Balls of Fire." The piano technique is called glissando; the elevator technique is called assholedo. Eyes rolled and tongues clucked as every floor light lit. Everyone felt the tension, except Jerry.

When we finally got to his floor, I helped him into the apartment, and he spilled into a chair like jello. I loudly explained that I could come back another time to hang the art, but needed to get back for the Quinn show.

He was invited, and we had a special place at a table for him, close to the artist, but he was one of the only no-shows that night.

As I left, I took a final glance into the apartment and saw Jerry, with half his torso limply hanging over the chair. He looked like one of the melted clocks in one of Dali's most iconic paintings, The Persistence of Memory.

He passed out before our business was consummated; I ran out of time to hang his art. Before I came to New York, he had promised to write a check for a Dali portfolio, Alchemie des Philosophes, that he still hadn't finished paying for.

The portfolio itself was integral to the art. Shaped like a huge book, it hinged along the spine and opened to reveal two halves, the first one with ten reproductions of ancient alchemical texts printed on handmade rag paper. The other half contained ten signed and numbered lithographs by Dali.

The portfolio's cover featured a mobile resin wheel injected with mercury, a fundamental material in alchemy. The front was composed of wheels meant to codify theosophical and alchemical knowledge into a single system.

Heady and pretentious stuff. And not inexpensive.

I barely had time to get back to the hotel and get ready for the show. The next day I called to check on Jerry, and he sounded bright and chipper and acted as if nothing had happened, which, in a way, it hadn't. He told me that he had had a good time.

TRUMP TAKES THE DAIS AT THE SHOW

I had no idea who Donald Trump was; no one did. We just knew that this young impudent guy owned the Plaza Hotel with his wife. She seemed to be doing the lions share of the work and was efficient. The hotel was the site for our Anthony Quinn show. Trump described his hotel as a work of art. He bought it for $390 million and sold it to Prince al-Waleed of Saudi Arabia for $325 million seven years later.

We had a floor of rooms that we used as showrooms, with art hanging for private shows for clients. We also had a large, well-appointed show space for the gala event.

On the night of the extravagant event, the gallery owner was set to take the dais to introduce Quinn and set the scene for our clients. But before Bill Mett had a chance to do that, without being asked or invited to do so, Trump took the dais to speak.

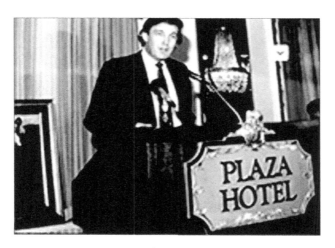

Early Trump

It was essentially, in now-classic Trumpian style, a plug for himself and the hotel. I thought little of it at the time because I was busy wooing and entertaining guests, but I did feel that it was inappropriate.

If you had told me that he would become president of the U.S. forty-plus years later, I would have fainted, farted, or both.

CHAPTER 16

AN UNWANTED KISS AND A GOLD DOUBLOON

Woody's ulterior motives became clear in hindsight.

During Anthony Quinn's first show in Honolulu, an old client, Woody, was on the island and really loved Quinn's bronze and marble sculptures. He was from a prominent family in Florida, with hospitals named after his relatives. He owned some of Red Skelton's work and now had his eye on seven Quinn sculptures. He was a strange bird, but I was an art consultant, not a shrink. I did my best not to judge people.

Like most galleries, we used red dots to show that a piece of art had sold, and by the end of our second round of consultations, we had seven red dots on seven beautiful Anthony Quinn sculptures. Woody put down the requisite deposit to secure them.

After that business was done, Woody asked if I knew a good location for a gay nightclub that he planned to open in Honolulu. It was not my forte, so I explained that I didn't, but the VP of the company might. He asked if we could arrange a dinner to discuss this.

So, I called Marvin, the VP, and suggested that we treat the client to dinner at the Third Floor, one of the swankiest Honolulu restaurants in those days. It was to be a thank-you for his past business and his pending purchase.

Everything was going well during dinner. The VP was loquacious and interesting, and the banter flowed. At one point, I excused myself to go to the restroom. I actually wanted to call my girlfriend because we were supposed to go out later that night, and it looked like time was slipping away.

When I returned to the table, there was a small cake holding a single candle with an antique gold ring around it on my table setting. I was more than surprised; I was flummoxed.

When I sat down, Woody grabbed my head and planted a kiss on my lips. As I pulled away, I looked at Marvin, and he had a huge ear-to-ear grin on his face. I was as red as a maraschino cherry and embarrassed at this scene in the packed restaurant. The client said that this was his way of thanking me. Egads.

I should mention that Woody was particularly unattractive. His complexion looked like a slab of uncooked beef. And his personality wasn't far behind. His whiny high-pitched voice sounded like an untuned violin. Had I been inclined that way, he would be at the end of the line.

I repeatedly told him that I could not accept the ring, but he insisted, ad nauseam. The VP was siding with him. I was pissed and felt betrayed and used. It took restraint not to tell him to go fuck himself. I didn't want to amplify the scene.

Two days later, Woody canceled the sale.

I ended up selling the ring that week to one of my friends and colleagues whom we nicknamed "solid gold Bob" because of his penchant for wearing gold. Cool dude.

He loved the ring and still has it. It was made of an old Cuban gold coin from the late 1800s. It was a nice ring, but I don't even wear a wedding ring because my knuckles are bigger than my fingers, and it is hard to get a ring on, even harder to get it off.

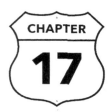

CHAPTER

17

SOME LIKE IT HOTTER THAN OTHERS

"Well, nobody's perfect." That classic last line in Some Like It Hot (spoken by Osgood Fielding III, aka Joe E Brown), starring Tony Curtis and Marilyn Monroe, could also apply to Mr. Curtis's paintings.

The artist Marc Chagall called Tony Curtis the most beautiful man he had ever seen. Curtis was the archetypal Hollywood star: suave, smooth and handsome. Like many leading men who lose their marketing appeal as they age, Curtis turned to painting. The gallery that I worked with signed him up.

The name recognition alone was a draw, and the gallery had now solidified its reputation for being able to market the work of celebrities. We were excited to meet Curtis but skeptical about the art. His style was loose and approachable, and he was a colorist whose work would appeal to a cross-section of the art collecting public. The name value was another great asset.

The first time I met Tony Curtis, in our Lahaina gallery, he lived up to his reputation as a polished professional. He talked about his art in a way that resonated with us. In retrospect, I felt bad about asking him the question that I asked.

Curtis had talked about how he hoped collectors would acquire the art on the art's merits and not on his fame as an actor. I asked him, if that was the case, why didn't he sign the work "Bernard Schwartz," his pre-stage, given name. I appreciated his answer: He explained that he had spent his entire adult life working to become Tony Curtis. That was no BS. Clearly it takes work to climb to the top of any field, slough off the old skin, and create a new persona. He was, after all, Tony Curtis: debonair and creative.

Steven Maier & Tony Curtis

No question, he was an artist and a good communicator. I later felt that the question had been cheeky, and his answer genuine and polished. As was he.

While Curtis was a terrific performer (particularly great as Joe, the saxophone player, in Some Like It Hot), the market for his art was lukewarm. Still, he could light up a room.

A MILLION-DOLLAR DALI

"Avida Dollars" was a derogatory nickname given to Salvador Dali. It's an anagram of the artist's name and means "greedy for dollars."

It's impossible to separate money and contemporary art. It is a storyline as big as the industry. We have grown up in an era in which prices continue to escalate impressively. Sometimes astonishingly. The relationship between art and money is incestuous. At the top of the market about fifty collectors vie for the top lots.

There are moments in art that withstand the test of time. The art-historical context separates the mega-priced art from the rest. It is a rarefied bunch of billionaires, vetted to confirm their financial wherewithal, who make headline purchases. Still, there is a brisk base of millionaire collectors on the next level down who don't generate headlines but bolster and fertilize the market.

I met a movie star good-looking couple two years before this unlikely sale. A classically handsome man&wife—in another era, they would have inspired a sculpture by Bernini—they were hard to miss, Italian-American, perfect puzzle pieces, outstanding

together. When we met on Maui, I liked them immediately. They were unpretentious, upbeat and new to art collecting.

Over several years, we built a rapport, a friendship and trust. I didn't realize it at the time, but they were very successful and had two knock-out gorgeous, well-mannered, teenage daughters.

In that time, I helped to curate their growing and diverse art collection and tried to ensure that they had work that would withstand the test of time. They trusted my advice and knew that I had their best interests at heart. I had advised them to diversify their collection with the proposition that not only would it be more interesting that way, but branching out also ensured that all of their art eggs were not in one big beautiful basket.

They liked that approach. After a couple of years they told me that one day they planned to own an original Dali. They would end up owning the best one.

We had many original works along with limited editions. They were looking at original sepia-toned pen and ink drawings that highlighted Dali's fluid draughtsmanship. A few of them were exquisite, but I explained that there were only a few periods that were important to collect. Dali was one of the biggest art whores, and controversy swirled around him despite his being one of the most popular Surrealist artists of all time.

I wanted to make sure that if they were going to acquire a Dali, the work they chose would transcend the controversies. We had one original oil painting from the early 1920s—a fertile period for Dali and Surrealist art. That painting had impeccable provenance. Circa 1923, the medium was oil on board. The painting was luminous, capturing both the essence of Surrealism and Dali's idiosyncratic style.

The work was painted predominantly in haunting hues of green in subtle shades. It was a spectral vision of a ghostly horse with a cypress tree growing from its back. The tree cast a light-infused shadow and the coast of Cadaques, Dali's favorite landscape, was rendered dreamily in the background. It was a well preserved classic example of Dali's early Surrealism.

In those days, Dali painted with a time-honored glazing technique that required layer after layer after layer of paint thinned almost to transparency. It was a laborious process, with long drying times between glazes, but one that created visual depth and a mesmerizing, scintillating quality.

The painting was a tangible dream.

The only trouble with presenting this painting was the fact that it was selling for a million dollars. We had been selling it for $720,000 weeks before, but the fire in Dali's home and his injuries prompted the gallery owner to raise the price.

As retail ghoulish as that sounds, it was.

The provenance was remarkable: In the early days of his career, there was a consortium of twelve businessmen, The Zodiac Club, that financially supported Dali. In return, the members were sometimes gifted a painting. In this case, there were letters between the original owner to whom Dali had given the painting. (He was quite old by then and had put the painting on consignment with the gallery.) He lived on Maui and had kept his correspondence with the artist. In one of the letters that he sent to Dali, he said that he was an old calvary man and requested that Dali paint a horse. Those letters that he had kept made the painting feel even more historic.

We went around and around for a couple of days discussing different collecting strategies, and I was unsure what would work best for them. I was hoping that they would get the oil painting, but had a feeling that the price was more than they had budgeted.

On the last day of their vacation, the Riccis came to the gallery, and the first thing they said was, "We are going to make your day." They offered $720K for the painting. I had to call the gallery owner, but he seemed happy to accept their cash offer.

I didn't find out until over a year later that, in fact, the consignment agreement for the gallery ended that week. We would have had to give the painting back to the consignor if it had not been sold before the consignment agreement expired.

It may have been the most that an original Dali had sold for up to that time.

It is worth noting that, years later, the painting ended up in the Montreal Museum of Fine Arts and was prominently featured in a two-page spread in their deluxe Dali monograph.

The Riccis gave us a cash deposit that day and asked that I pick up the next $200K in Vegas next month and the balance in NY some months later. To be honest, I prefer credit cards—less stress.

CHAPTER 19

NOW I'M THE BAGMAN

I would not want to do this again. Please note that this was almost forty years ago. The statute of limitations has passed. Laws have changed since this incident.

I arrived in Vegas to pick up the next installment of cash for the sale in the morning and was picked up in a racy Porsche and whisked to the Riccis' home. It was nice, but not lavish, and I took note of the bars on the windows.

Never having counted out several hundred thousand dollars before, I was not prepared for how tedious it was. It took longer than I thought it would. Freud called money filthy lucre, and he was probably right.

After we finished, the client brought in a large carry-on and lined it with bundles of carbon paper. After putting in each layer of cash, another bundle of carbon paper went on top. Our client explained that this was in case the carry-on was x-rayed; it would just look like documents. Hey, some days you learn something new. This was pre-TSA, and security was not as stringent as it is now. Still, doing this made me nervous. Odd thoughts and scenarios swirled in my imagination.

After counting the money, we washed our hands, and went out for lunch. After lunch, we went back to Tony's house. My flight was scheduled for that afternoon. It was a fairly fast turnaround, and he wanted to drop off his wife and then take me to the airport.

Before leaving the house, he poured a pile of coke on the glass-topped table and, with a razor, drew two long, Everest-sized lines before proceeding to snort one with Hoover-esque efficiency before handing me the tightly rolled currency he had just vacuumed his line with.

I don't like coke. I've done it more than a few times, but it was not my bag. I didn't want to be wired carrying cash, and I was already on an adrenalin high that I was trying to minimize. But I didn't want to make him paranoid. It's like being offered meat at a party, but you are a vegetarian, but don't want to offend the host. I did my best to ingest it in a few sniffling tries.

Despite it being an unspoken subtext, we had never talked about drugs, but the topic was always curiously there. I was not prepared for the coke. My heart was racing.

Looking back, that was the height of being a retail whore. In retrospect, doing what I did to make a sale looks desperate, and incredibly risky. Instead of being proud of being in the art business, I was paranoid.

My plane landed in San Francisco for a layover, and I had asked my brother if he wanted to meet me at the airport. My tight grip on that bag of money never loosened as we talked.

The flight to Honolulu was a relief, though I was apprehensive throughout. The gallery owner met me at the airport, and I was really relieved to hand the cash over to him. He asked if I wanted

to stay at his beautiful oceanfront house on Kaneohe. I didn't. I wanted to get home to Maui.

Exhausted, I headed to an ATM for some much needed cash.

CHAPTER 20

CASH CODA

Decades later, while discussing parts of this sale with one of the principals involved, I learned that some, not much, but some of the cash was counterfeit. Less than $2,000. Another detail that throws some shade on this story: When I sat down with the client to collect the payment in his living room in LV, he told his wife, "Corina, go dig up the cash." I had the vague feeling that it was laundry time. Mea Culpa.

CHAPTER

21

LA LA LA IN LA:
THE JANET JACKSON COMMISSION

A chance meeting can turn into a surprise opportunity. This one had some odd twists.

Before our meeting with Janet Jackson to discuss a commission for the cover of her new CD, the French artist Daniel Authouart and I went to Tower Records to buy her older work so that we would know more about her music. We both knew about brother Michael (who didn't?) but we had not been fans of hers and really knew little about JJ. Later Authouart told me that he thought that Janet was the most talented Jackson. She was impressive in person, thoughtful, and engaged.

About a year before meeting Ms. Jackson, I had met John McClain, a music executive and part of the Jackson team. Decades later, John was one of two executors of Michael Jackson's estate after MJ passed on. He was a perceptive and talented individual with idiosyncratic tastes. His vacation on Maui led him to the gallery and our meeting.

We represented French artist Daniel Authouart and his fascinating dreamlike narrative pop-culture paintings. John recognized the talent and acquired several paintings. I found

out later that he gave one to Janet, and she too became a fan. In fact, I got a call from John over a year and a half later explaining that Janet wanted to commission Authouart to create the cover for her Greatest Hits album. Wow.

The timing was critical. Not only had Authouart never been to Los Angeles, but he also did not speak English and was very busy with his work. His studio was a converted gymnasium, and he worked on large canvases—evocative, somewhat surreal dreamlike motifs of contemporary culture. A melange of imagery woven together by a sensibility that captured the spirit of the times, the psychological truth of the people and places depicted.

Daniel's work was complex and the art for the cover would take time to create. Janet was signed with A&M at that time, and they got involved. The incident left me with a sense that the record business can be pretty heavy-handed with their talent. Despite my entreaties to not wait until the last minute for this project, it came down to the last minute.

I did not want to put Daniel Authouart in a position of having to create something in record-breaking time, but he was in exactly that position by the time we got the green light. I found out later that the reason for the delay was that they tried to circumvent the gallery and deal directly with the artist. Fortunately, Authouart and his dealer Alain were honorable and reliable and preferred for us to put the deal together.

Authouart flew into LAX, and I was at the terminal with a greeting sign and high hopes that everything would be copacetic with all of the parties involved.

Commissions can be especially problematic. We drove to the Bel Age Hotel in Hollywood, and I introduced Daniel to Southern California. I was born in LA; my father graduated from Hollywood High School, and my grandmother had a radio show and worked in Hollywood when I was growing up. So I knew my way around town.

I had brought a huge unframed Authouart painting to show Janet. The subject was the opera singer Maria Callas. John McClain had shown her some of the smaller ones he had acquired and even given her one, but we wanted to give her a feel for the scale of the work. We had agreed that Janet would come to my hotel room to discuss the commission.

The afternoon of our meeting, I had smoked a cigarette, a habit I gave up decades ago now. Her manager came first and started freaking out. He told me that Janet hated cigarettes. So I opened all of the doors and windows and frantically tried to clear the air before she got there.

When Janet showed up with her then-boyfriend, I think that the smoke had cleared. She was lovely. Smart, focused, and gracious. Her boyfriend didn't say much, and the one detail that I remember about him was his shoes. The pointiest shoes that I had ever seen.

Daniel quietly observed. None of us spoke French, but he was perceptive and seemed to understand the gist of what was happening.

I rolled out the 10' canvas on the floor, and Janet really lit up. She loved it. I explained that Authouart wanted to include personal items and artifacts in the commissioned painting and wondered if she could accommodate that request. He planned

to include musical influences and create a very intimate work of art. She was down with that and said that she would provide what was needed.

Janet said that she wanted to take Daniel to Neverland Ranch to meet her brother. I was thrilled. As it turned out, they did not want me to come due to privacy issues (perhaps if I had been much, much younger, a pre-teen, who knows…sorry for that cheap shot). Anyway, that was a big disappointment for me. I felt snubbed. And pissed.

At the end of this project, Authouart's work was not on the cover but on an illustrative flip chart within the CD. Things can get convoluted when so many people get involved, especially people from the recording industry.

Authouart was impressive throughout this project—we were at an outside cafe on Hollywood Boulevard, and while we were talking, he was sketching upside down so that I could see the drawing as he was creating it. He then dedicated it to me, a personal treasure. It was a simple sketch of our waiter, but the fact that he could do it upside down blew my mind.

He would sit on the sidewalk, drawing and soaking up the atmosphere of Hollywood. He grew up watching American movies after the war and was a perceptive student of popular American culture.

Months later, I received a New Year's card from Authouart. He explained how hard it was to finish the work with so little time. He worked day and night on the project.

As it turns out, I left the gallery before the project was finished to open my own gallery and never got paid (a different story) because the balance of the commission money exchanged

months after I left. Even so, I would do it again. It was a blast, and I met Sugar Ray Leonard while I was staying at the Bel Age Hotel. A knockout experience.

CHAPTER 22

A LONG STRANGE TRIP TO OK

Most roads have twists and turns; this one to Oklahoma was mostly twisted.

I had met a young couple from Norman, Oklahoma. They were just beginning the process of building a new home. From their description, it sounded like their dream home. They were interested in acquiring some notable art. Family treasures.

While they were in Hawaii, I showed them a beautiful Marc Chagall from his Circus Suite, and they bought it. During the sale, they asked for consideration on the price. I told them that if they agreed to buy additional pieces that we would sharpen the gallery pencil. They explained that they would do that, but not until the house was much closer to completion. So I stayed in touch with them over the next two years. It must have been a big house.

The clients had flown to Hawaii in their family's huge plane. They were in the oil business and obviously doing well with their oil wells. They showed me a picture and it looked like a 707, but I suck at knowing one plane from another.

We were planning a major show of Manet, Renoir, Picasso, et al., and I figured that the time was right. After getting approval from the gallery owner, I called and explained that we had an expertly curated collection of the masters that would be shipped to Hawaii from New York. I suggested that we could have it shipped to Oklahoma first for a private preview. We wanted to give them first dibs—and we would fly in to provide them with an opportunity to select one for their new home, which was finally close to completion.

They agreed.

Because there were many crates involved and the art was worth millions of dollars, I needed someone to go with me. The gallery owner insisted that it be one of the most knowledgeable people in the business, an associate who had worked at Hammer Galleries in NY and had an encyclopedic knowledge of art and antiques. I was relieved because I knew that his expertise would be invaluable. But he was also one of the strangest creatures on the planet and not just gay, but Uber-gay. I am fine with that; after all, my mother had a gallery when I was growing up, and many of our best friends are gay. In this case, however, it would turn out to be problematic.

The agreement that I had with the gallery was this: The gallery would pay for the entire trip if we made a sale. But if we didn't, I would have to pay all of the expenses. I was confident of success because of my earlier agreement and rapport with the clients and the fact that we had a spectacular selection of work that would satisfy their desire to own exceptional big-name art. And importantly, they had the wherewithal to acquire what they wanted.

When we landed in OK, I rented the biggest van available and went to pick up the crates. My associate was a rotund individual, not quite morbidly obese, but on his way. He was not into heavy lifting and seemed to relish watching me struggle with the crates. He also would not drive the van. Total refusenik.

He did provide colorful commentary that kinda cracked me up. Some cynics can mash it all up. Michael was all innuendos and double entendres. Cynically delightful. Up to a point.

When we got to our motel, I called the clients to set up a time to meet. My heart sank when they explained that something had just come up with their business, and they could not meet with us for three days. That was not anticipated. What a drag.

So I lugged and huffed the crates into my room, adjacent to my colleague's room, and had just enough space to get to the bathroom. And to bed. It was cramped, and I literally could not leave the room because of the value of that collection. I had become an art security guard. A hostage to the deal.

My colleague went to the movies, dined, and carried on while I stood watch for three crate-cramped days.

Finally, the time for our meeting was at hand. I drove to the designated rendezvous, the home of the young couple's father. When we knocked on the door, he answered the door dressed in a tie; we weren't. Faux pas number one.

The house was just as fabulous as expected. As we walked to the van to unload the art, we agreed that this meeting was more formal than we had anticipated. My associate started to tell me about how much the antiques in the room were worth. He sounded like a walking price guide, an antiques calculator -

he was getting excited. He immediately knew that these folks were serious collectors. Our confidence puffed up.

The family was clearly ultra-conservative and religious and the father set the tone with a vibe that made uptight seem loose. I was getting the distinct impression that they did not like my associate, and probably did not like me either. The difference between meeting them in a gallery in Hawaii and Edmond Oklahoma, in the family patriarch's home, was severe. I forgot to mention that my associate catered to no one, talked down to everyone and had a hoity-toity attitude that exuded a superiority complex. He would have been good-looking, but he had a prominent overbite that dominated his face. He came off as gayer than springtime. Not a great combination in this particular situation.

But Michael gave what I thought was a brilliant, erudite presentation that provided art historical context to the collection as well as unique insights. I was really proud of him, but nervous as hell about the vibe that we were getting.

At the end of our hours' long presentation, they focused on one of the Renoir's, The Pinning of the Hat. I suggested that we take it to the young couple's new home and see if it fit their tastes. They agreed.

The new home was still a work in progress but very impressive. Hand-carved beams and all of the flourishes that might be expected. Expansive living. When I held the Renoir up to the marble fireplace, the size was perfect and I was struck by how beautifully the colors worked—subtle shades of a red becoming vermilion. I said, "How thoughtful of Renoir to use a color that harmonizes with your marble," or something very close to that.

The subject was genteel and pleasing: young ladies pinning a stylish hat.

I was confident that this was going to be the one they would get. They seemed genuinely enthusiastic. My plan was for them to buy four or five pieces, but now my hopes were on a diet.

When I genteelly asked if this was the one, they asked for time to think about it. I didn't want to go full tilt sales and ask what they wanted to think about and try to "close" them. We had brought plenty of art to think about. They were either going to get it, or not. And only if their father gave them his stamp of approval.

As I packed up to go, I was feeling relieved. Both because I was looking forward to going home and because I felt that we had given it our best shot.

On the way back to the motel, we talked in the van and agreed that it would be a sale. We felt like we had connected them to something beautiful and art historically relevant and that it fit perfectly with their new home.

Their call came early the next day. The husband explained that they really didn't want to own anything that we had brought, but would keep in touch. I was incredulous. Crestfallen. It was clinical and curt. And final.

The thought of re-crating and going home empty-handed, in defeat, owing thousands of dollars for the effort, was depressing. But I had known that it was a gamble all along and tried to keep a straight face with that stiff upper lip. But there were quivers.

Out of the blue (or was it?), my associate came up with an idea that might save the trip. One of his clients was the CEO of the Southland Corporation, the company that owned 7/11 stores.

He suggested that we drive to Dallas so that he could present the collection to them. I did, gladly, and probably drove over the speed limit. It was my first trip to Dallas. The drive was beautiful.

I would have loved it if my associate had taken the wheel, but that was not in the cards. When we finally got to Dallas, we rented a couple of rooms in a seedy motel with hookers and sketchy types all around. Again I was the schlepper-in-chief and security guard. Fortunately, this time we did not have to wait for days and met with the clients early the next morning.

We had a small original Diego Rivera oil painting that ended up saving me thousands of dollars in expenses when they acquired it. Diego was controversial for being a "communist," but that sale was salve to this capitalist worker.

What a relief. Michael, my associate, did fairly well with that sale, and I was glad that the longer-than-expected trip was not all for naught.

The masters' show in Hawaii that followed was a huge success. The rejected Renoir, along with many of the other paintings, sold.

I never heard from the couple in OK again. I never figured out why. Clearly, our original agreement was not worth the paper it wasn't written on. If I were to conjecture a reason: Their father put the kibosh on it. I don't think that he liked us.

Or, they thought that the art was overpriced. Or both.

It's a disheartening, artless, morality tale. More a gut punch than a punchline.

THE EVOLUTION OF JAZZ

"Writing about music is like dancing about architecture." Thelonious Monk

Jazz is more American and tastier than apple pie. Evolving from the African-American neighborhoods of New Orleans, the music inspires people around the world. Countless visual artists, including my wife are influenced by jazz, the folk music of the machine age. America's most original art form. Created by our most oppressed community. Liberating music.

One sculptor created the visual counterpoint to celebrate the great jazz artists.

In his upbeat and expressive Evolution of Jazz sculpture series, Ed Dwight used syncopation and negative space to depict jazz legends in an evocative and spatially jazzy way. Other artists eventually tried emulating his style, and became more commercially successful, but Ed is an original. His work has character and soul.

Down-to-earth, Ed is fun to be around. An energetic gentleman, generous with his time and uses it creatively. He told this story when we first met: Because he was on the short

list for the Astronauts in Training program at NASA, Ed had to be measured to be eligible. He was slightly shorter than the height requirement. So, before being measured, his friends helped him out.

They grabbed his feet, arms, and head, and pulled painfully hard from both ends at once. He needed to stretch, to eke out the height, to pass muster. He did. Barely.

Ed's resume is impressive: A former Air Force test pilot; America's first African-American astronaut candidate trainee; IBM systems engineer; restaurateur; real estate developer, and I am undoubtedly leaving out some important details regarding his stellar career because I want to focus on his time as a cutting-edge sculptor.

At the request of the National Park Service, he created, for the St. Louis Museum at the Gateway Arch, the series Jazz: An American Art Form. I immediately fell in love with this work. Duke Ellington, Miles Davis, Ella Fitzgerald, Louis Armstrong, Charlie Parker—in all over 70 sculptures comprise his sensational bronze jazz ensemble.

Dwight captures each subject's spirit and musicality; you can feel their presence. Often in syncopated time.

When I told Ed that my wife and I were planning a trip to Japan and asked if he wanted us to inquire if we could find suitable representation for his work, he didn't hesitate to say yes. He put together an impressive portfolio for us. We were well-received. Many Japanese love jazz and art. The response was enthusiastic. Jazz music has been popular in Japan since its inception and people appreciated the quality and originality of Dwight's collection.

After a few calls and visits to potential venues, we were introduced to a museum director. He loved the work and was interested until he asked how many were in each edition. When we said 40, he shook his head and said that he couldn't do it. The edition sizes in our minds were small, but we were told that in Japan they adhered to classic French standards. The edition had to be nine or fewer for their museum.

In spite of our best effort, we could not put something together for Ed's work in Japan. We were happy to continue selling his impressive sculpture collection in Hawaii.

A few years after buying a Dwight sculpture, one of the collectors came back to the gallery and seemed to enjoy telling me this amusing story: One night, he came home after drinking. Before turning on the light he was scared out of his wits. Almost jumped out of his pants. He thought that an intruder had broken into his house, and was standing there.

He then sheepishly smiled and explained that he had mistaken his almost life-sized Dwight sculpture of Benny Goodman for an intruder.

He had forgotten that he had put his hat on it.

I kidded him and suggested that Benny Goodman's clarinet looks like a blowgun. It did.

CHAPTER
24

DUCK IF YOU SEE ME OPEN A GALLERY

Timing is a huge factor in success and failure. It was in mine.

After working as a gallery director for years, I decided to take the leap and open a gallery. The Front Street Gallery was a partnership with a successful businessman who made most of his money as the second-largest t-shirt manufacturer in Hawaii. Second only to Crazy Shirts.

My business partner had secured the 35-year lease on an entire block on the seaside part of Front Street in Lahaina, Maui. It was a choice location, right over the water with a stunning view of Lanai island in the distance. The space was funky and needed a lot of work, but it had enormous potential.

My Front Street Gallery under construction

Our budget was limited. To save money, I did most of the work myself, much to my wife's dismay. I gutted the old space and turned it into a gallery. After the above promotional photo was taken, I shed the tux and got back into my work clothes.

The renovation was finished for just under $50,000. It looked great with a showroom off of the lanai. The waves lapping against the pilings below created a natural ambiance.

As charming as being perched over the water was, it ended up being problematic. The deteriorating old pilings needed to be replaced. The work was estimated to take a year and calculating that in "Hawaii time," I figured longer. We had to close down, as did the adjacent business'. It was a major project, essentially replacing the foundation over the ocean.

With a growing family, that insisted on eating three meals every day, I could not afford to spend a year off with no income. I left. The gallery lease ended up in Wyland's hands, one of the artists we featured. Decades later, it continues to be one of his most successful locations. A veritable cash (sea?)-cow.

On a side note regarding The Front Street Gallery: Before we agreed to work together, one night at a bar, the guy who owned the lease, told me that if I ever heard rumors about his former, murdered, business partner, disregard them. He said that they were not true; he didn't do it.

His old business partner was found burnt to a crisp in a car on the North Shore. As he told me this story, I thought, wow, this guy looks scary. His face was pockmarked, and he could have been out of central casting as a heavy in a movie about hitmen. He didn't strike me as capable of doing that, and I believed him, but that story was, and still is, hard to forget.

He ended up burning me in a way that left no visible marks.

Years later, when we opened our second gallery, this time in Honolulu, we had high hopes and a solid business plan. We built Fine Art Hawaii at a time that looked propitious. The art business was thriving worldwide and the Hawaii market needed more venues. We had a niche that we believed in.

A week before our grand opening, 9/11 slammed into our dreams.

Everyone said, "You are going to cancel the grand opening event, aren't you?" But we didn't cancel. We felt that it was important for people to get together and not give in to panic. We had already sent out 1000 invitations.

The turnout was better than expected. People needed to get together.

But the challenges of those days did not dissipate. We got through that first year and stayed open for seven years working from bell to bell.

Timing did not click in our favor. We had a few major success' during that run, but the work was non stop. Wearing multiple hats at the gallery and raising a family at home, was challenging in unanticipated ways.

I was no stranger to retail challenges and thought back to the time I was a gallery director for Merrill Chase Galleries, and we opened a location at the Ala Moana Shopping Center on a new level that they called Palm Court. It was designed for high-end retail, and we were the first tenant to open.

The gallery was elegant. The artists included some of the biggest names in art history. We had a huge collection of world-

class art and a great staff of experienced art consultants. A week later, the first Gulf War broke out, and the art business shriveled.

Those gallery opening and closing experiences are the reason I told my neighbor, "If you see me open a gallery, DUCK."

CHAPTER

25

TREASURE HUNTING

I met a real-life treasure-hunter/gatherer while scouring the Southwest for art.

Before opening the Front Street Gallery in Lahaina, I took a road trip through California, Arizona, and New Mexico in search of key artists. The most memorable stop on that journey was meeting the eccentric art dealer Forrest Fenn.

Walking into Fenn's Santa Fe gallery felt like a dream. A trip back in time. Hundreds of Indian leggings hanging from the ceiling and art and artifacts from a bygone era everywhere. The sheer quantity of art was arresting, but the quality was astonishing.

Paintings and sculptures from Frederic Remington and C.M. Russell; Winchester rifles; arrows; Indian blankets, baskets, and bows; moccasins; enchanting painters and ethnic art makers— an eclectic, if not eccentric, wonderfully curated collection. Art from a bygone era.

I knew nothing of Forrest Fenn until I walked into his gallery. It felt like the Shangri-La of Southwest art galleries, and he was a striking figure. Fit, tall, and articulate. And he had the goods.

As we talked, he asked me why I was there, and I explained that I was opening a gallery in Lahaina and was looking for artists. Elaborating, I told him that one section of the gallery would be devoted to faux, more colloquially known as fake, art. Replicas. I had contacts to get well-done, you may say fake, I say faux, art.

The idea was to create a faux museum-like space with stanchions and replica guards and security cameras and have the most famous public domain art in the genre created to display and sell, with fake certificates of authenticity. The whole farce, upfront. People could order from a catalog, and we would create their preferred art in the size of their choosing. I thought that would turn him off, but I wanted to be upfront about our Front Street Gallery.

He surprised me. Mr. Fenn took me upstairs to show me his faux art collection, which was seriously the best, most expensive, faux art in the world. I was blown away. It was better than I had imagined that it could be. He had an extensive collection of Elmyr de Hory Impressionist paintings. De Hory was the most famous/notorious forger of all time; he fooled museum curators and seasoned collectors.

If fakes are sold as the original art, it's a felony; if sold as the best forgeries in the world, it's a big sale.

The prices reflected the rarity of these fakes. Way beyond my budget, but I loved meeting the idiosyncratic art dealer Forrest Fenn and was delighted that he liked the idea of offering faux art as an option. He was a gentleman, his gallery a treasure.

Decades later, I learned that Forrest Fenn was a decorated Air Force pilot and had flown over 300 combat missions in Vietnam. He described himself as an artistic lowbrow with no college or

business acumen. He said that he was just in the right place at the right time with the right product. He regarded art as little more than a commodity.

Ten years before he passed, Fenn created a bizarre project that, in retrospect, looks a lot like performance art. He created a two-million-dollar Romanesque bronze treasure chest filled with gold doubloons and precious gemstones, buried it in the Rockies, and challenged the public to find it. This treasure chest was finally discovered in 2020, just a few months before Fenn's death.

I thought that it was the stuff of kid's dreams and myths and loads of fun. People died looking for the treasure, trying to follow Fenn's poem full of cryptic clues, but the hunt fueled the imagination.

His memoir was titled The Thrill of the Chase, and he had a career or two with many thrills and chases. This was his way of sharing his passion.

Judging from my brief experience in his gallery, just one afternoon, I think that he embodied the idea that doing what you love is important. And going all in. He was not just the right guy in the right place at the right time with the right product, but importantly, he had the right attitude. Being a tall, proud Texan may have helped.

Going to his gallery took me back in time in a way that few experiences can. A great gallery can create memories. His did.

CHAPTER 26

IT'S TOO CHEAP:
AN EXPENSIVE LESSON

Sales are often lost because the price is too high. We lost this sale because the art was too cheap.

Mihoko and I were working with a museum in Japan. The curator of the collection was a doctor representing a billionaire building two museums as an attraction for a shopping complex in development.

One of the museums was built to display his extensive collection of classic cars, but the one we were working on was for his fine art collection. He owned just about every major name in 20th-century art and was adding contemporary artists that he admired.

We represented Mexican born artist Leonardo Nierman at that time. Like a few other artists whom we have enjoyed over the years, Neirman was a musician before turning to the plastic arts. His abstract paintings, sometimes referred to as "magical expressionism," were colorful and vibrant. We sold two of his paintings to the museum before we learned a valuable lesson about pricing art.

Nierman called me to say that he had a painting that he felt was truly museum-worthy, his best work. He wanted me to present it to the collector. I presented the curator/doctor with the art. A few weeks after that, they let us know that they would not be acquiring it. I was perplexed.

Months later, while he was visiting Hawaii, we took the client out to a sushi dinner. At one point, I asked why they turned down what the artist believed to be one of his finest paintings. His answer surprised me: He said that they thought it was too cheap, that it couldn't be that good. Because the price was too low.

Nierman had purposely priced it for the museum. He wanted it there. Many collectors equate price with quality. An expensive lesson.

SAVE THE WHALES AND A CAREER

The difference between a Wyland Whaling Wall and a billboard is in the mind of the beholder.

In the process of opening Front Street Gallery, my business partner suggested that I fly to Laguna Beach and introduce myself to Wyland, a then-fledgling artist who painted whales on walls to promote his work on canvas and paper. I told him that I was not crazy about Wyland's art and resisted, but he insisted. So, obliged, I went.

Arriving at the Sawdust Festival in Laguna Beach, an outdoor art festival with sawdust on the ground, I found Wyland alone staffing a booth. Introducing myself, I showed him photos of our new Maui gallery, and asked if he was interested in having us represent him exclusively in Maui. He was eager to show there and agreed to come and visit and paint in the gallery. He stayed in an apartment upstairs next door to the gallery with a charming view of Lanai.

While I was not a big fan of Wyland's paintings, I did think that he was one of the best promoters of his generation. He also had phenomenal timing. And clear blue eyes that made you want to trust him.

Tying his career to whales would prove to be a winning formula. The large Whaling Walls an inspired idea. He announced his plan to paint 100 walls, murals of whales and dolphins, to save the seas. I did admire Wyland's ability to work on a large scale. That was his forte. His ability to generate publicity was huge. People believed in him. At heart, he was a savvy promoter.

Makes me wonder what Michelangelo could have done with a spray gun?

A story that Wyland told me about the time he was painting one of his early Whaling Walls on the side of a hospital provides insight into how the artist thought about controversy. That hospital is long gone now, replaced years ago by the Prince Hotel overlooking the Waikiki marina, close to Ala Moana.

Wyland got up before dawn and was making progress on a large wall when the wind started to pick up. He uses a spray gun to paint the walls, and the light wind was getting stronger. He watched helplessly as a misty blue paint cloud wafted towards the pristine, mostly white, yachts docked in the marina.

What a mess. His Whaling Wall triggered wounded wails from distressed, outraged and aggrieved yacht owners.

The publicity was priceless.

Another incident wrenched my mind. After he took over the lease for the Front Street Gallery in Maui and changed the name to Wyland Gallery, he decided to paint a Whaling Wall on the wall at the end of the block. All the shops on that stretch of Front Street abut one another.

It is one of the most prominent locations in Lahaina. The point where the buildings stop and the shore begins for a refreshing stretch of beach. But that entire block of old buildings is part of

the historic district, and any changes have to be approved by the historical society—a particularly tight-assed group. When I had burned off the old paint on the windows to the gallery and repainted them the exact same color, I got in trouble for not getting prior approval.

But Wyland told me that even bad publicity is still publicity, and he was no stranger to controversy. Often courting it with his cavalier approach.

So he cut down a tree and painted a big breaching whale on the small wooden wall. That part really got to me. It seems ironic that a self- proclaimed "environmental artist" would cut down a tree to spray toxic paint on an historic building.

But he did. Proudly. Unapologetically.

Then he told a story that sounds more apocryphal than true about a whale that breached right offshore just as he was finishing that mural. He explained that the whale looked him straight in the eye. In his telling, it sounded like the whale was a wise critic approving the tribute.

The historical society also looked him in the eye and demanded that he paint over the mural. They were irate. It was big news in Maui and pissed a lot of people off. Not Wyland. He basked in the publicity and insisted that he was on a mission to save whales. And perhaps to become one.

A wily promoter, Wyland's philosophy on publicity has proven to work for him. Not being in the news is worse than being the subject of bad news. The old saying, "No news is good news," is not in his repertoire. Especially because he could always point to his magnanimous motive; saving whales.

Hawaii does not allow billboards. The Outdoor Circle, the oldest environmental group in Hawaii, has championed the ban on outdoor advertising and billboards ever since they led the charge on the state to outlaw them in 1927. Because such advertising undermines the scenic beauty of our islands they continue to lead the fight against what they regard as visual blight. Wyland's walls, with his prominent signature, have managed to circumvent that ban: It's public art to save the whales and most of the time he gets permission first.

Wyland was clever to advertise on a large scale to draw publicity in a state than prohibits outdoor advertising. The legal spats that came later, with Hawaiian Airlines on Oahu near the airport and Hawaii Telecom on Maui just added to the publicity. In the Hawaiian Airlines case, Wyland's lawyers stopped them from painting the building by asserting artist rights, even though they needed to paint the building for maintenance purposes. In the case of Hawaii Telecom they did not give Wyland permission to paint their building in the first place. They painted over it like he was a graffiti tagger on private property.

I used to snidely comment that whales may be endangered, but paintings of whales are overpopulating our walls. That became truer year after year.

CHAPTER

28

MAKE ME SOUND BETTER THAN PICASSO

How did a lanky teenage Maui surfer dude become a self-taught multi-millionaire art sensation?

I met Chris Lassen right after he graduated from Lahainaluna High School. He was a terrific surfer with a budding interest in painting. I took Japanese language classes at a University of Hawaii extension class on Maui, and the older guy sitting next to me was Wally Lassen, Chris's father.

Wally was a nice guy and studied the language to help his small jewelry shop at the Sheraton Hotel succeed. He had been a sailor on the USS Missouri at the end of the war and had witnessed the surrender of the Empire of Japan.

He told me stories about his son, a fledgling young wannabe painter, and an avid surfer. Wally was not sold on his son's career choice, and urged him to get a "real" job, which we would later joke about.

Our first show with Lassen soon after he graduated from high school was lackluster, but it was a start. His paintings were not great. Still, he was determined, and he continued to work hard at his craft.

Rilke, the poet, and C.S. Lewis, the writer, both gave this advice to aspiring writers: "The art of writing is the art of applying the seat of the pants to the seat of the chair." Lassen applied that advice to become an accomplished painter.

He did his best to emulate some of the seascape artists selling well at that time, especially William DeShazo. We had no predictions or premonitions that he would soon become one of the most successful artists in Hawaii and a superstar in Japan. We just wanted to support a young local artist.

Chris evolved into one of the painters of what became known as the "Two Worlds" style: paintings depicting above and below views of the ocean and the surrounding landscape. Bright, colorful, and detailed, they were fun to look at.

In the beginning, the style was a novelty and appealed to a lot of collectors. The paintings sold well. Much to the dismay of Robert Lyn Nelson, said to be the first one to popularize this idea, and Wyland, another painter who trafficked in that imagery. The competition among the artists working in this style became heated, especially between Wyland and Lassen. Wyland called Lassen "Lassie," and Lassen looked down on Wyland's work and thought that he was a "crappy painter."

After showing Lassen's art for a couple of years, I received an email from my gallery's owner asking me to be the liaison between the gallery and the artist. They were not getting along and needed to communicate more; they wanted a go-between to smooth things out. The request did not come with additional compensation, but I appreciated being asked. I hoped to enhance my standing with the company and thought that the interactions with the artist might give me an edge selling Lassen's work.

I would drive out to his rental in Paia town and meet Chris at his then home/studio to discuss various issues and I did my best to steer him in a direction that worked for everyone. In those days, he was modest and appreciated all of the help that he could get. Little did I foresee how fast his personality would change as he became more successful.

One night I got a call from Lassen asking me to write the copy for a brochure that he was putting together. He said, "Make me sound better than Picasso." He was not being ironic. He meant it. He was raised on Maui and really didn't have perspective on the wide world of art. He genuinely believed that he was better than Pablo Picasso.

Picasso didn't paint breaching dolphins.

Chris's work improved, along with his sales. He was, technically, the best of the Two Worlds painters. But he was a follower, not an innovator. His work was derivative. He would visit the Lahaina Galleries and study Robert Lyn Nelson and then publish limited editions that thematically and compositionally were Nelson-esque, but with a tighter, more refined technique. It pissed off Nelson and the people at Lahaina Galleries. Fed up, they finally barred Lassen from visiting the galleries.

Lassen was outselling Nelson by a lot. The feuds and snits mounted between the artists.

Another Two Worlds artist, much older than Nelson and Lassen, Anthony Casay, claimed that he was the first to do that kind of work. He resented all of the young upstarts. The concept actually came from an antique etching created during the whaling days, but everyone did their best to claim credit for the idea.

Originality matters in art, and they all wanted to be crowned as the first to develop this style.

One day a family visiting our gallery asked if we had any work by Robert Lyn Nelson, an artist that they liked and had collected. I introduced them to Lassen's work as a counterpoint, and they were receptive.

I called Chris and asked if I could bring the family to meet him in his studio. He said that he was painting in his mom's kitchen in Lahaina and that we were welcome to visit.

When we walked into Chris's mom's small kitchen, he was working on a 30" x 40" painting that looked like it was about two-thirds finished. The entire family was in awe and asked how much it would sell for.

When Chris said forty-five thousand dollars, I had to steady my jaw. That was almost twice as much as any of his work had sold for at that point in his young career. I was not expecting that, but I acted nonchalant.

A few days later, the family left the island as the owners of that painting.

Less than a year later, my wife was asked by one of our art consultants to work with a 21-year-old Japanese girl who spoke no English. This young lady loved Lassen's work and really wanted it. She asked my wife to call her mother to explain why she should buy the painting. It was $105,000 and at that point the most that any Lassen had sold for. It sold. Lassen was on a roll. Riding the art wave of a lifetime.

As Lassen became a multi-millionaire and a celebrity in Japan, with groupies, he insisted that everyone call him Christian and started to go by his full name, Christian Riese Lassen. By this

point, he had a stretch limousine, and his newly-minted success convinced him and his mom that he was a genius, but the people who had helped him establish the market for his work soon became disposable.

Over the years, my appreciation and affection for Lassen lessened as he treated those who worked with him badly. An especially egregious example was the way he treated his girlfriend. She did more to further his career than anyone else had up to that point. She was street smart and a hustler and had a natural ability to make things happen.

She got him commissions with Disney and the Olympics and helped to sell entire limited editions to Japanese publishers.

Once their relationship ended, they still continued to work together. Eventually, she got engaged to a doctor. Her fiancé realized that she was working on a handshake agreement. He urged her to contractually memorialize the working relationship.

When she finally asked Lassen, their short discussion ended with him summarily firing her.

Later, Lassen's limo driver came to work with me as an art consultant. He told me story after story of how Chris treated people, and it was clear that success had skewed his judgement.

On a surfing trip to Tahiti with a group of surfers, his driver said the everyone would get on the boat that they had sailed on to wash off after a day of surfing. Chris insisted that his limo driver/assistant hold the hose for him and carry his board to the beach every day. The eager young man whom I had met as a teenager had become a full-fledged prima donna.

Years later, I ran into a successful Japanese publisher who told me this story: He had been buying the rights to publish entire

editions of Lassen's work in Japan and had been successful marketing them, until this transaction changed their relationship.

He bought the rights to what he regarded as an especially good and marketable Lassen painting. He printed an entire edition of serigraphs. He invested millions of dollars to do this. Much to his surprise and dismay, one of his competitors had acquired the rights to the same painting, but the rights to publish an edition of lithographs. It got worse. A third competitor had bought the rights to a mixed-media edition of the same painting.

It was a retail fiasco.

I have mixed emotions about Lassen. Admiration for his ability to work hard and become a successful artist. The first time I asked him to speak to our gallery staff when he was about 19, I was embarrassed for him. He was tentative and inarticulate. But just a few years later he was giving presentations to packed auditoriums in Japan and generating millions of dollars a year. He was capable of painting in a number of different styles with proficiency. Chris is a gifted painter, but his work is derivative.

Watching him change from a thoughtful young man to an arrogant and overindulgent older guy was disconcerting. He spurned the galleries that had given him opportunities and the people who had helped him get started. He disrespected and hurt publishers by not honoring exclusivity. He lost perspective. Took advantage of a lot of people.

The last time I saw Chris, a few months ago, we had a nice talk. He asked if I wanted to open galleries around the country with him. I told him that I was winding down my career because I didn't want to offend him by saying that he had had a great run,

but his work was no longer fresh and marketable the way it was in the 1980s and '90s. Markets change.

I forgive him for what I regard as personal flaws because success came to him when he was so young. It is hard to have perspective when you were raised on an island and exposed to a thin slice of life. He made the most of what he was given. His career was mostly charmed. He rode the art wave as well as he surfed. His timing was remarkable.

As I finished writing this chapter, a story was published in the Maui News that is upsetting. Lassen was arrested for property damage, and terroristic threatening. His lawyer blamed his actions on the fact that he could not afford his medication. That his monumental success crashed is hard to fathom. I truly hope that he recovers.

Success doesn't last forever. There can be downsides.

CHAPTER

29

MADISON AVENUE DEALER

You need to have the right address to be taken seriously in many art circles.

Another sepia-toned character was Milton Melon, an art dealer with a gallery on Madison Avenue in NY. He had an impressive collection of Warhol's and other art and artists with names that resonated in contemporary art circles. An eclectic mix of new and old, but always recognizable names.

We had met years earlier on Maui, and he supplied select galleries with high-octane art. We reconnected when I called him to ask if he had anything for us to take on one of our trips to Japan. As soon as he opened his mouth, you knew he was a New Yorker. Milton was rude and polite at the same time. New York brusque. Fast talker. Street smart and market savvy.

He consigned a handful of Impressionist paintings by Pissarro. Fortunately he trusted us, and it was done with handshakes. But the artist was not Camille Pissarro, the sought-after Danish-born French Impressionist; this was a grandchild with the same name, channeling his grandad's style.

That was a time in the art business when name-value ruled. The paintings were beautiful, but I thought that it was a bit of

a stretch. When I questioned the prices, he said, "The client always wins in the end." He explained that, in his opinion, the prices would go higher and assured us not to worry about it. But we did.

CHAPTER

30

HAWAII'S FIRST REAL PAINTER

"Artists that traveled to Hawaii in the 1880s had to be adventurers. The pioneers of art in Hawaii took great risks to come here, endured hardships to stay, and experienced only modest rewards….

"Jules Tavernier, the French artist, made his way across Europe, across America painting the American Indians and then across the Pacific to settle in Hawaii where he inspired an artistic movement, the Volcano School…."

That is an excerpt from an article I wrote for Honolulu magazine, November 1996.

That period of art in Hawaii fascinated me because the paintings were outstanding and romantic. It was an awakening of artistic sensibilities in a remote outpost on our planet and helped to shape what was to come. Tavernier was the most picturesque, tragic and talented of all of the early painters in Hawaii. He lived fast, loved hard, died young and left some great paintings. His short life took him from Parisian salons to New York publishing houses, from Geronimo to the Hawaiian volcano. He helped to cross- pollinate the art of Europe with the Hawaiian islands. Tav was a seminal influence on the art of Hawaii and it was fun to research and write about such a colorful figure.

86

Publishing that article in Honolulu about an artist I admired and thought should be celebrated was a career milestone. It validated the work that I had been doing in this small niche of the art business.

It also taught me the value of a good editor. As much as I worked on that article, reworking, and rereading, even backward, when the editor made changes, it made a readable difference.

The seven-page article was about one of my favorite artists from that early period, Jules Tavernier. I titled the piece, "Jules Tavernier: Hawaii's First Real Painter." I was elated to see letters to the editor the next month asking for more articles like that. It also lent a smidgen of credibility in a field that demanded it and led to something completely unexpected, a letter from the BBC. Ann Freer, a producer for the original Antiques Roadshow in England, wanted to know more.

CHAPTER

31

THE ANTIQUES ROADSHOW MUST GO ON

The saying, "the show must go on" originated in the 19th century at a circus as a runaway elephant stopped the action. Antiquities, not elephants, were involved in this show.

Ann Freer, a producer for the BBC South in England, the folks responsible for the original Antiques Roadshow, had read my article about Tavernier and said that she had gotten more information on the artist from the article than she had been able to gather previously. She explained that they were drawing up a proposal to produce a show on Tavernier. She asked if I would be interested in helping if a budget was approved to proceed with the show.

Naturally, I wrote back with a positive response.

As they say, the show must go on, but in this case, it didn't. The funds to finance the project never materialized. Nonetheless, I was happy to receive Ann's offer and surprised that a regional magazine article reached all the way to the UK. Also gratified that the taste for Tavernier was far-reaching.

Jules was a colorful talent during a dynamic chapter in history. His Hawaiian paintings are treasures and his story evocative. It would make a great episode for the Roadshow.

THE LOSING BID @ AUCTION

Art auctions, I've been to a few, but more as an observer than as a bidder. This one still stands out.

A slim horizontal oil painting by Jules Tavernier came up at a local Honolulu art auction, but it was unsigned. The bidding went from four paddles to two in no time. I wanted the painting because I had collectors looking for his work, and it charmed and enchanted me. Additionally, I was convinced that it was a genuine, first-rate, Tav.

I blinked first and dropped out at $2,500. Wha...? The buyer was a well-known local dealer with a gallery on the Big Island, dressed in a stylish white suit. If the painting had been signed, I would have gone a little higher, but not much. In any case, he looked determined to get it and had deep pockets.

A week after the auction, as a professional courtesy, I sent him a copy of my article in Honolulu magazine, "Jules Tavernier: Hawaii's First Real Painter." It was the definitive published piece on Tavernier's time in Hawaii. I included a note of congratulations. My goal was to maintain cordial if not collegial relationships with fellow dealers. I waited for a response until the crickets retired.

The number of people who were trading in that market was limited and insular. When the auctioned painting came to the retail market, I was surprised that it was signed. Hey, it's a free country if you have the money and the chutzpah. Maybe the signature was there after it was cleaned and restored. Who knows?

As a postscript, it strikes me as paradoxical that people will eagerly outbid one another at auction but demand a discount in a gallery. The gallery stands behind the art and provides services for years, while the auction has a disclaimer, in the fine print, releasing them from liability, and charges fees from both the buyer and the seller. Go figure.

CHAPTER

33

FINDING PARADISE

It's glib to call Hawaii "paradise" when actually finding it can be a challenge.

Don Severson was a well-known figure in the tight-knit Honolulu art circle dealing in classic old paintings and objects. He owned Tahiti Imports, but his passion was buying and selling the art of Hawaii circa 1880-1940. Over the years, we bought paintings from and sold paintings to one another. I enjoyed working with him and regarded him as a key player in this small market. His office was a treasure trove of old paintings, koa wood bowls, feather capes, vintage Hawaiiana books, and a bygone era's paraphernalia. He had a lot of stories about the old days.

During our professional relationship, he asked me to write a chapter for the epic book he was working on, "Finding Paradise." He paid me, but given the amount of research and writing involved, I was not doing it for the money, but rather for the connections and credibility it might bring. Monetarily it made no sense. It was too time-consuming.

Years went by before the lavishly illustrated book was finally published, and everything had changed. While I was credited in small print in the credits section, what would have been my

chapter was written by Jennifer Saville, the then-curator of Western Art for the then-Honolulu Academy of Arts, now the Honolulu Museum of Art.

I liked and respected Jennifer and had worked with her on our Hawaiian Classics Collection, which had included a few pieces from the museum, but I was bummed out. Because Don needed the backing and credibility of the Academy and various corporations to publish, he turned my manuscript over to the Academy, and some of it was incorporated into Jennifer's well-written chapter. She was top notch. Having her write it gave Don's book credibility and gravitas. And access.

The most important transaction that I had with Don dealt with an original Enoch Wood Perry oil painting. Perry had only spent a short time in the islands, about fourteen months.

Classically trained in Germany, he had worked in Yosemite, painting in the romantic realist tradition with renowned American artist Albert Bierstadt. Perry's grand compositions of sweeping landscapes, along with his sharp eye for detail, were the reasons he became the gold standard for many collectors in Hawaii. His classic Romantic realist paintings will echo through time.

By most accounts, Perry only created thirteen paintings while in the islands. Most of them are in museums or permanent collections. It was rare for one to come to market.

An old friend and former business associate lived on Maui. His family had lived there for five generations. They owned a huge swath of land that went up the side of Haleakala, the house of the sun. The pie-shaped property climbed more than 10,000 feet from the Kula side. Out of the blue, I got a call from my

friend asking for my advice about a painting that had been in their family for more than 90 years. He asked if I would come to Maui to take a look at it.

The painting that had hung forever on the wall of their charming old upcountry estate was painted by Enoch Wood Perry. It was in dreadful condition. The paint was bending and peeling; it looked like it wanted to escape from the canvas. The painting desperately needed to be professionally restored and cleaned.

I explained that this was an important part of the cultural patrimony of Hawaiian art and suggested that we take it immediately to Larry Pace, the best art restorer in the Pacific. Larry did most of the work for the museums and was meticulous in every way. A pro. My friend agreed and asked that I take care of it for the family.

When he asked how much the art would sell for, I felt obliged to tell my friend that the family should hang on to it. The painting was important and would likely hold value and possibly sell for much more in the future. He explained that his father had Alzheimer's and that they wanted to sell it.

I suggested that we have it appraised and told him that I would be happy to split anything we could get over the appraised price. I knew that selling it would not be a problem because I had a few collectors chomping at the bit to own it. Because there were so few comparable's for an appraiser to work with, the appraised value was not huge—$50K. I thought that the valuation was too conservative.

The painting came back from Pace's restoration a few months later. I was elated that it cleaned up so well. Larry Pace was painstaking in his work and adhered to the highest restoration

standards, documenting every step. The painting required that kind of expertise. I called my friend and sent him a jpeg of the restored painting along with the documentation. I gave him one more chance to change his mind about selling.

He didn't. I was glad because I had been talking it up to whet some appetites.

I contacted the collectors I knew who had the interest and the wherewithal to acquire the painting. It was no surprise that the reaction was positive. "Eager" was probably more accurate. The only gentleman who deferred was the one I wanted most to own it. Not only was his personal collection museum-quality, but he was also a terrific person and was planning to leave all of his art to the museum that his grandmother had started and endowed. But he told me that he thought that it was overpriced.

Because his family had been among the original missionaries to Hawaii, the gentleman was accustomed to prices that preceded the current boom for rare offerings such as this one. I tried to get that across to him, but he was unmoved. For years after that, almost every time that we talked, he told me that he wished, in retrospect, that he had bought that Perry. It was almost like a running routine. Everyone has an art story about the one that got away.

It finally came down to two collectors who both REALLY wanted it. One of them offered me jewels on the side if he could buy it. But Don Severson said that he had always wanted an Enoch Wood Perry and if he bought it, he would never sell it. He offered to buy it for $70K. We had a good relationship, and I always appreciated his knowledge and enthusiasm for the art, so we came to an agreement.

Everyone, except the collector who wanted to, but didn't, buy it, was happy.

About two years later, a friend and fellow dealer told me that Don was selling the painting. I was pretty surprised by that because he had said he would never sell it. That was part of his buyer's pitch.

His asking price was almost $170,000 more than he paid for it. Reasonable enough. I think that that was the last transaction we had together. I was moving in a different direction, and he passed on way too soon.

I still wish that he were around and that we could hang out in his period piece art-laden office with precious paintings, bowls, paddles, feather capes, miscellaneous knick-knacks and artifacts. And tall tales.

CHAPTER

34

VISUAL JAZZ

My wife is jazz crazy. Certified.

Guys like to say that their wife is their better half. It makes them look good and modest and is generally true. So I will go one up on that: Mihoko (Me-ho-ko), my wife and better three-quarters (half is fractionally incorrect) is a beauty. A tiger mom who can be a pussycat; the best friend a furry or feathered creature in need could meet; a dynamic and accomplished artist; a world-class and conscientious home chef—and she LOVES to sing. Mostly jazz.

Mihoko attended one of the best all-girls art schools in Japan, Joshibi. I did not realize until years after we married just how good she was. I had admired her sketches of people and pets, and was impressed by how skillful she was. How perceptive in capturing the essence of her subjects. But it wasn't until she started painting abstracts that I was just knocked out. Wow, just wow.

Mihoko truly is a jazz nut. A passionate one. She loves singing and playing the piano. Her inspiration to paint comes from listening to jazz. The titles of her work are generally tied to the jazz compositions that inspire her paintings. So I suggested that she call her work "Visual Jazz." She agreed.

When we opened our Fine Art Hawaii gallery, we bought a baby grand piano and placed it in the middle of the gallery. We had regular jazz nights featuring some of the most talented jazz musicians in Hawaii. Mihoko loves to sing and, despite English being her second language, knows a huge number of songs from the great American songbook. She loses her accent when she sings, and it makes her, and me, happy.

For years Mihoko organized what she called "The Jazz Peace Concerts." The idea grew out of her work as the spokesperson for the Japanese Religious Committee for World Federation. This was a consortium of religious leaders from Japan who came to Hawaii every year to participate in the Pearl Harbor ceremonies, memorializing the fallen soldiers. The priests were Buddhist, Christian, Shinto, religionists of all stripes. They prayed for the souls of the dead and promoted the idea of world peace.

Mihoko would get up at 4 a.m. to prepare to organize the Japanese priests and their entourage for the December 7th formal religious ceremony, with stops at Pearl Harbor, Kaneohe, the Punchbowl and places in between. She would speak at the official Pearl Harbor ceremony. And every year, they took the boat to the USS Arizona Memorial and watched the movie of the soldiers dancing to the sounds of big bands before the attack.

That movie moved Mihoko. Instead of the traditional prayers and solemn ceremonies, she wanted to celebrate the soldiers and the big band jazz music they were dancing to before the attack. Everyone understands music and can tap to the same beat. She felt that the music reflected the lives and spirt of the soldiers better than the somber ceremonies did.

She believes that jazz transcends boundaries and that music speaks to everyone. So the music and the paintings are mutually dependent, inter-connected. They accent one another. Here is a snippet from her web site:

www.Mihokom.com

"Mihoko has a rare eye for music: she captures the movement, the tonality, and the rhythm of jazz...with paint." With her keen ear for color, Mihoko creates jazz-art musicals on canvas.

ARE YOU PART OF THE
WITNESS PROTECTION PROGRAM?

A rtists need patrons…

Most successful artists have notable patrons who believe in the work and help establish the artist and further his or her career. Their support is invaluable. Our most important patron was a local lawyer. A mercurial character.

One night two guys, one who looked like Mr. Burns, Homer Simpson's cartoon boss, and a good-looking young Vietnamese gentleman, his protege, ambled into our gallery. When I engaged them in conversation, the older gentleman asked, "Are you part of the witness protection program?" I laughed. He said, "To be in this location, I figure that you must be."

He had a point; the location of our gallery at that time was less than ideal. I enjoyed his wry sense of humor.

We loved our space at Restaurant Row, with an upstairs workspace and a mezzanine. We were sold on it by the owner. He maintained that they had plans that would make it the great destination it once had been. Restaurant Row had a movie theatre with six screens at that time, and Ruth's Chris Steak

House, my new acquaintance's favorite restaurant, was next door.

But other restaurants came and went with an alarming frequency. There were always empty spaces for lease. The glory days were now just talk. The good times faded when Aloha Tower Marketplace was built down the street. Before that, Tom Selleck's restaurant, Black Orchid, was a draw and Restaurant Row rocked on all cylinders.

The new owners said that they would make the neighborhood better than ever. We believed them. With plenty of parking and an accessible location, we figured that we would be positioned to succeed.

Our soon-to-be client, the top foreclosure lawyer in town, loved my wife's abstract paintings and, over time, acquired more than forty of them. He had a huge practice, and we were proud of how great the art looked in his penthouse suite of law offices.

At his request, and as a service, I hung the art for him. He always loomed over me and was extremely fastidious about how it was done. Millimeters mattered.

I didn't learn until years later that our client had spent a couple of years in prison for tax evasion, a charge that he continued to vigorously dispute. What surprised me was that he was in the same prison that housed my old boss, Bill Mett. They knew each other well. The fact that two highly-accomplished, intelligent individuals spent years in prison and worked for seventy-five cents an hour while incarcerated was perplexing. What a huge waste.

Knowing this did put his initial witness protection program crack in a new context.

Can someone please get Justice some coke bottle glasses, or a seeing-eye dog?

OUR NEW LANDLORD

Dylan's song "Dear Landlord" wasn't playing, but the landlord was on my mind. "Dear landlord, please don't put a price on my soul…" Or our sole-proprietorship…

We were now on our own. Our Fine Art Hawaii featured Mihoko's Visual Jazz abstracts and ceramics, my mom's Impressionist paintings and my Sonny Pops pastiche, along with our Hawaiian Classics Collection. Because foot traffic was so slow in our gallery, I was always eager to engage the people who visited. One day a distinguished gentleman came in, and it didn't take long for me to realize that he knew a lot about art. In fact, he knew the owners of the original paintings that I, aka Sonny Pops, was parodying. He was clearly a man of means and well-connected. Brimming with confidence.

When he left without buying anything, I was crestfallen. In fact, I thought about him for days, going over the meeting, analyzing what I could have done differently. We were in no position to let high-caliber collectors walk. We had rent to pay, and the months seemed to go by like an old Hollywood movie with the pages of the calendar peeling off and blowing away in the wind. Faster and faster as the camera fades away.

A month later, the gentleman returned. This time he introduced himself as the new owner of Restaurant Row. What a surprise. He mentioned that his wife told him that Restaurant Row was a 'piece of shit' and he shouldn't buy it. I heard what he said, but I wanted to hear him repeat it. I asked him, "What did your wife say?" He repeated it, "Restaurant Row is a piece of shit."

I agreed with his wife and thought of her every time we sent in our rent.

Jay Shidler was not only a mega success, he was a philanthropist of the first order. He gave the most generous donation ever to the University of Hawaii. The university's school of business now has his name on it.

I was still bummed about not being able to interest him in our art, but I understood why when, a year later, I met the pilot of his plane. I asked him what kind of art Mr. Shidler collects. He explained that the last piece he bought in Europe and brought back on the plane was so offbeat he could not describe it. The pilot was not a fan of his boss's art collection. Mr. Shidler bought cutting-edge art that will probably end up being another valuable legacy for a good cause.

Except for two fake abstract expressionist paintings by Motherwell that he acquired from Ann Freedman director of Knoedler Gallery in NY. They closed the gallery after the FBI uncovered over $80 million in forged art bought by some of the biggest collectors from around the world over a 10 year period. There is a documentary movie about it, "Made You Look." At the end the names of bilked collectors scrolls by and Jay Shidler was on the long list. At least he was in good company.

As much as I appreciated our dear landlord's public-spirited generosity, I wish he had given us a break on the rent. It kept going up.

CHAPTER 37

A CALL FROM AN OLD ZERO PILOT

Aviation dogfights didn't end with WWII.

During the initial attack on Pearl Harbor, Fusata Iida , a Japanese Zero pilot was shot down and crashed on the windward side of Oahu. Iida was the commander of the Japanese Imperial Navy's Third Patrol and led the attack on the then-Kaneohe Naval Air Station about ten minutes before the attack on Pearl Harbor. His plane crippled by machine gun fire, the 28-year-old pilot crashed and died before reaching his target.

A local Japanese-American family, the Tsukayamas, ran to the crash site and recovered Iida's helmet. Fifty-eight years later, they still possessed that weathered-leather pilot's helmet.

They wanted to repatriate the relic to Fusata's heirs, the Iida family.

My wife was the spokesperson for the Japanese Religious Committee for World Federation. She became the go-between and was instrumental in getting the two sides together.

The fallen pilot's cousin and the local family who had retrieved and kept the helmet finally met in Kaneohe for the formal return of that wartime artifact. The family heirloom was finally going home.

It was cathartic for everyone. A deeply healing gesture, with intense emotions, and forgiveness. Months later the Tsukayama family visited the Iida family in Japan.

It was a kum-ba-ya moment.

The Japanese Religious Committee's idea was to bring people from different religious backgrounds together to represent the Japanese religionists praying for the souls of those who died at Pearl Harbor on December 7th. (I came to think that their mission was to vacation in Hawaii and drink, because these guys really could. I actually liked that about them.)

Organizing and coordinating buses and vans and schedules for that diverse group was hard enough, but Mihoko also gave a speech every year. The gist of which, in variations, was the message that old foes can become great friends and allies. That war needs to be avoided. A celebration of peace.

The speech and the prayers were meant to help atone for the attack and to remind everyone that now, more than ever, we should focus on peace and have hope that seemingly intractable international issues can be resolved. It was delivered by Mihoko in English and translated by an attending priest into Japanese.

The most bizarre, and, if it weren't mildly disturbing, funny thing that happened was that Mihoko received persistent phone calls from surviving members of the Japanese Zero Pilots Association, a group insisting on their right to the helmet.

They very much wanted the helmet for their museum. They got kind of pesky, zeroing in on that weathered relic. They sounded as if they felt entitled to it. Mihoko is great at handling these kinds of things and deftly shot down all of their requests.

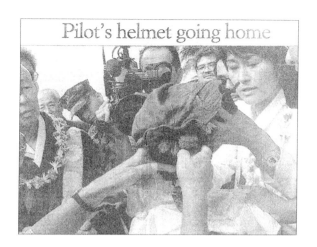

Mihoko presenting the helmet

She simply explained that the family was expecting, and would be receiving, the one physical shred left connecting them to their memories of their WW II hero. The helmet is proudly home.

CHAPTER 38

NUN-FUN BY FRAN

We internalize our parents' voices in ways that we can't escape, even after we find our own,.

My mother, Frances Rozella Trailer Maier, is a person deeply interested in aesthetics and a big influence on those around her. As a child, I remember that she was always working on creative projects. A memorable one: being asked to design and create the collar necklaces for the Egyptians in the Cecil B. DeMille movie classic The Ten Commandments.

The necklaces were constructed with ceramic tiles that she had to cut and shape by hand. When finished, the necklaces each weighed a few pounds. They were basically highly-stylized collar mosaics. We had a few boxes of little square ceramic tiles in many colors left over from that project for years.

In 2018 I ran into two guys in the costume department of a Hollywood studio on island to shoot a movie. I mentioned that Ten Commandments project, and they told me there are still a few of those necklaces in studio storage rooms. Wish we had kept one.

When I was a teenager, Fran opened an art gallery, but I was not involved, and really didn't pay much attention. I was

living with my father at that time. Her gallery, on Main Street in Scottsdale, Arizona, the Gold Key Gallery, opened in the early 1960s, before the Western art boom. There were about three galleries in Scottsdale on Main Street. Now there are over forty. She was also a certified fine art appraiser.

The one time I got involved with her business was when I was seventeen, still a clean-cut kid. I could drive, and she asked me to deliver a painting that she had sold to Barry Goldwater, the senator from Arizona and later a Republican candidate for president. He ran against Lyndon Johnson and lost in an historic landslide.

Goldwater's home was in Paradise Valley and had a very long driveway leading to the top of a small hill with a guardhouse manned by a very nice Hopi Indian.

Senator Goldwater had a huge collection of Kachina dolls (gifts given in hopes of future prosperity and health) that I was hoping to see, but he was not home. My mom was good friends with his sister, and my grandparents were friends with him. My family loved and admired him.

Fran sold her business, a few years before western art boomed, and moved to Hawaii. She wrote this about her experience:

DUMB-MAINLAND-HAOLE IN ALOHALAND

"The first year I was in Hawaii I thought dumb mainland haole was one word. [in Hawaii, Haole is a pejorative, a non Hawaiian, especially a white person]. I migrated to the Islands in 1972 with a hula in my heart, and, I imagined, a rainbow around my shoulder. Having owned and operated a fairly successful art gallery in Scottsdale, Arizona for eight years, I had no qualms about being welcomed for productive and

financially rewarding work." She went on to write about the difficulty of finding suitable employment and the high cost of living. "I realized I had, in a very short time gone from reasonable Mainland prosperity to Polynesian poverty."

Francis loved painting and the Impressionist school of art, especially Monet. After taking on challenging jobs, she became a professional artist.

Before she evolved into painting in a classic Impressionist style, she painted "Nun-Fun by Fran," small whimsical works featuring nuns. These paintings depicted the Catholic Sisters of Mercy, with their distinctive black and white habits and pointed hats, juxtaposed against colorful backgrounds, in playful situations.

Hawaii Six-O depicted six nuns in an outrigger canoe off Diamond Head riding a wave. She had them flying kites, in flower markets, taking a sheep to the Eternal Revenue Service (aka IRS), and so on. Fun and colorful stuff. Think Grandma Moses and the flying nun meet a, naif, Gauguin.

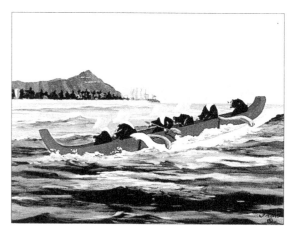

Hawaii Six-O
"Nun-Fun" by Fran

Those small intricate paintings sold very well and were fun. But after painting in that style for years, she grew tired of it. She evolved into an accomplished Impressionist painter. Her new work sold well. An apt description—think of a female Monet with a softer palette influenced by the light in Hawaii. She is now 100, and I think of her as a latter-day Impressionist, Grandma Moses meets Monet.

My mother was quite opinionated as regards to good and bad art and never minced words about it. When I showed her my Sonny Pops collection, she just rolled her eyes.

To illustrate the generational divisions in my family, and the country, in the early '60s while spotlighting mom's sense of humor and pluck: Her family and her gallery clientele were conservative. She was embarrassed that her sons all had long hair and were labeled "Hippies." Fran came up with the "Mippies"—middle-aged people making a counter counter-culture statement. Members received a MIPPIES card, and a white badge with a red square (a small round campaign-style badge that you could pin on) and a short pledge to form a club, which she branded the "MIPPIES," an acronym that declared independence from the hippies. You could join for a small fee. She was appealing to middle-aged parents who were essentially fed up and exasperated by their kids. Luckily, card carrying MIPPIES did not become a cultural phenomenon.

She thought that it was funny and that she was making a statement to her friends and clients. She had a fairly high-society, conservative clientele and an image to project. I thought that it was weirdly amusing.

When she remarried, she married her art teacher, Bill Schimmel. They lived in Estes Park, Colorado, during the summer and Scottsdale during the winter with my younger brother and my stepfather's son, Schim, a nice kid. Their marriage was not long-lasting.

My stepfather and I did not get off to a good start. I guess I made sure of that with a teenage attitude, but I really didn't like him. The first time we met I was struck by his all-white shock of hair and his height. A striking presence, but something was off. He was older than I expected too.

I was getting ready to meet a friend and my mother said, "Mow the lawn before you go."

We were still in what I regarded as my father's house. I responded that I would do it when I got home. My newly-minted stepfather got up and commanded, "Do it Now." I didn't. (Ironically, a few years later "DO IT NOW" became a hip '60s rallying cry.) I left abruptly on an expletive deleted as I soundly shut the door behind me. I don't recall ever interacting with him again after that. I never gave him a chance to be a nice guy.

When my folks were divorcing, they asked me if I wanted to live with my mother or my father, a choice a 15-year-old should not have to make. I chose my father.

I didn't learn until after my mother and Schimmel divorced that my stepfather had already been married six times, so it should not have been a shock. His son, Schim Schimmel, became a very successful artist with a big following in Japan. We only met once or twice.

I have a lot of respect for my mother. A child of the depression, she knew poverty. Her fiancé was on the USS Oklahoma during

the attack on Pearl Harbor and was killed. Her family worked hard and became successful. They lost their wealth and made it again, but the family did not stay together. Her father was a twin, and he and his brother were in many of the major battles of WW I; they came back with PTSD before that was a diagnosis. She was born 100 years ago. A rare Centenarian.

Mother had four boys and wanted a girl. Outlived her youngest child. Two failed marriages. Many loves. Things did not always work out right, but she did.

Her focus on art, from playing the piano to painting, sustained her. And she had a wonderful circle of friends who added vitality to her life. Smart and talented and indomitable—her perseverance has been a great life lesson.

CHAPTER 39

A GIANT POSTCARD

Postcards are the poor cousins to a proper letter. They are cheap and the correspondence exposed for all to see. They were the twitter of the 19th century. Brief.

Our most cherished client's terse description of a large painting, commissioned to be the centerpiece to the entry to his prestigious newly-built Tokyo high-rise corporate headquarters was unexpected. It took me aback.

After it was finally installed, I asked how the painting that he had commissioned over a year before looked. Dryly, he commented, "It looks like a big postcard." He said it in Japanese, but the description does not sound any better in English. It landed like a letter-bomb in my heart. I wanted this to be a great experience for all involved, but it made my heart skip a beat.

The painter we commissioned, Adolf Sehring, was a character out of central casting with an abundant mustache, bushy eyebrows, a thick Russian—but sounded German—accent, and enough attitude to be a divo. He always wore an ascot tie and played up the role of the artiste.

I called him to ask if he would be interested in doing a commission for a corporation in Japan. He was.

Adolf was a Russian-born, Berlin-trained painter who lived in rural Somerset, Virginia, on his Tetley Plantation in a 200-year-old home that was restored with authentic period furniture and all the trimmings.

Adolf's paintings were vaguely reminiscent of Andrew Wyeth in their tonality and depiction of rural subjects rendered in a spare realist style. His great claims to fame were his papal portrait of John Paul II in 1979 (He was the only American commissioned by the Vatican to paint such a commission.) and a bronze sculpture of Pocahontas.

We set up a time for our Japanese clients to visit Sehring's studio and stay for two nights. We flew to the nearest airport from New York in a private plane and a driver picked us up in Sehring's stretch Rolls Royce.

Sehring's home was ostentatiously magnificent with an old plantation motif. He had a seven-car garage, and each garage door had a separate security code. He had a Rolls in every one of them. He personally opened all seven to show us the shiny reminders of his success—all that and a beautiful young girlfriend/secretary who took care of his business.

That night we had a very formal dinner. Adolf had hired two neighbors to dress up like butlers to serve the meal. It was pretty awkward. The butler was visibly shaking with nervousness. I figured that this was not his regular gig before asking Adolf, in private, about him the next day. The butlers were friends in rented outfits.

The dinner was almost like Thanksgiving with loads of heavy greasy food. I could tell that our Japanese clients did not love it, but I think that they enjoyed the theatre of it and appreciated being feted.

By the end of two days, everyone got along, and we were able to pen an agreement. The painting of Mount Fuji would be large enough to have a commanding presence in the entrance to the new high-rise the company was building in Tokyo.

A year later, the painting was finally installed. When I asked our client how he liked it, his description was non negotiable. He was not impressed. We offered to have the artist go back to the easel, but he grinned and said that others in the company liked the installation.

Gracious to the end, he was a special breed of Japanese businessmen, post war, that exuded confidence, competence and integrity. He bridged the pre and post war periods of business in Japan and his company became an International success.

The painting would have made a great postcard to promote the company. That didn't happen.

THE HAWAIIAN CLASSICS COLLECTION

Sometimes really good, even great, art gets overshadowed and overlooked by history.

It's important, critical really, for an art dealer or consultant to stay abreast of the market. A collector whom I admired and respected told me during one of our meetings that it was no fun to collect the big names in art anymore. He explained that the quality of what was available was not great, and the prices had gone too high. He asked me what I would recommend he collect.

This collector had inherited his father's art collection and owned just about every major artist from the 19th and 20th centuries. His appetite for art collecting was still not sated. The answer had to be spot on.

There is a law of displacement in the art world that led to my answer.

The concept is that when one sector of the market gets too hot, there is something else that collectors turn to to satisfy their hunger for art. In this case, I explained to our client, a serious collector, that a few talented artists had traveled

to Hawaii between 1880 and 1920 and they had created beautiful, historically relevant, work. Their paintings were still undervalued.

These painters, I explained, reflected the stylistic spirit of their times, but were overshadowed by more famous artists. What made these artists even more appealing was the small number of paintings they had created, and the even smaller number of works that came to the market.

In those days, I was fortunate to know a few local collectors who cherished this period of art and the dealers who specialized in this regional niche market.

Our client embraced the idea. When shown the actual work, he fell in love with it. He gave us the green light to put together a collection. We did. The client owned so much art that he asked us to hang on to the paintings he was acquiring.

About five years later, I received a call from a dealer asking if we would sell the collection. I thought that it was too early to sell, but felt obligated to let our client know about the offer. The price tendered was substantially more than what our client had paid, but I suggested that time was on his side with this market. Nonetheless, he appreciated the offer.

We sold the art for him.

If we had waited another five years, the prices would have been close to double what we sold the collection for because by then more collectors were vying for fewer paintings.

My wife, Mihoko, and I still feel good about our advice and how the transaction worked out for everyone concerned. The fact that we got to live with the art for a few years was a beautiful bonus. Today it is difficult, if not impossible, to find any, let alone

great examples, of these artists' work. If you do, the prices reflect the rarity.

This experience led me to immerse myself in the lives and times of the artists we were recommending and searching for, and we became even bigger fans of this historical period of Hawaiian art. Because of the high prices and limited availability, I thought that creating a collection of limited-edition reproductions of the best art and artists from that period was worth doing.

The work was over seventy-five years old and in the public domain. Still, I wanted and really needed to work with the museums and the private collectors, the owners of the originals, to ensure that the fidelity of the reproductions was accurate. We had to work directly from the original paintings to make this collection aesthetically pleasing. We used state-of-the-art printing technology.

We did our best to ensure the integrity of the Hawaiian Classics Collection.

To achieve perfection, we created up to twenty trial prints, giclées on canvas. Working with the experts in the museum to edit the colors, we marked up the canvas prints with corrections until they matched the originals. That meant at least a couple of days, sometimes weeks, between printings, and days between appointments to get the work done.

But a labor of love does not feel like work.

I met with the directors of the Honolulu Academy of Arts, now the Honolulu Museum of Art, and the director of the Bishop Museum to see if we could work together. I proposed that we pay the museums royalties and give them the last word on the quality of the reproductions. Also, they would be given the first, #1/265, editions to present as gifts to donors.

I also presented this proposal to a few of the oldest families in Hawaii because they owned some of the most important paintings by the artists we wanted to publish.

This project turned out to be more complex than anticipated. The museums were particularly difficult to convince, but, after many presentations and re-approaches, they agreed that it was a good idea. They realized that we were taking great pains to do it right—to create a high-quality product that would add to their bottom lines. Importantly, the project would allow people to know about this overlooked period of art in Hawaii.

This was the beginning of what I titled "The Hawaiian Classics Collection."

This carefully curated collection included the work of Lionel Walden; D. Howard Hitchcock; Theodore Wores; Enoch Wood Perry; and Jules Tavernier. The most accomplished early artists to work and paint in Hawaii.

In the 1880s—because Hawaii's Native ruler, King Kalakaua, had put an exorbitant tariff on art—it was cost-effective for an artist to take a slow boat to Hawaii and paint for a year or two. The exotic locale and gorgeous scenery were compelling. The commissions from some of the affluent local families and Hawaiian royalty were significant.

King Kalakaua befriended some of these painters. The combination of talented artists, culture-starved local families, and royalty resulted in significant art that has withstood the test of time. It is a key part of the cultural patrimony of Hawaii.

It pained me to abandon the Hawaiian Classics Collection, but circumstances demanded it. More profitable, if less compelling, opportunities were being offered. I was not able to market

the collection in a way that made continuing with the project profitable enough. As much as I loved the collection, feeding my family was more important.

Clearly, I had made some boneheaded moves with this project. Trying to do everything myself, to vertically integrate and not farm out any of the work, was foolish. I was not playing to my core strengths. It was shortsighted. Successful people understand this.

Buying two expensive giclée printers, persnickety machines that required daily maintenance, was dumb. They were capable of printing accurate, subtle reproductions that looked like the originals. But the printers would sometimes spit after an hour of printing—one of the brushes would mess up with tiny droplets on the print, making it unsalable.

It was state-of-the-art printing, but too expensive and time-consuming to ultimately make sense. I had to fly in a guy to work on the machines because no one in Hawaii was trained to do it. Printing technology was changing fast. Cheaper and better printers came out that made my printers dinosaurs.

It is disappointing to have a dream, actually go for it, and not have it come to fruition. In this situation, the finished product was superb. The museums and collectors agreed that they could not have been more accurate. We kept the editions relatively small, took pains to document everything, had stamps with the Hawaiian Classics logo and the edition number on the back, and ensured that everything was copacetic with all involved.

I stretched the canvas, built the frames, sold the prints, packed and shipped them, and kept the books. I paid the royalties and taxes and was in charge of quality control. What I calculated

would be a four-million-dollar opportunity, if weighed against what I could have been doing professionally instead, ended up costing me time and money.

But I would do it again.

I knew they were good. When a highly successful artist came in and said, "I love that original," as he was looking at a Lionel Walden reproduction, he validated the effort.

That relative failure, in retrospect, is one of my proudest achievements. This is where I should put on Dylan singing, "There's no success like failure and failure is no success at all…."

CHAPTER

41

STEAK AND ART

"**I**sn't this painting delicious?"

That is an expression that I sometimes liked to use to describe art, much to my associates' consternation. Mixing senses just made sense to me. It was fun. I especially liked to use it when talking with overweight people. Not nice.

Our gallery's next-door neighbor, for seven years, was Ruth's Chris Steak House—the anchor tenant at Restaurant Row. It was a big space with multiple dining rooms, a VIP room (elegantly appointed with our Hawaiian Classics Collection), and a bar. There was space for several art collections, and we filled it. An expensive steak dinner tastes better with fine art. Especially a tasty art collection. The art made a T-bone steak, and the bill, easier to digest.

For us, it was a way to show our art instead of keeping it in storage. Our gallery was hung salon-style, and space was at a premium. Ruth's was like having an auxiliary gallery. They let us put up an easel in the front of the restaurant to remind patrons that they could see more of the collection next door at our gallery, Fine Art Hawaii.

It was a win/when do we eat?

This was a mutually advantageous quid pro quo: They received an extensive collection of curated art that provided a dynamic and sophisticated look to the restaurant, and in return, we were treated to complimentary meals at the restaurant.

We never took advantage of their offer to eat there regularly, but we would take friends and business associates to dine at the restaurant from time to time. It was always lavish, and thoroughly enjoyable.

Their service and friendship added to the experience. The entire staff was excellent. When we closed the gallery and finally removed our art from the restaurant after seven years, the paintings were covered in thick, blackish, greasy spider-webbed dust on the back. It took extensive cleaning to refresh them.

The lighting in the restaurant was always a drawback. Art needs light. I wonder if they saved on cleaning and lighting bills by keeping it dim? Ambiance a money saver?

The memories of feasts with family and friends are priceless. And being surrounded by art that we created was an ego boost that we should not have needed, but apparently we did.

OUR BIGGEST SALE

Polite perseverance furthers.

When our client from Japan walked into our gallery with an original unframed Matisse oil on canvas wrapped in a blanket tucked under his arm and handed it over to me to sell, I appreciated the trust and confidence that he had in us.

My wife and I had enjoyed our 20-plus year relationship that started with his interest in Miro and developed into a lifelong friendship. We had celebrated New Year's dinners with him and his wife and his entourage, which included movie stars and professional golfers, for almost fifteen years. We always went out of our way to insure that their time on Maui was fun. My wife was great at making sure that they arrived with a flourish that included his favorite fish that were hard to get on Maui. When one of our sons was born, they sent us a bassinet suited for a prince. Two years later our newborn daughter enjoyed the opulence. A princess.

He had asked us to give our opinion of his art collection. To advise him on how best to market it. He had confided in us that he would "go bye-bye soon." We knew that there were some issues related to his having had two wives and kids with both.

We understood that he wanted to simplify his affairs as much as possible.

What a thoughtful gentleman. The scion of a multi-generational company that was mega successful, dominant in its field. He led it to new heights during his career and, at one point, his company had over 10,000 employees.

We spent two weeks in Japan, the year before this sale, to inspect his extensive collection. After that, it took a year of research to ensure and document the provenance and provide some scholarly context for the art.

We visited his various homes, took the paintings out of the frames, and had a professional photographer shoot close-up shots front and back. Our client's father had acquired some of the art in the 1920s in Europe. Some of it was in a vault when we saw it.

Having the responsibility for his original Matisse was something that we took seriously. Though it was not a spectacular oil on canvas, it was nonetheless significant. A nude odalisque, basically a harem concubine meant for ogling, against a distinctive, curvaceous, balcony.

I took the painting to the top art restorer in Hawaii to see what he would say. He put it under a blue light and, after close scrutiny, declared that the signature was legitimate. But he expressed concern about the railing that adorned the background of the painting. He said that "Matisse was nothing if not meticulous," and he expressed some doubt about that detail.

After consulting with specialists in the field to solicit their opinions, I was not convinced that we had solved the apparent mystery of this painting. Opinions and judgments were mixed.

It taught me a lesson: Experts don't always agree, and vested interests can play a part in that.

I had explained to Sotheby's, upfront, that we didn't plan to sell the art through them but that we would pay for an opinion and use their expertise regarding authenticity. After keeping us waiting for months, they finally responded to let us know that they had questions about the authenticity and would not verify it.

I was skeptical and wanted another opinion.

Christie's was more proactive and much easier to deal with. After expert analysis, their assessment came back with a ringing endorsement. The provenance was impeccable.

Sotheby's. WTF?

The stamps on the back of the canvas from the Thannhauser Gallery in Paris, along with another stamp from a show at the Museum of Modern Art in New York, were just part of the proof. Those stamps, along with a detailed and professional analysis, led Christie's to conclude that the painting was, without doubt, an original oil on canvas from 1923, in excellent condition.

The art business never lacks for intrigue.

Finally, after working for close to two years on this project (not all of the time, but never dropping the ball, and keeping it a priority), the painting sold for $2.2 million to a private collector from the Middle East.

What pleased us most was being able to come through for, and live up to, our client's expectations and trust. Not giving up after hitting multiple roadblocks was critical.

After the sale, we wanted to wire the funds to our client ASAP. The money was in a client trust account under my name. Our

client was in no hurry to receive the funds because Japan's tax laws are pretty severe. He was in the highest tax bracket and was going to get plucked no matter what; he wanted to wait almost a year.

That was the most respect that I have ever experienced from a bank. For the first time in my life, they addressed me by my name. No one hits you when you're down like a bank and then hits you up when you don't need it.

We paid our taxes right away. Relieved to have the painting out of our possession and the sale behind us.

Knowing and working with a perceptive collector, with taste and experience was a career highlight. Mr. Sugoi taught me more than anyone about art.

ALMOST LIKE A RELIGIOUS EXPERIENCE

Trashing someone's religion is dicey. It could be like taking a warm coat from someone who is shaking from the cold. Cruel. Or, it could be like showing someone with a warm coat the actual temperature so they know it's warm enough to take the coat off. Compassionate. In any case, belief and faith are matters that are not easily challenged.

Growing up, going to Sunday School singing, "Onward Christian soldiers, marching as to war with the cross of Jesus going on before…" was confusing. I loved all of the voices singing together but began to question some of the premises.

Plus, we were part of what I now regard as a somewhat fringe religion, Christian Science. When I read Mary Baker Eddy's book Science and Health with Key to the Scriptures at thirteen, I concluded that I wanted a doctor if I got sick. I was trending toward science and away from blind belief, more politely called faith. But the book did teach me the potential healing power of the mind.

When I told my parents that I didn't want to go to Sunday School anymore, they pushed back. When they realized that I had actually read the "good" book and come to my own

conclusions, they understood. To have been heard at that age is something I still appreciate.

I was so happy to get my Sunday mornings back. Surf's up.

ALOHA 'n LOVE

CHAPTER

44

WTF?

W hen I was working on Hawaiian parodies of Robert Indiana's famous '60s icon, LOVE, I was surprised to learn that he too grew up with the Christian Science religion. His LOVE with the lazy leaning O was inspired by Mary Baker Eddy's book and her "God is love" belief. These were the most uplifting words in the book. I felt a kinship.

My parody of Indiana's LOVE, using ALOHA, was one letter away from working graphically; I know because I tried every possible variation. Not inspired by scripture, but rather by my crass desire to translate Hawaiian iconography into classic Pop forms, I kept trying anyway.

While researching the background of Indiana's most famous work I was surprised and amused to learn that his first version was the word "FUCK," with a tilting "U." His boyfriend, the artist Ellsworth Kelly, had left him, and that graphic painting was his pained response. Later, when he was commissioned by the USPS to design a postage stamp. He used a different four-letter word. The slanted U transformed to a leaning O.

And that is how LOVE evolved from FUCK. You're welcome.

CHAPTER 45

NEW YORK ARTEXPO

Hawaii is a good place for art, but NY is still the center of gravity for the art business.

Flying all night from Hawaii to New York to work from early morning to late at night for five days from the moment you land, and to pay over $25,000 to do it, sounds pretty crazy, and probably it was, but that's what we did. It seemed logical. NY Artexpo was a chance to meet gallerists from all over the world and see what others in the business were doing. It was a gamble that we had to take.

As a promotional tool, before we left Hawaii I had 500 individually-wrapped fortune cookies made at a local Japanese bakery. The fortune inside had our booth number with a pithy saying. I forget exactly what it was, perhaps, "Good fortune awaits at Booth #321." I planned to walk around, handing them out.

Some people travel well, sleep on the plane, and arrive ready to go. I don't. When we landed in NY, we took a cab to the hotel, dropped off our luggage, and headed straight to the Jacob Javits Convention Center to start setting up the show.

We had many wooden crates that I had constructed and shipped to the venue. The scene was somewhat chaotic, with everyone trying to set up and waiting for workers to drop off their crates at their allotted spaces. Having put together many shows over the years, we were pretty efficient and were getting it done despite being tired and hungry.

While putting the finishing touches on our booths I noticed that one of the lights needed to be adjusted. I took a chair to stand on and was in the process of adjusting the light when a Javits worker approached me and barked: "what are you doing?"

I stepped down from the chair and explained that I was adjusting the light. He flipped out. He took the metal folding chair and heaved it, telling me that I was required to get a union worker to do it. If I hadn't been hungry and tired, I might have kept a cooler head, but I flipped out, and we had a short argument. I lost.

Five days later, at the end of the show, I learned my lesson. We were just as eager to take the show down as we were to set it up. Every vendor has to wait for their empty crates to be dropped off by the union guys before they can pack up and leave. As we watched all of the other vendors get their crates, pack, and leave, we wondered when ours would come. The huge expo space was almost empty when we got our crates, and one was busted. I figured that that was payback for talking back to the union guy. An unforgettable lesson.

NY Artexpo was a turning point for us. We went for it and got some decent traction. The organizers chose Mihoko's work to feature on the cover of the show guide given to everyone who came to Art Expo. The fortune cookies brought some good

luck. We met and inked deals with galleries in Santa Fe, Boston, Tennessee, and New Orleans and made some great contacts that we later followed up with.

It was a success, not an EXPOnential leap, but a step in the right direction.

CROSSROADS CONTEMPORARY

O pening an abstract art gallery in Santa Fe with no figurative work was always going to be a gamble.

We were thrilled when the owners of Crossroads Contemporary Gallery on Canyon Road in Santa Fe selected Mihoko's work for their well-curated new enterprise. With a strict focus on contemporary abstract art, Crossroads was the first stop on Canyon Road, the main art drag in a town that caters to western art collectors.

The best possible location, with passionate representation and a sophisticated staff who really knew their stuff. It was a dream come true.

They put together a superbly conceived and executed blockbuster show that involved the local museum. Elaborate tents on the grounds of the museum, with caterers roaming the event with mouthwatering treats, on a perfect Santa Fe full moon evening felt like magic. We met their fascinating stable of artists and nary a negative word was muttered.

We were grateful to be there.

Traveling to Santa Fe was a joy. The look of the gallery and the quality of the staff was top notch. The events were outdoor elegant, almost cinematic—all in all, a career highlight. We were so hoping for them to succeed in an art town known more for Western art.

The gallery business can be such a crapshoot, and when you put all of your chips on abstract, you are putting them all on an exciting but fractional segment of the market. It is high risk.

It really was fun while it lasted.

GALERIE D'ORSAY BOSTON

Boston is a heck of a lot more culturally literate than most places west of there.

This was another dream come true. We were so happy to meet Sallie Hirshberg, the vibrant owner of Galerie d'Orsay. We appreciated that she loved Mihoko's work and then amazed when we realized that she was partners with an old friend of ours, one of only a few people at our wedding and a longtime associate before that, Chris Kelley. The art business can be a small world.

One of the facets that I love about the art business is how women have no glass ceiling. Women make as much and often more than men. Over the years, I have hired more women than men, and find that they have a natural talent for thriving in the arts. And they do. Art galleries are gender-neutral.

Women may even have an edge.

KAT ON A HOT TIN ROOF

For us, Kat put the must see in Tennessee.

Sometimes you meet someone and just like them right away: Kat Semrau, from Tennessee, was one of those people. She was vivacious and had a good eye for art. She knew what she liked.

We were not really sure about her gallery because we didn't know much about the market in Jackson, Tenn. But we really loved the lady who owned Art Under a Hot Tin Roof gallery and immediately trusted her. As it turned out, her husband was a shrink and supported her passion for art. A dynamic duo. It's nice to have some ballast in this business. We consigned some of Mihoko's paintings to her and she bought one.

Kat was terrific to work with, and she sold a lot of art out of her offbeat, but historic, tin-roofed location. People trusted her; she exuded positive energy; people liked and respected her. She had taste. And flair.

She was beautiful in a wholesome way. Much of the heart and soul of the art business is not on Madison Avenue. Kat was a cool one.

CHAPTER 49

SUSAN AND JANE

One of the perks of being in NY at ArtExpo is the chance to interact with artists and dealers.

A very dear old friend and former associate, Susan Nagy, managed Jane Seymour's fine art and was responsible for all of Jane's art shows and sales, as well as wholesaling. She graciously introduced Jane to my wife and me. Jane was lovely and gracious.

Susan was someone I had enjoyed working with early in our art careers. Her family fled Hungary during the revolution in the 1950s; I admired her Old World values of honesty, reliability and hard work. A rare combination when coupled with her keen intelligence and ability to connect with people.

We also took Japanese language courses together in hopes of communicating with the many Japanese tourists visiting Maui in those 1980s boom days.

Susan had a client in Nagoya, the Detroit of Japan, where most automobiles are manufactured. He was interested in some of the modern masters we were selling, and she planned to travel with the art to present it to her affluent collector. I went with her to assist and was glad that I did.

The client loved the selection that Susan had put together and he bought all of it. There was a Picasso and a Chagall and other art that I don't recall. All of the art was museum-quality. He paid in cash.

After the deal was consummated, he said, "I have one important question." My heart jumped, and I was wondering if a curveball was coming. He said, "Where do you want to go to celebrate tonight?" I breathed a sigh of relief and just grinned. Susan must have felt the same.

That night was, to this day, one of the most memorable celebrations with partying that I think I have ever experienced. We went to many charming places, sometimes down and sometimes up steep stairs. We were always surrounded by beautiful entertaining ladies who seemed to know Susan's client. We drank and laughed late into the night. He was a most gracious host and had fun teasing me about my loud green Hawaiian shirt, which really was out of place.

I felt bad for Susan because, being the responsible person she always is, she was diligently concerned about the cash and how we would get it back to Hawaii. She was restrained and focused, but I just got juiced from it.

The next day we took the Shinkansen (bullet train) to Tokyo and went to an office that was the only Bank of Hawaii branch available. It was by no stretch a full-fledged branch; we walked into a small office and put the bag of cash on the table. The lone Japanese bank rep said, "Ahhh, greenbacks." We wired the money to Hawaii, feeling, for the first time on that trip, free.

Recalling the taxi ride as we left the hotel in Nagoya forever endears me to polite Japanese culture. I looked back as the taxi

pulled away, and the two ladies from the hotel who were sending us off were bowing from their waists (respect is demonstrated by the depth of your bow). Half a block later, they were still bowing. The politeness and care shown in Japan are legendary for a reason.

We decided to visit Kyoto, the spiritual center of Japan. It was one of the highlights of the trip. Amazingly, while we were walking across a small bridge, we saw Susan's client walking in the opposite direction. We were surprised. What were the chances of that in such a densely populated city? He invited us to another delicious dinner, and the festivities left us glowing.

That Susan became Jane Seymour's key person for her paintings and gallery appearances makes sense. Jane would be hard-pressed to find anyone as capable, reliable, and experienced. I would love to hear Susan's stories.

NEW ORLEANS

"In New Orleans, culture doesn't come down from on high; it bubbles up from the streets." Ellis Marsalis

"New Orleans jazz" should be all one word: a run-on sentence, a hand in a glove. New Orleans is a great city for, and because of, art. It draws jazz lovers, arguably the most original music idiom in America. NO is one of the most welcoming and hospitable cities anywhere. Hawaii is known for its aloha spirit, but we found that New Orleans was even friendlier. Southern charm.

Windsor Fine Art on Royal Street was a fitting gallery for my wife's Visual Jazz collection. In a town synonymous with jazz, it felt right.

We were jazzed that they chose her work.

A BEER STEIN INSPIRES A HIGH-RISE

G rowing up with buildings shaped like hot dogs and restaurants, like the Brown Derby in Hollywood, I was familiar with mimetic architecture that referenced a business. But this was on a whole different scale.

When Mihoko and I were in Japan working with the Asahi Breweries to select art for their new high-rise in Tokyo, the CEO's assistant took us into his office and showed us two paintings on opposite walls.

One painting was a by the Post-Impressionist Maurice de Vlaminck, with bold, energetic strokes, and the other was a placid Renoir. The assistant told us that their shacho, the head of the company and his boss, keyed his day to the art. If he was going into a meeting and needed to get energized and pumped up, he would focus on his Vlaminck. If he was too keyed up and needed to settle down, he focused on his Renoir.

I was moved by that and respected the rare aesthetic sensitivity of the CEO.

For their conference room, they chose a large painting by Graciela Rodo Boulanger, a Bolivian artist married to a

Frenchman. She gave up her promising music career to pursue painting, but her paintings exuded musicality. Many, if not most, of her paintings were stylized round-faced children. The figures were like musical notes playing together.

They chose a charming painting. Happy-looking figures riding a bicycle built for five, harmoniously. It was perfect for their conference room. The unity represented and created in that painting, I am sure, is still working to their advantage. Subliminally the message was "work together to get to where we want to go." Beautifully.

What I remember most about meeting the beer company brass were the drawings and models showing us their high-rise then under construction. From a distance, it was designed to look like a beer stein. The top of the tall building had what was meant to look like the frothy foam top on a just-poured beer. To me it just looked like a hot pepper, but either way, it made a statement.

Got beer?

CHAPTER

52

OUR EXTENDED OHANA

It's interesting how randomly some relationships start. And evolve.

Out of the blue, Mihoko received a call from a well-known realtor in Maui asking if she would work as a translator. The realtor had a Japanese client who spoke no English searching for a property. He requested a translator, and said that he would pay.

Mihoko met them in upcountry Maui, and they drove to Kapalua on the west side of the island. The Ironwoods was an exclusive gated community that boasted Carol Burnett as one of the owners. The clients were looking at buying two properties there.

The negotiations took a few days before the sale was consummated.

The good-looking Japanese gentleman offered Mihoko a choice: a generous flat fee, or the car that was parked in the garage. The car came with the sale of the house, and he didn't want to deal with it.

Mihoko came home and asked for my advice. I asked her the model of the car, and she said that it looked like a Mercedes. I didn't hesitate and calculated that the car option was amazing. Mihoko does not drive, and is worse than I when it comes to identifying models of cars, and I struggle.

The car, it turned out, was the smart option, and it solved a problem that the buyer didn't want to deal with. But it was not a Mercedes. Our new car was an older VW station wagon.

Sometimes it is better for a car to be driven than to sit idly in a garage. That was the case with this station wagon, though despite its age, it had low mileage. Getting the title transferred was an utter bureaucratic fiasco, and it was a pain to work out some of the mechanical issues. But we eventually straightened it all out and sold the car. All in a day's work.

Mihoko had told me how well she got along with and how much she liked the Onishiis. When I met them, I understood why. A beautiful-looking couple with great open smiles and personalities to match. They were energetic, upbeat, and fun. We were the same age, the same height, and really had a personal connection. The friendship allowed me to practice my fledgling Japanese language skills, and they got a kick out of my mispronunciations. They enjoyed knowing a local family and making new friends. Mihoko loved being able to relate to people from Japan and speak in her native language.

As our friendship grew over the years, we regarded them as family. They were wonderful with our kids. They didn't have, but always wanted, children. They had the advantage of playing with ours, and then we would take the kids home with us, so the Onishiis could live their elegant lives.

One night Mr. Onishii and I sang a duet of Elvis's "Love Me Tender" at a local restaurant. The audience was delighted.

Thirty years later, we are still good friends and have worked together on multiple projects, including completely renovating their Maui property and helping them curate the perfect art for their home. When we finished the renovation, they hosted a party for all of the subcontractors involved—what a wonderful gesture of goodwill. We still love seeing them.

GOOD IMPRESSIONS

Emotion overshadows detail in Lau Chun's paintings. We see what he feels through color, movement and space.

I admire Lau Chun's paintings, One of the most talented Impressionist painters in Hawaii, his abstract paintings stood out, but the Impressionist work sold better. I was happy when Lau asked me to be the gallery director for his elegant gallery at the Royal Hawaiian Hotel.

Lau sold original paintings, at reasonable prices given the quality, but many people could not afford to acquire them. I suggested that we create a few limited editions to appeal to a broader spectrum of art lovers who wanted, but could not afford, the originals.

He resisted, but I kept broaching the subject. I finally suggested that we try one giclée to see how the work translated as a print. I told him that if he didn't like it, I would not ask again. He agreed.

Because Lau used an impasto technique with layers of thick paint—the art was highly textured—I too was unsure how it would translate in the print version.

The test print, knocked us all out.

The artist's legacy is, and always will be, with the originals, but it was nice to offer an affordable option to satisfy the demand. Many new collectors were happy to have something beautiful that fit their budgets. A few returned to acquire originals.

AN ARTIST TELLS ME
"THIS IS A BIG PIECE OF S#*T"

Working with this male diva was a lesson in humility. I know that a diva is a woman, but this guy was a bitch.

During a dormant stretch in the art business, when more galleries were closing than opening in Hawaii, I got a call from a business acquaintance. A gallerist with locations in Carmel and San Francisco, Mario Simic is another character from those retail-centric days.

Mario's galleries were well-located and appointed, moderately successful, and followed a safe formula. Pretty middle-of-the-road art, tried and true stuff. The galleries emphasized salesmanship to compensate for the fact that their art could have been purchased in many other galleries across the country.

Simic had a reputation that vacillated somewhere between skeptical and respectful. I wasn't sure what to do when he asked that I relocate to SF to be a gallery director for his huge space near the waterfront. You could see Alcatraz from the windows.

With limited options available at that point, I thought that I should not turn down the offer, but my sense that there might

be pitfalls and minefields led me to suggest that we agree that I would come and work for one month before we committed to something longer term. Get to know one another before jumping in with both feet. He agreed.

When I got to SF, I could have stayed in a hotel, but my brother lived on a houseboat in Sausalito and suggested that I stay there. That reminded me of how much I still loved the Bay Area, my home for close to a decade before moving to Hawaii.

The gallery was almost too big. There was no dearth of art; it was everywhere. No space was left unhung. I appreciate a well-curated collection. Having a diverse potpourri of art for customers to select from in that brisk market makes sense on one level. The something-for-everyone approach left no excuses.

But it felt tasteless.

I wanted this to work, but from the first days, it didn't feel right. More than anything, I wanted to boost the people working in the gallery and prove that I could help improve morale and profitability.

It was a lot of work. The look and flow of a gallery, the way the art is displayed, can make the difference between success and failure. Changing the look can help shape the crew's outlook, and getting everyone involved in making the changes can be invigorating. Everyone doing their best and taking ownership. Working together.

I had a lot to learn about the collection and how the gallery operated and the personalities involved, and little time to get it done, so I worked diligently.

One of the artists represented that I did know, and admired, was Richard MacDonald. His bronze work is impressive. His dancing musicians are exuberant and fun. The patinas are flawless, his attention to detail impressive. I was pleased that his one-man show was scheduled near the end of the month. Looked forward to it.

We had plenty of time to plan for the show and the presentation. To that end, I moved the many artists who shared that voluminous gallery space to the back and gave the lion's share of the space, the entire front and middle, to MacDonald.

I thought that he would be happy, and we were looking forward to having him thank us for the effort we put in to move and dynamically display his entire collection of often-heavy bronzes.

We looked forward to greeting him for the show.

His entrance was dramatic: "This is the biggest piece of SHIT that I have ever seen," the words leaped and spewed from his contorting mouth.

I am not sure if my jaw dropped or my shoulders slumped, or if I got my gander up, maybe all of that, but I do know that I thought his comment was outrageous. Just couldn't say so. Not at the beginning of a show in a gallery in which I was essentially a guest host. I remained calm and asked him what he wanted to change. He said, "I want all of that [pointing to all of the other art in the back of the gallery] out."

There wasn't time to explain that the gallery represented well known artists who relied on our sales and expected us to have their work on display all of the time. To emphasize the fact that the gallery is HUGE. With loyalty to all of the artists, fiduciary duties. To appeal to his better nature.

The right move, the one that I made, was to apologize and then minimize what he regarded as a distraction.

Stuff was moved. Post haste.

Time truly was of the essence. The show went on, and it was a success.

I should have known that MacDonald was somewhat of a prima donna when he required that the car we leased for him during his stay be a certain color and model. Looking back, it's not the fact that he was annoyed that other artists would be on the same floor during his show. Not at all. The show did look better with a more pared-down presentation. What bothered me was the way that he flipped out—the tantrum.

I still think that his sculpture is engaging and fun. Taking the show down was a relief.

Mario initially called me with the offer in SF because I was recommended by his right-hand man, Bernie Schantz. Bernie was an old business acquaintance of mine and someone I regarded with affection. We had worked together for a few years in Hawaii. I once saved the life of his then-wife when we were in Makaha searching for puka-shells in 1979. A wave came and took her off her feet, pulling her into a bigger wave, and she was helpless. I was able to run in and rescue her. Brought her back to shore.

Bernie was a master salesman. He sold more of what he liked to call "Lincoln with a nude on his nose," aka "Lincoln in Dalivision," than anyone. This was a pixelated image of Lincoln with a portrait of a nude Gala, Dali's wife, on his nose, in a limited edition meant to be viewed from twenty meters away in order to see Lincoln and not the pixelated mosaic of images that comprised the portrait.

Bernie was the guy who could sell wet matches to Eskimos and then eat an Eskimo pie. The first time I met him, we were on the top of a high-rise in Waikiki looking out at all of the construction. Crane after crane in projects as far as the eye could see, and he said, "That's the state bird...."

This bird flew. I left on good terms with Mario and Bernie. They understood that my heart was not in San Francisco.

CHAPTER

55

OPPORTUNITY KNOCKS
ON THE COCONUT WIRELESS

"The coconut wireless" is a colloquial Hawaiian way of saying that you heard it on the grapevine. That's where I took the call.

My wife, Mihoko, and I were in NY to meet a client about a corporate commission. While there, I got a call from the vice president of Merrill Chase Galleries in Chicago. She asked if I would meet with them about the possibility of helping to open galleries on three islands in Hawaii.

Weeks before, preemptively, I had sent my resume with a short note explaining that through the "coconut wireless" I had heard they were planning on expanding to Hawaii. I wanted to throw my hat into the ring.

A few days later, I was on a plane to Chicago and a career highlight. The Chase galleries were well established, with a stable of artists perfect for the Hawaiian market. All we needed to add were great local artists.

Chicago is like New York without the attitude. The people at the company were down-to-earth. Excellent at what they did. The hiring process was rigorous.

It required multiple visits from Hawaii to interview with two VPs and Bob Chase and his lovely wife, Moya. I also had to visit a private eye and take a few tests, including a math test, and meet all of the directors in Chicago.

I appreciated how thorough they were and understood that their first hire had to be trustworthy and capable of putting together a team and helping with the buildout of three galleries, on three islands. With minimal corporate supervision.

Merrill Chase Galleries was founded by Bob Chase's late father. Bob had recently sold the company to the Pritzker family, owners of the Hyatt Hotels, and a prominent presence in Chi-town. Jay Pritzker is the current governor of Illinois.

At a critical inflection point in the company, with new ownership and plans for exponential growth, being new was an advantage. I was excited. Gtateful.

Most of what I learned about the transition was from old Merrill Chase employees. They readily spilled the beans. Art consultants love to talk: That is what they are really good at.

According to the company tittle-tattle, when one of the Pritzker kids turned 25, the family allowed him or her to buy a company. It was a rite of passage. If the business failed, it was a write-off.

The young Pritzker who chose Merrill Chase Galleries fancied himself a musician and loved art. Chase Galleries had a solid reputation in Chicago. The harmonic convergence of a 25-year-old on the market to buy, and a 25-year-old established chain of galleries ready to sell, was perfect. Bob's timing was especially prescient. The art market was unaware that shock waves were just over the horizon. He knew when to fold 'em.

Bob's agreement for the sale of the galleries included a provision that he stay on and work for three years to grow the company. The goal of the new owners was to eventually expand to every state. It was the best of times. Travel with all expenses paid to cool cities and the chance to shape the future of the company, his namesake. And work with artists he loved.

Working with happy people is fun.

Hawaii was the first step. It was an exciting and ambitious plan and a good time to be part of the expansion. I loved working with Bob and Moya Chase and really all of the people in that company. Everyone was brimming with optimism.

The training was the most comprehensive that I had experienced to that point, and it never stopped. They owned an extensive collection of old master prints: Rembrandt, Goya, Dürer, all the greats. They had elegantly appointed Fine Print Libraries in each gallery with catalogs raisonnés and all of the background materials required or needed. It was a white glove experience with flat files and a stellar selection of fine art prints.

To get up to snuff, I visited R.S. Johnson on Michigan Avenue in Chicago to discuss the finer points of presenting the art and did a deep-dive study to sharpen my skills. There was a lot that I didn't know.

The corporate culture at Chase was more formal than what I was accustomed to in Hawaii. Everyone wore suits and ties, and the guys were pretty competitive about their ties. That was weird to me, but I ended up buying the most expensive tie that I have ever owned just to keep up. Laid-back gave way to laced-up.

It took almost two years before we opened our first gallery in Hawaii, and when we did, we discussed how we would dress for the Hawaiian market. I suggested that resort casual made sense because people are mostly on vacation and relaxed. The folks at corporate headquarters said they didn't want to change the brand and required everyone to work in a suit and tie.

I felt like I was suiting up for action every time I put that work suit on. That was every day. I was determined to make the gallery successful and earn the generous salary. Even before we opened our first gallery, which took over a year, they paid me. I worked from home, but it was not a full-time gig until we opened.

I owned a house in Maui in those days and had worked for three years with a lot of sweat equity to make it a keeper. But the first gallery was planned for Honolulu at the most popular shopping spot in Hawaii, the Ala Moana Center. The company asked that we relocate to open the gallery. The move from Maui to Oahu was not far, but the lifestyles were light-years apart.

We rented out our Maui house and moved. My wife was happy because she was a big city girl and felt that Honolulu offered more options. I missed Maui. I had thought I would live there forever, but I loved the new challenge and was glad to see my wife happy.

The new gallery was elegant. A work of art that included what we called an "Artique," a small section that included exquisite jewelry by Erté and glass art by Chihuly. (He was the premier glass artist of his era, and I wondered why he wore a patch over his missing eye. He could have created the grooviest glass eye ever.)

The Artique was well-crafted with dark wood and glass. It looked sophisticated. Thoughtfully designed to showcase a tasteful selection of wearable art and expensive knick-knacks. An art-full boutique that was manned by a lady we hired to especially for that section of the gallery. The Artique provided another buying and selling opportunity and kept some people browsing in the gallery longer than they might otherwise have stayed.

No expense was spared in the gallery buildout. It was the most beautiful gallery in Hawaii.

The gallery collection was worth millions of dollars with work by artists who had shaped art history. It was, for me, a tall step up.

The opening was complicated because the entire floor that we were on, Palm Court Ala Moana, the most successful–per square foot–outdoor mall in the US, was new, and we were the first business to open. They let us store our shipping crates in the empty space next door.

Being surrounded by empty stores was not my preference. I had asked Bob Chase, early in our relationship, not to rent the space at Ala Moana because there was a much better location, with constant foot traffic, in Waikiki. The space across the street from the International Market Place was substantially less rent, and the buildout would have been at least half a million dollars cheaper. But Bob said that he was totally stoked about the Ala Moana location and that it was the best one. His license on the Mercedes read: "ByART." Hard to argue with success.

Getting to the gallery required climbing stairs, going up an escalator, or taking an elevator, and we were at the far end on the mauka (mountain) side of the mall–the last store on that level. Traffic lagged.

After our lavish Grand Opening, almost immediately, it seemed, all hell broke loose. The first Gulf War shook the business to its foundation.

Everyone was glued to their TVs following events that were going to reverberate in the retail world for years to come. Our dreams of success were being shot down day by day as the economy reflected the angst and malaise of those tumultuous times. Uncertainty is not a prescription that works for luxury items.

Given the enormity of the conflict, our troubles seemed minuscule but nonetheless daunting.

WHERE IS THE BATHROOM?

The monumental Iwo Jima Memorial was the work of a diminutive Austrian-American sculptor, Felix de Weldon.

Felix was prolific. He created more than 2000 public monuments. He was the featured artist at the opening of the Merrill Chase Gallery in Honolulu. It was a tall order, so we made a big deal out of it.

The state legislature declared it Felix de Weldon day. We were given an audience with the mayor. (His dog was sitting up in the mayor's seat when we visited his office.) He gave de Weldon a proclamation and a key to the city. We had invited all of the high mucky-mucks in town for our black-tie catered event.

One of the sculptures that we displayed that night was de Weldon's bronze bust of John F. Kennedy. De Weldon said that the other one of these was in the Kennedy Presidential Library. While moving that heavy bronze sculpture before the show, I tweaked my back and was in pain for days. I thought of JFK and his bad back during the show. I did my best to carry on. Do not ask what your company can do for you, ask what you can do for your company.

Felix told almost everyone that he met that his home in Rhode Island had twenty-three bathrooms. It struck me as funny that one of the most prolific monumental sculptural artists of all time did not have more cogent things to say. He never mentioned that he was commissioned to create the Malaysian National Monument, but never failed to talk about his twenty-three bathrooms.

Felix was full of piss and vinegar.

CHAPTER

57

A PAINTING CRASHES

The CRASHING sound of a pristine painting dropping through a thick glass table is not art gallery music.

After opening the gallery, I hired a man who had all the qualities to be a successful art consultant. Smart, with a winning attitude, he was a quick study. His experience as an actor and acting teacher made him a natural. I was confident that he would succeed.

Our gallery's hanging system was called the Walker System, with a rail near the top of the wall and adjustable metal rods with hangers extending from the rail. It is considered sophisticated by art gallery standards. I am not crazy about it.

In the first week of his career with the gallery, our enthusiastic new hire accompanied a couple into the showroom while softly sliding the the door shut to demonstrate how the painting looked alone, without all of the other gallery art vying for attention, under a softer light. In a private room.

Minutes later, a sound like a china closet crashing through thick glass shook our senses. Commanded everyone's attention. A heinous sound in a gallery. As the door slid open, our stricken

art consultant, looking like he needed to catch his breath, white lips and wide eyed, in shock, asking without words, "whaterwegonnado?"

Looking over his shoulder into the showroom, I couldn't miss seeing the elegantly framed original painting with a jagged shard of glass from the shattered table jutting, with an acid critics swift poke, through the canvas. It had fallen off of the wall because the Walker Hanging System was not as intuitive as expected. It was a shit happens moment.

The clients were aghast. What an awkward situation for them. "That's the first time that that test has failed" was the flip, pressure releasing, line that I led with. I assured them, and our consultant, not to worry. Accidents rarely, but sometimes, happen. 'This was not a demonstration, don't try this at home' I tried smiles and humor and was as nonchalant as I could be under the stressful circumstances.

It was no surprise that they left without buying a piece of art. I would love to have heard how they recounted that vacation experience to their family and friends. I am still friends with the consultant, and we continued to work together for years.

We sent the abstract painting back to the artist. He cut it down, reworked it, and eventually sold it. That was surprising.

Leonardo's relationship with the gallery was more important than that single painting. Our consultant more important than the accident. By not freaking out and just dealing with the situation with humor and understanding bonds were strengthened.

ARIGATO GOZAIMASU

If Japanese pronunciation unwittingly makes people laugh; laugh with 'em. It was fun being the butt of the joke.

In retrospect, Japan played a huge role in my life and career in art. Most of all, because I met my Japanese wife, Mihoko, in an art gallery. Together, we created a beautiful family. In the art booming 1980s, we traveled to Japan many times.

Our trips were exciting and rewarding at the height of the Japanese economic boom. Our favorite clients were Japanese and treated us like family.

A funny thing happened one night while we were at dinner in Japan. Our esteemed client took us out to an unusual restaurant. He owned it. A tall distinguished-looking Chinese man came to the table and, one by one, took everyone's pulse. Literally, he would close his eyes, put his fingers on your wrist, and feel your pulse. First time for me.

Our client explained that before coming to Japan, the man I thought was a waiter had been a doctor and herbalist in China. He left because of Mao. He brought with him a memorable herbal drink. Each drink was individualized, depending on each

person's physical condition. That is why he took everyone's pulse. They called the drink "binki."

The drink worked. I felt energized. At the behest of the owner, after our delicious dinner, the Chinese herbalist came to the table and presented us with a whole ceramic bottle of binki.

His advice: Just drink a little every day. I looked forward to it.

A few nights later, we were with the same clients at a different restaurant. Our client's wife, a formidable woman, was seated next to me. I wanted to thank her for the previous dinner and that marvelous drink. In my most polite and deferential Japanese, I said, "Thank you for the benki." Almost before I could finish, she looked at my wife and they both cracked up with booming belly laughs. I knew that the joke was on me, but I was not sure why. They made me laugh.

Mihoko explained that what I had actually said was, "Thank you for the toilet seat."

You say binki and I say benki and that does not make a comedy career in Japan, but it clearly got some laughs that night.

Incorrect pronunciation can cause international incidents. Or giggles and guffaws.

CHAPTER
59

PISTOL OPERA

If you could edit your career like a director edits a film, would you change anything?

One of our favorite people in Japan was Mihoko's uncle Seijin Suzuki, a well-known film director. Mostly because my wife respected him so much, both as her uncle and as a film director. He looked like a Japanese Col. Sanders, with longer hair. Even as he aged, he had kinetic energy.

When I read an article about Quentin Tarantino, and he cited Seijin Suzuki as an important influence, I was impressed. When I watched Suzuki's movies, especially Tokyo Drifter and Pistol Opera, I could see the influence. Entertaining, emotionally gripping films with eye-popping action.

As a filmmaker, Suzuki was ahead of his time. His films are psychological explorations of the post-war period that so affected the Japanese zeitgeist.

His movies used color almost melodramatically, practically like a character—certainly a presence. The imaginative non-linear storylines in his films create room for interpretation. The action is nonstop. His arresting, at times jarring, visual style became his signature style.

He was so offbeat that Nikkatsu, the oldest film company in Japan, eventually exiled him. He was fired.

After his movie Branded to Kill, they told him that no one understands his movies. His career was kaput. Owari. Owatta. Finished. The End. Fade out. He went into hibernation.

His films were low-budget B movies that he had to crank out on a breakneck schedule. They are fun to watch, and some have now become cult classics. His work reflected the post-war aesthetic. Deprivation and despair have catbird seats. Part of the appeal is the stark rawness.

Twenty years later, he was thought of as an auteur, an innovator, and was feted at Cannes. When he was invited to the Hawaii International Film Festival, he declined because of his failing health.

But his career redemption had finally come and it allowed him to live out his twilight years with respect, if not adulation.

Seijin Suzuki and Mihoko

Once fame happened, people came up with some extravagant ideas of what his films meant. When journalists would ask, "What does it mean?" Suzuki demurred, deadpanning: "They don't mean anything. I just wanted to entertain people." He did.

CAMEO CITY...NAME-DROPPING

Name-dropping is terrible for your credibility. It's perceived as manipulative.

In 1984 I was working at a stunning gallery at the Hyatt Regency Maui overlooking the property's water features and the black and white swans. The elegant Swan Court Restaurant was downstairs. The gallery space was large and open and we had some of the biggest names in art on display. It was hard to stay in the hotel and not experience the gallery.

Most galleries have doors, but ours had multiple doors that slid into the wall and opened in a way that made it feel like you were in the gallery even if you were just passing by. The set-up made interacting with guests easy and natural and led to some memorable encounters.

This event still seems almost unreal to me, out of a home movie. I was standing outside the gallery and down the long flagstone corridor that opened to the Kaanapali ocean view, a man in a baseball uniform, with a bat over his shoulder, was casually strolling towards me. The closer he came the clearer it became that it was Willie Mays, the "Say Hey Kid." Just ambling by. I must have looked like a Christmas light being plugged in as I enthusiastically greeted him and asked what he

was doing there in a baseball uniform. He patiently explained that he had just played for a charity fundraiser in Wailuku. We shook hands; he could no doubt tell that I was another eager face in the packed bleachers of slathering fans, but he kindly indulged me. He was genial. Meeting Mays, baseball royalty, made my day.

I am a big fan of the San Francisco 49ers and especially love the years that Bill Walsh was the coach, so I was elated when he visited the gallery and totally lived up to his reputation as a class act. He was reserved but not aloof.

The owner of the Indianapolis Colts, Bob Irsay, provided a counterpoint to Bill Walsh's cool class act. During his visit to our gallery he fell in love with an original oil painting that depicted a sailboat being tossed in stormy waves. Painted by Russian-born artist Eugene Garin, it was dramatic and probably struck an emotional chord that mirrored some of the storms he was sailing through as the owner of a struggling franchise facing fierce competition.

He asked how much the painting was selling for and when I told him, he pulled out his business card and said, "Call my room if you will sell it for...." He mentioned a figure that was somewhat insulting, and then he said, "Don't call me unless you will sell it for this price."

After he left, I called the owner of the gallery and he suggested that I call his room with a counter-offer. I knew that the amount he specified, saying that it was the "lowest possible price," would displease Mr. Irsay.

I was between the proverbial rock and a hard place.

I called Mr. Irsay's room and he brusquely told me that his offer was final and hung up. Following directions is not always my strong point.

Dealing with retail bullies was not my idea of fun.

One of my all-time favorite things to do in Maui was to bodysurf at DT Fleming Beach. A stone's throw from my house. On a good day the break was all exhilaration. After a particularly vigorous surf session, I was taking a shower.

DT Fleming's showers are under ironwood trees overlooking the beach. Like most beach showers in Hawaii this one had multiple shower heads and a guy got into shower across from me. Without my glasses, I am probably blind to a jury of my peers, but I can still figure stuff out. I said, "Aren't you Jim Palmer?"

He answered yes. I explained that I had batted against him in HS baseball. He was a star athlete in three sports. I was lucky to make the team. He asked how I did. I was the leadoff batter for my team that year and jumped back at his first pitch and then struck out. He was a lefty with the fastest pitch that I had ever seen. He became a Hall of Fame pitcher for the Baltimore Orioles. I told him that he struck me out. He smiled, looked at his wife, and put two thumbs up. Competitors love to win.

On my way home I was grinning all ears.

One night Michael Caine visited the gallery. He was charming and engaging and took a good long look at the collection while the lady who was with him kept trying to get him to leave. I assumed that she was an assistant there to shepherd him safely through Waikiki.

When I asked what brought him to the island, luckily he didn't wisecrack, an airplane. He said that he was filming a movie here. Without thinking, I blurted out, "You've been in enough movies." Later I thought, what a dopey, ambiguous, semi-insulting thing to say.

He seemed non-plussed and our conversation moved on. In retrospect I think that it was a flip and dull-witted remark. It just kind of drooled out. He continued to his hotel room, but I thought about it afterwards. Probably more than I should have.

Country singer Randy Travis came in one afternoon to the Manoa Gallery, which had moved from Manoa to Kakaako. The longtime owner, Holly, had taken on a partner, a well-known sports medicine doctor who had a radio show, and it didn't take long for them to start butting heads. Then it became a legal matter.

I had become the court-appointed receiver for the business while the partners worked to unravel their legal dispute. I had turned this job down two times, but the lawyers and gallery owners were persistent and said that it would look good on my resume. To be respected and selected by a judge to get such an appointment was supposed to be an honor. More compelling, they said that it would not take too much time for the legal matters to end.

I should have followed my original intuition and turned this down. It dragged on far too long and I never had a reason to put it on a resume.

It was unusual to have a customer at Manoa Gallery, but tall, lanky Randy Travis came in with his wife and an assistant. They were cordial and took time looking at the eclectic collection

of art that, honestly, was not very good. Hodgepodge gives it too much context. A few redeeming originals were not strong enough to warrant the Manoa gallery being open. It was a gallery on its last gasp.

I told Randy that I thought that he had the best voice in country music. I wasn't bullshitting, but it sounds pretty kiss-ass in the retelling. I meant it.

He took a good look around, but left without buying anything. They drove off.

Fifteen minutes later he came back and bought an original oil painting of a tiger. That was great two-part harmony.

Along with being the greatest relief pitcher of his generation, Rollie Fingers had a world class mustache. Baseball Reference dot com ranked it as "the best in history." One day in our Lahaina gallery I saw a guy with that mustache walk by. I darted out the door and called out, "Mr. Fingers." He turned around. I approached him and explained that we had a Norman Rockwell in our gallery that he should see. Every time that I looked at that Rockwell limited edition lithograph from a 1936 Saturday Evening Post cover, I thought of him and I let him know it. His interest piqued, he followed me into the gallery to see what I was talking about.

Spontaneously reacting to seeing Mr. Fingers, believing that he really did personify the baseball pitcher in Rockwell's lithograph, and following through with my sales pitch led to a sale.

He acquired Rockwell's The Wind Up. It depicts a baseball pitcher with a Rollie Finger-esque handlebar mustache winding up to hurl a baseball. It was him in an earlier era, the era that inspired, and popularized, his famous mustache.

About six years later he threw me a curve ball when he called to tell me that he wanted to sell the art. I explained that we could not deal in the secondary market but explained to him the best way to sell the lithograph.

Acquiring The Wind Up from Rollie Fingers, a pitching legend, added a unique selling point: It was a piece of Americana. Provenance matters.

At closing time one night a group of seven well-dressed, long-haired, Indian men visited the gallery. They were looking at the art and speaking in Hindi. I engaged them and asked if they were from Bollywood; they were flamboyant enough to be.

The shortest guy with the longest hair answered and said that he lived in Beverly Hills, Hollywood's elite neighbor. He suggested that I google him and told me that I would be on the computer for a week to follow all of his accolades.

Bikram, as in Bikram Yoga, the hot yoga guy, showed me his million-dollar watch, bragged about his many Rolls Royces and puffed himself up more than a narcissistic porcupine. Bikram was a study in what can go wrong with success. A walking example of humility consumed by hubris. And a bit creepy to boot.

He also feigned interest in the art and said that he just bought a unit at Nu'uanu Tower and needed art to decorate it. His friend/associate then proceeded to totally bust my balls with what he wanted to show me, which was what he regarded as cutting-edge fine art photography. His idea of what really mattered. He commandeered my computer to find examples. If what he said was true he spent about $3 million on photographic art for his two kids. I wondered if they do that to chefs when they visit a restaurant - show and talk about other menus.

In spite of their skepticism, they asked me to send them a proposal for art they might want to acquire. And to come to the apartment at Nu'uanu Tower with some of the art. There are yoga exercises easier than that, but was glad to oblige.

Not long after we met, Bikram was indicted and convicted of some sleazy crimes that would be comical if they were not so serious. The more I googled, the more alarming it seemed. He had started off as a young yoga prodigy and success had brought out the worst in him. One of his acolytes, a lithe young lady, told the court that Birkram told her that they were lovers in another lifetime and had unfinished business. What a line.

He ended up having to flee the country. The last I heard he was living in Mexico giving lessons on hot yoga. Not a cool guy. He could star in a reality TV series: Guru's Gone Wrong.

In Marin County, across the Golden Gate from SF, my good friend Jefferson's next door neighbor was Jon Hendricks. Famous for the seminal jazz group Lambert, Hendricks and Ross, he was working on a major stage production in North Beach, The Evolution of Jazz. Jon used to visit Jefferson and play his piano and get away from his wife for a while. We had visited his home a few times and once he had a Miles Davis record playing and was scatting masterfully. It just blew me away. Head-shaking stuff.

His house was one of the five oldest and most historic houses in Mill Valley and one afternoon I was invited to an event to raise money for Democratic candidates. The gathering was brimming with interesting people, including Jane Fonda; we met in a brief introduction.

Jon was a musical genius and a great thinker with a keen social conscience. One of the originators of vocalese, adding lyrics and replacing instruments with vocals. Al Jarraeu called him "pound for pound the best jazz singer on the planet, maybe that's ever been." Time magazine dubbed him "the James Joyce of jive." He exuded humanity and connection.

He was impressive. I wish that he could have met Ed Dwight, the sculptor of the jazz greats. They struck me as kindred spirits. Both exceptional individuals.

There were many more well known people that helped to make gallery life exciting: Boz Scaggs, Tom Jones, Barry Gordy, Chevy Chase, Robin Williams, Milton Berle, Clinton Portis, Howey Long, the list is long and becomes gratuitous. But the people that I fondly remember were not well known, but inspiring to meet.

SALES MENTORS AND TORMENTORS

Why and when does a mentor become a tormentor?

Classes on "How to Sell" art were like learning a musical scale without the music. Necessary, but, ugh.

One of my early mentors was Tom Hopkins. Perfectly coifed, with the flawless suit, the perfect Rolex watch, and a rap that could make Santa buy his own toys. Tom was on top of his game. A bit slick for my taste. Old school smooth. His sales course consisted of having an answer for everything and a way to overcome every objection.

My favorite body surfing spot on West Maui was Slaughterhouse Beach above Kapalua. A walk down a cliff on a winding path takes you to one of the most beautiful waves in the world. It was often private and always wonderful. Too much trouble for most people, not a lot of parking and easy to pass by on the winding west side two-lane road in what was then an undeveloped part of Maui.

We had just spent three long sessions with Tom Hopkins in his sales seminar. Seeing him sunning on Slaughterhouse Beach, more rocks than sand, was surprising. Without his hairpiece I did

a double take to see if it was really him. I had never questioned his hair, but now realized that it was a rug. There he was. Without the dark blue suit, sitting on a beach chair with his wife. Soaking in sun.

It was awkward for a moment. Delayed recognition interrupting their, and my, expected seclusion. We were the only ones on the beach.

I body surfed that day like I was a seal performing at SeaWorld for the Impresario of Sales. I felt like I was on stage and wanted to show off. (BTW, I had once won the entire Hopkins library of sales books in a contest he devised to see who could come up with the most closes that he had had us study.) LOL. I was basically a kiss-ass.

Another more local sales trainer, Ron Martin with his Success Dynamics brand—a "sales- resultant," not a consultant—put the tormentor into mentoring.

In contrast to Tom Hopkins' uber professional persona, Ron wore shorts, aloha shirts and slippers. All of his promotional material featured him at the beach with a graph and a long pointer, wearing a broad-brimmed straw beach hat. He wore his hair tied back in a ponytail. His laid-back island persona masked a retail bully.

His casual lifestyle promo shots peddled his manipulative approach to sales. He had a nine step program that he insisted everyone follow. One of his nine sales steps was to position the art consultant between the prospect and the door. To essentially block them from leaving. His schtick was "sales made easy." It wasn't. His nine-step sales process almost drove me to a twelve-step program.

Zella Jackson designed a specialized course, "The Art of Selling Art." She had some currency and some value. But when the proverbial tire met the road, she was flat. We were at the same art expo in NY and we both had show space. It was our best show, she sold nothing. Zip. She had great energy and I really liked her, but selling sales methods and selling art don't always mesh.

I sometimes wonder: At what point does a salesperson say, "Screw floor sales, I'll train others to do it and become a latter-day Dale Carnegie or Zig Ziglar type (really the best name of them all for sales)?" He knew when to zag. Too bad Soupy Sales never tried.

The training was theoretical and I was grateful for the time to think about the profession abstractly and to frame it in different ways, but I think art sales success takes being natural and sincere. And if you can FAKE that, you've got it made—I used to tease associates with that line, sincerely.

Being natural and interested in what art might work for people, or finding what they like, trumps most training. Good art consultants are a catalyst between the collector and the art. Hosts for a party to celebrate the art and the artist. Most galleries have good lighting. An art consultant's verbal light should shine to create a comfortable atmosphere with engaging commentary and well-timed questions. Always find ways to make it fun and memorable. Tastefully enhance the experience.

Most important sales have little to do with sales training. It's about the people. Connection and collaboration are the keys.

DIAMOND HEAD GALLERY

Sometimes you really don't know what you are getting into until you are in a buzzing hornets' nest.

For me, survival in the art business meant changing gears. As much as I respected the artist Lau Chun and loved managing his elegant gallery at the Royal Hawaiian Hotel, it was too laid back and when the offer came to be the director of the then-largest gallery on Kalakaua, the main drag in Waikiki, I jumped at the opportunity. It was time for another change.

With the Diamond Head Gallery, I got into a fabulous space in a key location with an owner whom I respected and a staff who seemed to know what they were doing.

But there was a lot going wrong. Digging deeper, I found that the sales staff was ethically challenged in scandalous ways.

One of the consultants, June, was an intelligent woman. She could have attracted attention in Hollywood: a tall Mae-West-meets-Calamity-Jane type. I found out from her stepfather that she was a murderess. She was certainly killing the camaraderie among the staff.

We represented her mother, a local artist specializing in painting close-ups of flowers, in the gallery. She was no Georgia O'Keefe, but her work sold fairly well. Mostly watercolors. One day June's stepdad confided to me that his stepdaughter murdered her old boyfriend on the mainland. Other disturbing parts of her past were not altogether past. He intimated that the murder thing was not totally buried.

It should be pointed out that June had had breast implants that looked like torpedoes ready to launch. Her rack was like the continental shelf, and the stepfather explained that she was already amply endowed before the surgery. Didn't need it. And the platinum hair was off the charts. If she were an album she would have gone double platinum. With an attitude that was cynical and condescending but mostly jaundiced, she was sowing discord among the staff. June's liabilities outweighed her assets; she had to go. Her best friend among the consultants was the top seller.

They both had to go.

As it turned out the top seller, Laila, and her boyfriend, would steal an original painting from the gallery. She was a somewhat nondescript woman: 5'5" tall, short-haired brunette, early twenties, a few pounds overweight. Someone who would be hard to spot in a lineup. A local girl who was so nice you would never suspect her. And gifted with an ability to connect with people. She was consistently a top producer in the gallery. And nice to work with.

But there was something that was hard to put a finger on that wasn't right. She was also best buds with the Platinum Calamity. They were really sisters in crime and over time created enough

of a shit show in the gallery to be let go so the rest of the staff wouldn't be subjected to their shenanigans. Being polite, they were rascals with criminal intent.

Over the decades, one of the hardest things that I have had to do as a gallery director is to fire art consultants. When it had to be done, I tried to do it with dignity and respect whenever possible. I worked with a lady who told me that she loved firing people. I never did.

When I filed the police report about the theft, we had no idea who had done it. It was a brazen act that entailed breaking and entering and the expertise to pick a painting that could easily sell on the secondary market.

Out of the blue, about a month later, I got a call from a guy on the mainland who wanted to confirm that the original painting he was in the process of buying online was legitimate. It was the stolen painting. I got his phone number and had the police call him back.

After leaving Diamond Head Gallery, Laila had gotten a job at a small gallery at the Sheraton Waikiki. Across the street. Evidence in hand, the police set up a sting at her new place of business and arrested her.

Many, many months later, I had to testify at the trial. By then it felt like stale news. Nonetheless, I had to get on the stand and confront her again. She was convicted. Given probation. Her boyfriend too. Maybe he was to blame.

Hopefully someone learned something from that debacle.

The third problem consultant was even more difficult to deal with. Tom was off-the-charts smart. An odd bird, but he seemed to have his act together. On closer inspection, looking back at

the books and following the night cash deposits, money was missing. When we confronted him, it was clear that he was the culprit.

When I told him that he was no longer needed at the gallery, he immediately started shouting shrilly, yelling so that the adjoining businesses and passersby—everyone—could hear: "F#*K YOU, F#*K YOU…" Over and over. It was an embarrassing scene.

I did my best to stay calm and defuse the situation. He had, and I needed to get, his gallery key. He snarled that it was at home. After cajoling and then demanding that he return the key, right now, he relented. I drove him to his apartment a couple of miles away. He calmed down, and gave me the key.

Then he asked for a hug. I just shrugged and left. The purge was complete. After cleaning house, we rebuilt the staff.

Still, there was always the issue of the lease renewal.

One common denominator among all galleries doing business in Hawaii in key locations are leases with rents that are often ruinous. Borderline obscene.

When the lease renegotiation came up, the gallery owner opted to give up the street-level location and move everything downstairs, upstairs. To keep the second floor open. That's the way it penciled out for him.

I understood. But I knew, without hesitation, that the second floor location was not viable. Location is critical. I prepared to change career gears again. Happily.

The owner of the gallery was one of the young business stars in Honolulu. I admired his entrepreneurial spirit and drive. He

had multiple businesses, including the largest frame shop in the state. He had a Tony Robbins look and vibe. Kent had been a star football player at UH and was drafted by the Dallas Cowboys but blew his knee out. He did not intend or plan on going into the art business, but with his businessman's mind, he saw the opportunities and went for it. All out, like an elite athlete.

Years later I ran into him and his lovely wife and commented on how much I admired him for his success. In my mind he was one of the good guys in the business. He was a man of his word. His answer was modest and telling. He said that he had "made one more good decision than bad."

I would add that he persevered and stayed positive, Tony Robbins style.

CHAPTER

63

IS 15 MINUTES ENOUGH?

The most quoted remark that Andy Warhol ever made was, "In the future, everyone will be world-famous for 15 minutes."

Warhol has been proven right again and again about our fifteen minutes of fame, though it might be calculated in pixels or megabytes today. And, if he were still alive, he might amend that statement today and pare it down to five minutes.

We might get it down to egg timers.

THE PRINCE OF MOROCCO

If you have ever met a prince and he was down-to-earth, genuine, smart, and kind, you may have met the Prince of Morocco.

Not the purple androgynous one.

It's a mistake to take anyone for granted. Especially if you are in a gallery. The idea that everyone will reflect their circumstances or interests in the way they are dressed or acting can lead to missed opportunities. Despite advertising telling us otherwise, clothes do not make the man. It is best to regard everyone as a valued guest. Treat them like an Everyman Prince. That way, you don't regret it when you treat an actual prince like a prince.

This guy was no pauper.

When a man walked into the gallery wearing a t-shirt, flip flops, and shorts, I thought that he might be from south of the border. It didn't take long to realize that he had a formidable entourage with him. The five black SUVs with tinted windows waiting in front of the gallery on Lewers Street were a clue.

The Prince of Morocco visits Honolulu every year. Honolulu and Morocco have a formal sister-state relationship to promote cultural and educational exchange and international trade. And the prince told me that he loves Hawaii.

He was decisive about the art he liked. No hesitation. As soon as we put up a piece for his consideration he would say yes, or no. After selecting what he wanted, he would leave. His experienced and capable team followed up and coordinated his purchases. The hardcore negotiating commenced after the prince had selected what he wanted and exited stage left.

Khalid was a model of what you want in a right-hand man to a prince: multilingual, loyal, an accomplished martial artist, and a world-class negotiator. More of a "no" than a "yes" man. He was a formidable individual who was also physically imposing. I grew to like him. After a few years, I felt for his wife and kids because he was on the road with the royal retinue most of the time.

Everyone must save face and look good. I did my best and always looked forward to the excitement and buzz that the prince created in the gallery. When we first met, I remember asking Khalid how people were supposed to address him—I explained that America had split with English royalty and we are challenged in that regard. He said, "The English have no problem; call him His Royal Highness." I became very polite. HRH it was.

During one visit, the prince chose another beautiful collection and, as in the past, exited without paying, leaving that task to Khalid. I didn't see them for a couple of days and was getting antsy, wondering why. Then one night, almost at closing time, Khalid showed up with his own imposing right-hand man who kept flipping through rolls of cash while we were talking. That seemed like something they had planned.

I had the paperwork ready and reviewed what the prince had selected and the prices. They wanted a better price. They

explained that they were on their way to the airport and had very little time. They put me on a timer. We needed to wrap this up in fifteen minutes. Talk about professional negotiators. These guys were hard-wired.

Between their last purchase and the one at hand, our prices had gone up. Not a lot, but they noticed the difference and did not want to pay it. They wanted the same deal that they got the time before. I explained that the difference was to cover increased material and labor costs. But they were not going to budge and kept looking at their watches.

Between the proverbial rock and a hard place. Again.

I needed to call the corporate office to get the OK to accept their offer. It was late, but I called the one guy who could give me the go-ahead and woke him up. He refused. He said, "What if the Prince of Saudi Arabia and the Prince of Morocco were at the same party and compared notes and one of them got a better deal? The price is the price...." I thought that this was absurd. We were going to let a six-figure sale walk over a few thousand dollars and an imagined party. And, more importantly, we were going to offend a great client. I tried again to sell him on the importance of this sale, to get him to relent and just say yes.

He didn't.

Khalid looked at me like I was loco. His associate put the roll of money in his pocket. They couldn't believe that we would not bend a little. Especially, as they reminded me, because they were loyal clients who had already bought hundreds of thousands of dollars' worth of photographs and had important connections. I knew that this would make him look bad with the Prince, but I had no alternative other than to apologize politely and profusely.

I continued to stay in touch and provide updates on new work and was relieved to see them again the next year. Fifteen minutes before visiting, they called my cell phone. I was grocery shopping and dropped everything and made a beeline for the gallery to meet them. I was dressed in shorts and flip flops. Luckily, I was just minutes away. They acquired more art during that visit, and all was finally well.

Still, I tend to fiend on the deals that could have been. No doubt, too much.

We always did our best to give everyone the royal treatment, but doing it for bona fide royals can be intense. A royal pain that feels so good.

CHAPTER 65

RACING TO FINISH THE SALE

Art sales rarely happen fast, it's a process. A dance. This one was a race.

When a tall, beautifully dressed, exotic-looking woman breezed into the gallery, I did not recognize her, or her famous boyfriend.

Because I don't follow Formula One racing, I didn't recognize Lewis Hamilton. Arguably the best driver, ever, in that sport. I found myself trailing him as he raced around the gallery, pointing out pieces that he liked.

His beautiful girlfriend, Nicole Scherzinger, the lead singer for the girl group The Pussycat Dolls, was from Hawaii. They were visiting her family for the holidays.

She was nice but understandably aloof: it must get tiring to be recognized and ogled at. At one point, she told Lewis that she was leaving to pick something up at a dress shop a few stores down. She left.

That made Lewis go into overdrive. He made five decisive selections and explained that he was in a hurry. He asked if I could speed up the paperwork. I did my best to do that without

careening off course. It was one of the fastest sales that we had ever made. No wonder he is a champion race driver.

He came back the next year with his parents; his father was especially engaging. Lewis acquired more art, but this time the sale took place at a more leisurely speed.

Champions are different; they win a lot. Lewis won this one by getting expedited service and a winning price for acquiring five at one time.

CHAPTER

66

IT WAS NUTS, NOT "BERZERKELEY"

In my generation, our adult lives didn't really start until after high school. If then. We were more dependent than nesting baby birds.

Three days after graduating from high school, I flew the coop and took off from Arizona. My oldest brother had just graduated from UC Berkeley, and I was longing for adventure. He had a place in Piedmont above Berkeley.

I left at night—to beat the heat during the drive through the Sonoran desert—in my weathered old VW bug. My heart was in my stomach for much of that drive. Not only hoping that the car would make it, but anticipating the new and the sloughing off of the old had me thinking. Luckily that rattling tin can, crossing a highway that stretched for hundreds of miles through the desert, didn't break down. It just overheated.

That was the beginning of the mind-blowing, life-altering experiences that followed.

It was the summer of 1965, the times they were a'changin'—at least for me—and Berkeley was the epicenter of social change on the West Coast. It was a great transition from HS. Exhilarating

and transformational. My brother Chris and I looked similar, and I used his ID and name and got a job on campus that summer.

The UC Berkeley campus was the battlefield for the free speech student movement. A battleground unlike any other. It was a riot of conflicting ideologies. Everything from holy rollers standing on soapboxes telling everyone they were sinners to students shouting for revolution. It was a cacophony of energetic radicals and reformers.

I sat in on some English classes and realized how much I didn't know. To say that I was impressed by the Berkeley students is an understatement. That college experience really put me on my toes, humbled me, and made me pay more attention and try harder. I knew nothing. It was scary. I was meeting poets and wannabe prophets who spun my head around.

Looking back, I can't help feeling a little guilty about some inadvertent trouble I caused. One campus job involved being a subject for psych graduate students doing research papers. Being a guinea pig and taking psych tests devised by grad students paid well, but according to their records, I was a college graduate, not a high school graduate. So it must have skewed their results. Sorry.

My odd jobs helped pay the rent. Another project was moving furniture between academic departments with a Ugandan exchange student. Strongman and vicious dictator Idi Amin was the leader in Uganda at that time, and I remember how much admiration I had for my fellow furniture mover. Bwanbale was intelligent and clearly a good man. He exuded kindness and humanity and left a lasting impression. He had a huge beautiful round face with the brightest eyes and a radiant smile that made

the have a nice day emoji look uptight. I wondered how he fared when he returned home. The stories of human atrocities in Uganda were rampant in those days. I hope that he survived the upheavals in his homeland.

To finance my eating habit, I also cleaned houses for tenured professors. One of them was the world's foremost scholar on Mark Twain. He wrote the definitive monographs that were landmarks of research on the subject. When I was cleaning his bathroom, I was gobsmacked at how many pills he had. It looked like a pharmacy.

The atmosphere on campus was unlike anything that I had experienced. The diversity and intensity were ratcheted high. Bustling, rowdy and raucous.

The world was radically different from today—LSD was still legal, Dylan and growing social consciousness energized and inspired, and it was exhilarating being a teenager. But by the end of that summer, I had to head in a different direction.

My father was a great guy. He was the hardest-working man that I ever knew. He mastered many difficult skills along the way and had a funny sense of humor. He was a master sailor, had a pilot's license, could build radios, was a good carpenter, builder, master salesman and a great provider. He had integrity, and he was full of love. He also was politically conservative to an extreme and was adamant that the family adhere to conservative ideology.

If you think that this set up a CONFLICT between my Berkeley brother and my anti-commie Dad, you are correct. At times, their different viewpoints were the source of fierce politically-triggered arguments.

I returned to AZ and ASU. Living in Berkeley was not an option unless I dropped out. It would take two more years for that.

I made some questionable choices during this time but was like the fool in the Tarot, stepping off into the unknown with a blithe joyous spirit. It all worked out despite my naïveté.

CHAPTER

67

COURT GESTURES

There should be a library for unpublished books.

My older brother Chris and I were house painters in 1977, but we thought of ourselves as artists and writers and visionaries. Dressed in paint-splattered pants, we had dreams of breakthrough success.

As a single father with a toddler daughter and a seat-of-the-pants house painting business with my brother/business partner, I regularly played tennis on Sundays to relieve stress and enjoy a sport that I loved. We were living in Sausalito at the time, and the tennis court was spectacular, with a panoramic view of Angel Island. I met some interesting people who taught me a lot about playing the game.

One character stood out: Jack Klammat, a WWII veteran who represented the Army at Wimbledon after the war. The first time I saw him, he was walking across the street. He stopped, looked me in the eye, took out his teeth, and grinned from ear to ear. He had a face for comedy.

The next time I saw Jack was at the tennis court. He was old, but the wiliest player I had ever encountered. He kept me

running from side to side, and then he'd drop a shot that would just die on the court. Jack thoroughly enjoyed toying with me. I don't remember ever winning a match against him, but I loved the challenge, and the exercise, and looked forward to playing with him every weekend. He kept me laughing with his antics and offbeat banter. He used to bring a carton of milk to the court and one day he handed it to me and said, "Take a sip." Heavily laced with alcohol. I almost spit it out geyser style. It was foul.

A mutual friend told me that Jack was reeling around the Fillmore District in San Francisco one night and went into an all-Black bar loudly declaring upon entering, "I didn't know that they allowed Black people in here...." He made friends wherever he went. Jack loved being outrageous, and it came naturally, but he was also very bright and kind and knew everything about tennis. An offbeat mentor, to be sure. I asked a friend how Jack supported himself and he told me that he was a porno writer.

Chris and I often brainstormed ideas of turning that experience and enthusiasm for the game into something tangible. The idea gelled when Chris came across a passage in Laurens van der Post's Jung and the Story of our Time about tennis growing out of jeu de paume, a medieval monks' meditative sport. We did a deep dive to learn as much as we could.

Court Gestures

As obedient children of the flower-powered '60s, we enjoyed smoking pot and plotting grandiose plans that did not involve the heavy lifting of stripping and prepping and painting houses. A book on tennis made perfect sense at the time, and we threw ourselves into the project.

Our preface to the book provides an overview and the trajectory of the project:

"Court Gestures evolved from a desire to trace the original monastic design, the mythic dimensions, implicit in the modern game of tennis. Sometimes it was well hidden, and our search for clues led us to unexpected places: the moon and China, King Arthur's court and Sir Walter Scott's garden, Hitler's library, and the bar at Wimbledon, where bloody corsets hung.

"This diamond of games has been seen through the eyes of historians and economists, psychologists and sociologists, philosophers and fools. Our aim in Court Gestures is to give the reader a multifaceted vision, a synthesis of the best that's been seen and said of tennis.

"Often during our research, we felt like prospectors digging through mountains of coal dust. When we found diamonds, we were delighted, and to the creators of these visual and verbal

gems, we are grateful: for without their work, ours would not exist. We apologize if, in cutting and setting, we have thrown out any diamonds with the dust...or left any dust on the diamonds."

The design of the book was critical. It had to be the same shape and relative dimensions as a tennis court, with a graphic emphasis. My sister-in-law, Chris's wife, Karla, was a terrific artist and one of the most idiosyncratic people I have ever known. She became an integral part of helping us translate our vision of how our best-selling tennis book would look into the physical object. Karla was intuitive and had the ability to articulate the vision in an artful and archetypal way. We were convinced that this was going to be a classic.

We were not aware that a bevy of books were being written, and would soon be published, in the tennis space by some of the game's biggest names, but we knew that getting published would be challenging and that we needed someone famous to get behind this project. We thought that we had a chance to get Billie Jean King's husband at the time, Larry King. Not only was BJK the biggest name in the game, but she was also an integral part of our writing on women in tennis, and we thought that she

would be happy with how she was portrayed as a leading figure in the game. And importantly, we had a special connection who would introduce us to Larry.

Larry King (not the talk show host) was registered to participate in the Western States 100-Mile Endurance Run that Shannon Yewell, a dear friend of ours, was organizing. We made plans to be there and pitch him on our project.

What we didn't know at the time, something that made our plans—in retrospect—look absurd at best, was that BJK would soon come out as gay and divorce Larry. Our depiction of her in the book as the leading figure in our chapter about "Amazons and Ladies In Tennis" would offend some people, including, perhaps, Billie Jean. We weren't intending to be politically incorrect or socially out of step, but we were somewhat clueless. In any case, Larry was only interested in and focused on that 100-mile endurance run.

Regardless, confident that our work was creative and insightful enough to be worthy of consideration, we submitted our book to publishers without a notable endorsement. None of the many rejection letters we received were saved, but we surveyed the plethora of books about tennis published that year. The game's biggest names did indeed come out with books: Bud Collins; John McEnroe; Jimmy Connors; Björn Borg; BJK et al. Good books. Big names. Not Court Gestures, but books that sold.

Publishers were inundated with proposals, and house-painter wannabe writers could not get in to play the game. We were overmatched, but we hoped, not out-imagined.

Love, in scoring tennis, means zero. In the end, we were merely court jesters. We wrote Court Gestures for love.

HAWAII'S AMBASSADOR OF NU'U POP

"All great art is about art." Leo Steinberg. "Not." Sonny Pops. No project has fueled my enthusiasm and teased my imagination as much as Sonny Pops, Hawaii's Ambassador of Nu'u Pop Art. It was the culmination of all of my art world experiences. A dream that needed manifesting.

The idea crystallized while in NY on business. While thinking about the last twenty years of selling art in Hawaii, it occurred to me that something fun and worthwhile was missing in the local Hawaiian art market.

We had talented painters of all stripes and styles, but no one had created a definitive regional Hawaii-infused Pop art. That is when Sonny Pops, Hawaii's Ambassador of Nu'u Pop Art, was born. Perhaps hatched.

Sonny Pops silkscreen on canvas

For the next thirty years the Sonny Pops challenge of ferreting out ideas and refining the concept animated me. I continue to this day. A work in progress.

In 1994, before selfies were a thing, I had this selfie interview with Sonny Pops to answer pressing questions:

Q. First, Sonny, a question on my mind: the name "Sonny Pops." Why?

A. *I hope that it makes you smile. The name is effervescent, tropical, and fun. It is just a handle that I liked, and it sounds appropriate to the work that I am doing. My parents never called me Sonny, and my kids never called me Pops, so the name is strictly a nom de brush. I think of it literally as the son of Pop art. Sonny Pops is an attitude, a point of view.*

Q. What are you trying to say with your art? Is your work relevant today, decades after Pop art exploded on the scene?

A. *When I survey the art in Hawaii, I see many lovely things—beautiful paintings, some truly inspired work. But what I don't see, and what appears to be missing in this market, was work in the idiom that helped define the 60s—Pop art. Pop exerted a tremendous influence on American culture but barely affected Hawaii's visual vocabulary. It is interesting to see how classic Pop images work when re-contextualized into Hawaiian imagery. The regional context forces the viewer to see the art in a new way.*

Q. How do you place yourself in relation to Pop artists?

A. *No one can discover Pop the way that Warhol and Co. did because Pop culture is no longer discoverable. It is now something that one cannot escape from. Pop is no longer a style but a large and rich vocabulary with its own regional reflections. It is also a fruitful source of allusions that almost everyone recognizes. I see Sonny Pops as part of the regionalization of American art. It is a rephrasing of Pop with pidgin inflections. Is it relevant? Well, the economic and cultural dynamics that fueled the initial experiments with Pop imagery are just as prevalent in Hawaii today as they were in the '60s. Maybe more. There are some interesting parallels, too: the civil rights struggles that raged during the first onslaught of Pop art are curiously mirrored in the Hawaiian sovereignty movement today. The commercialization of culture that gave rise to Pop is even more dominant today than it was thirty years ago, especially in Hawaii.*

Q. Some of your work seems political. Is it?

A. *I don't have a political agenda. The images attract me because of their inherent power. Nonetheless, the relationships are bound to touch political nerves. It is unavoidable. The problems that confront us, specifically the Hawaiian sovereignty movement, tear at the social fabric and subtly undermine the aloha spirit. The nagging sense of betrayal in many Hawaiians' minds, far from fading, seems to be gaining momentum as time goes by. If I have an attitude about all of this, it is ambivalence. I like parties, but not political parties; I prefer parodies. Welcome to my parody.*

Q. What is it about Hawaii that makes you want to create a body of work devoted to it?

A. *There is a wellspring of imagery in Hawaii to draw from. The peculiar relationship between Hawaii, the place, and Hawaii, the product, is fascinating; accenting this relationship is compelling. Having spent about ten years in the American Southwest, I saw how the American Indians' image had been incorporated into the marketing of the Southwest. While the Indian nations' essence had been reduced to a stereotype and a parody, the Indian image was kept for its exotic appeal as a marketing tool. The only Indian that we ever seemed to really care about was on the Indian head nickel. There is a curious parallel between the Indians and the Hawaiians in the American experience. We put a price on aloha. That is fascinating to me. The aloha spirit is naturally priceless, but we still bank on it.*

Q. Can you explain why anyone would be interested in Hawaiian Pop?

A. *The work is bright and cheerful. One of the pitfalls of answering these questions is that I risk making more of the art than it deserves. The art should simply show on the surface qualities. For instance, I love the image of Duke Kahanamoku. He was beautiful and inspiring. I did the Triple Duke because I thought that it would be three times more beautiful. Well, really, I wanted to create something with primary colors. To take something old and give it new life. It is just fun. And it is happening now.*

Q. Many of the paintings have multiple images. Why do you keep repeating the images?

A. *Repetition is the very heart of modernity. Besides, I like threes and fours. They look good to my eyes, and you get more for your money. Henry Ford influenced Andy Warhol and Sonny Pops.*

Q. How would you describe your work?

A. *Hawaiian kitsch. Nu'u Hawaiian Pop—I'm a Post-Pop Regionalist. Ideally, at its best, this is a critical reconsideration of Pop icons in the changed context of Hawaii today. I'm trying to explore what the idiom means now.*

Q. What kind of people collect your work?

A. *In the early days when Pop art was fresh and edgy, it took self-confidence and vision to collect it. Now, it just takes money and lots of it because the classic Pop artists have become blue-chip. For the most part, it isn't as much fun when you have to call*

your banker to buy a painting. With Sonny Pops you can collect a parody at modest prices. I can't categorize the collectors other than to say that they seem to be open-minded and have a sense of humor.

Q. Do you think of your work as avant-garde?

A. *What blew my mind in the '60s and remains a revelation is just how fast the avant-garde becomes the cultural norm. Artists cannot position themselves outside of the social norm without quickly becoming absorbed by that voracious norm. New forms and movements have almost instant influence. The recognition that mass culture absorbs the avant-garde for economic gain ends the notion of the avant-garde. My generation is really very nostalgic. Perhaps because the '60s were so traumatic, we keep referring back to that decade. Doesn't it seem like oldies music stations have always been playing? If we recycled garbage the way we recycle culture, we would be environmental heroes. We love revivals. Everything old is "new" again. But something is only really new once. The context changes.*

I sent that selfie-Interview to John Berger, a local art critic with the Honolulu Star-Advertiser, after he attended my show at Luxury Row in Honolulu. This was a month before the Covid catastrophe. His response made me smile like Mona Lisa: "Thank you for your preemptive email." He was kind to make sure that the show was prominently announced in the newspaper but explained that his calendar was full and he would not be able to review it.

sonny pops : artist statement

Sonny's *Nu'u Pop*,
the **ICON SMILE COLLECTION,**
looks like Hawaiian Pop Art,
but it is Conceptual.
The idea,
hatched thirty years ago,
was to create a Hawaiian infused
pop parody / pastiche
of the pantheon of pop artists -
Warhol, et al -
with an island perspective
and point of view.

Having come of age in the era of pop
and outlived a few isms that are wasms,
provides a freedom to re contextualize,
if not bastardize
familiar themes,
to scramble our shared visual vocabulary
with da kine regional inflections.

Part pop with some dada moments
and a guiding concept, Sonny Pops
was created to entertain, amuse and evoke
Nu'u ways of looking at familiar pop art.

This fusion of pop and Hawaiian iconography,
a bit kitshcy,
can be combustible,
oddly classic
and was created to be fun...

love 'n aloha

PRANKSY

A prank is a practical joke. Pranksy is an impractical gag .

Banksy is a favorite. He makes us all take notice and focus on issues of import with wit and street smarts. With a Chaplan-esque charm, his stencils simply address shared dilemmas, social issues, and dreams. He is the philosopher-king, the poet laureate of street art.

As if the art world needed anymore shredding, his performance piece at the big Sotheby's auction was an actuary's dream. Dada on steroids. A pastiche of pith and moment. Fun as fuck. What can be more fun than watching a work of art that just sold for a million dollars being shredded on the spot with the shocked hoity-toities looking on? The painting doubled in value.

Banksy's assault on the art establishment, hilarious as it is, is seditious. His company, Pest Control, outwits the experts and amuses us all.

Sonny Pops was created as a parody. A pastiche meant to be fun. An elaborate goof. While walking my dog one midnight, I thought it would be amusing to do a Hawaiian parody of Banksy.

Pranksy was born.

Sonny Pops' adopted brother, Pranksy, Banksy's pale Hawaiian cousin twice removed, was stillborn, climbing Diamond Head, at midnight.

My stencil of the Hokulea (a full-scale replica of a Polynesian double-hulled canoe) with a missile being launched from the bow and big cannons was the kind of thing that I actually worked on. But I am not as ballsy as Banksy, and street art is not my schtick. It would look good on the thirty-meter telescope proposed for Mauna Kea, if it ever gets built.

Pranksy, Armed Hokulea

Other ideas for Pranksy:

A stencil of King Kalakaua at the battle on the Pali with warriors falling to their death from tall cliffs and the words: "King K's Pali Tours."

A Hawaiian net fisherman throwing his net over a sign that says "No Trespassing" in the spirit of Banksy's flower bomber.

There are plenty of motifs, and socially relevant, if not seditious, subjects that work in this regional format that I think would be impactful. I have a vetted list. But the politics become problematic. I want to live a simple life. I've shied away from this project, and if I do it, I'll need a protégé with more guts and street savvy than I've got.

Pranksy is a pussy: Banksy is the man.

ABSOLUT ART

Absolut Vodka had one of the most successful commercial ad campaigns of all time. They used famous artists to enhance their brand. As a consumer, I appreciated the aesthetics that they were using to get people tipsy. They also used regional artists.

When they sponsored a contest in Hawaii, I was invited to participate in a juried Absolut Art show. The winner would actually have their work included in Absolut's artful blitz. And they would purchase the piece.

I felt like a debutante planning for an important date. Ridiculous in retrospect. So eager to prostitute my work and time for any commercial recognition. Jumping through imaginary hoops.

I created a multi-dimensional silkscreen and painting on canvas and plexiglass. Based on my Sonny Pops' pastiche of Indiana's Pop classic, LOVE. It was a hearty effort.

I didn't win. The winner was worthy. A Hawaiian artist who painted on a ukulele. Not a cheap one. I loved his work.

A few years later, I was approached by the most successful publisher of Hawaiian kitsch, cards, and wrapping paper.

They wanted to use my art from the Absolut show. But they needed Absolut to agree to let me license my art. Absolut refused. It was polite, "…We love your work, Sonny, but we will sue you if you publish this…."

So, I redid it. The first move was to correct the spelling. The missing vowel was part of Sonny's parody. ABSOLUTE, with the E. Then I rewrote the label with a Hawaiian-centric sensibility: "This sweet Aloha was distilled from the people of the Hawaiian Islands with a tradition that stretches back to the beginning of recorded time." I made changes in the label, from "80%" to "100%," from "Imported" to "Exported," from "Sweden" to "Country of Hawaii."

I created a full-on pastiche. Something that utterly conformed to fair-use copyright laws, section 107 in the US copyright code. The work was now clearly a parody. It was much better than the one that I had submitted to the Absolut show in Honolulu. Sunnier. But the local publisher still shied away from using it. No one wants to mess with powerful lawyers. Even a win can add up to a loss. So the publisher chose a different image and used it on wrapping paper. I thought that it kinda sucked.

Then, I put a full-page ad in the NY Artexpo book of exhibitors highlighting the reworked ABSOLUT image. I sent an invitation to the Absolut lawyers who had sent me that letter threatening a lawsuit if I published the image. They came; well, one lawyer showed up. Something inside of me was hoping that they would sue. I wanted to be in the news. To matter. Publicity is oxygen to an artist. I saw myself in court asking their lawyers, "How do you spell absolute?" It would have been good theatre.

This sweet Aloha
was distilled from
the people of the
Hawaiian Islands
with a tradition that
stretches back to the
beginning of recorded
time.

100 PROOF

EXPORTED

But it was copacetic. They knew that suing would be a coup for me. Not for them. Had they sued, it would have been a career game-changer. The publicity could have put me on the map. Or the radar.

CHAPTER 71

FAKES

The difference between faux and fake is intent.

The same client who owned the Matisse owned an original Goya that he was very proud of. He said that it was on the cover of textbooks he used growing up. His father had acquired the painting in the early 1920s, and he never questioned its authenticity.

We had to do everything possible to ensure and document the provenance before we could sell it. After a laborious search, I realized that this was not the original, but rather a period piece reproduction in the master's style. It was a superb copy. A masterful study by a student of that school and era, but not the original Goya.

Breaking that news to the client was not something that I looked forward to, but I couldn't shirk the responsibility. Art becomes very personal. I may as well have been telling him that his son's DNA didn't match his. There was no nice way to frame this.

The news did not go over well. We also had the same issue with his Modigliani. I hated having to deal with that, but it was

unavoidable. It was tantamount to being the one to tell him, "You lose millions of anticipated dollars, and your father was defrauded." Not the message that I wanted to deliver.

And it certainly didn't act as glue to our long professional relationship. I am not sure how it fits into the next wrinkle in this story.

The last piece that we planned to sell for this client was Rodin's "The Thinker" (Le Penseur). We had a buyer lined up after he asked us to sell it for him.

Our client had a spectacular lifetime cast of the sculpture that graced the entrance to his home in Tokyo. Another gift from his father. My wife had gone to Japan to arrange for the packing and shipping. When you turned it upside down, the embossed bronze stamp inside the sculpture checked out with the Rodin experts and the museum and the estate. It was a coveted cast made during the artist's lifetime in beautiful condition.

We had a wooden shipping crate built, and the sculpture was literally being lowered into the crate by movers when the client said, "Matte!" WAIT!

He had changed his mind. Please rewind this. I like to think, as if I am an unemployed comedian, and this setback was just a punchline, not a gut punch: I wish that our client didn't have second thoughts about selling his Le Penseur.

CHAPTER 72

HE BRONZED DUKE KAHANAMOKU

Sonny Pops DUKE graphic

Duke Kahanamoku, arms stretched in aloha and welcome, stands nine feet tall in Waikiki.

The most prominent bronze sculpture in Hawaii is King Kamehameha in downtown Honolulu. The most viewed sculpture is the king of surfing, Duke Kahanamoku, in Waikiki.

Bigger than life, Duke is the consummate Hawaiian Icon: Ambassador of Aloha; Father of Surfing; Hawaiian demigod.

I met the creator of that welcoming bronze sculpture, Jan Fisher, when he visited our Merrill Chase Gallery at Ala Moana. I liked him immediately and thought that his work was underrepresented and would resonate with collectors.

Looking through his portfolio showed me how diverse and capable he was. I wanted to show his work in the gallery. Still, we had many sculptors, including the enormously successful Frederick Hart, with his claim to fame of having created Ex Nihilo, part of his Creation Sculptures for the National Cathedral in Washington DC. Bob Chase was the first to publish his work, and they were tied at the hip.

Jan was vying with one of the retail heavyweights of that time.

I was not the owner and could not make a unilateral decision, so I put together a proposal for the top decision-makers in Chicago. They chose to focus on the work that we were already showing. They were deeply invested in making the Frederick Hart sculpture program successful.

Jan was a professor at BYU-Hawaii in Laie on the North Shore of Oahu. He had, at that time, twelve children. When I mentioned that I had three kids at home and wondered how he handled twelve, his answer made me smile: "Just add more water to the soup." His humble down-to-earth nature was a welcome relief for me.

I stayed in touch with Jan, and he kept me up to date on his work. I was delighted with his series of Sumo wrestlers and thought it was a unique subject that he approached with verve. They would have translated beautifully as monuments in the right space.

A couple of years later, a chance meeting with a Japanese businessman who was building the largest golf clubhouse in Okinawa provided an opportunity to finally work on a project with Jan Fisher. I put together an ambitious proposal that I thought was inspired. Jan agreed.

The fees just to join that club were hundreds of thousands of dollars. It was designed to be world-class. I proposed creating a life-sized bronze ensemble showing a foursome in various poses as if they were playing the last hole.

I thought that it would even be possible to get sponsors to defray some of the expenses. The proposal also included two smaller bronzes in limited editions that would be given to prospective members as an added incentive to join the club.

The developer liked the idea of the smaller work but vacillated on the life-size idea.I told him that the ensemble could get worldwide publicity and would look fabulous in brochures and magazine articles. Nothing like that had ever been done. A monumental bronze foursome with a gallery of bronze onlookers would have created a worldwide buzz.

I kept Jan in the loop during these discussions and negotiations. The owner of the golf club wanted to see what the sculptures would look like. Jan agreed to create the maquette for two of the figures for a modest fee. The scaled-down version of the sculptures came out better than expected.

Hole in One and Power-Drive were stylistically different. One was in a realist style, based on Sam Snead teeing off. Power Drive was more abstracted, almost in the spirit of the Futurism movement. I loved them both.

I was so confident that the client would proceed that I paid to have the maquette's cast in bronze so that we could show the finished work. They came out beautifully.

Without missing a beat, I put together a presentation for the client. He was happy with Jan's work, but explained that his

father had just passed on, and he was hit with a monumental tax bill. He said that he owed tens of millions of dollars.

Because that project was taxed to death, I planned to market the work on my own. We displayed the work in our Fine Art Hawaii gallery, printed a top-notch four-page brochure. But the sculptures didn't sell.

Talk about fortuitous, and things coming around. I was surprised, delighted really, to meet Jan Fisher's sister Kandi, twenty years later, by chance. I had lost touch with Jan years earlier as our careers careened in different directions. I was sad to hear that he had passed on.

When a nice-looking lady approached me in the gallery and asked me for directions to a Waikiki restaurant, I started explaining how to get there. I mentioned the Duke Kahanamoku statue as a frame of reference. She stopped me and said that her deceased brother was the artist who created the statue. I was stunned.

When she found out that I had worked with her brother and had published a four-page brochure promoting his work, she lit up. Kandi excitedly explained that the family was trying to reconstruct some of his life and work posthumously. That is what had brought her to Hawaii on this trip. They felt that his legacy was important and wanted to honor it.

I agreed. Jan's work was under appreciated.

Our paths crossing is probably not so surprising; after all— many paths cross in the islands. But I felt a sense of coming full circle. It was a random bullseye.

The Covid-19 pandemic came on the heels of our meeting. Months passed. Then I received an e-mail saying that she was in

town and wanted to come by to discuss the sculpture. We had not had anyone over to our house since the lockdown, but she assured me that they would be tested in the morning before visiting. Kandi was delightful as was her husband Dennis.

They left that day with the sculpture on their way to the Big Island to visit Jan's kids. We all wore Have a Nice Day smiles.

SOME SKIN IN THE GAME

That aphorism essentially means that you have something on the line. Replace skin with money, and that's generally what's on the line.

The golf club in Japan was delayed for years, but when it finally opened, the owner asked if I could recommend an artist to fly in. He wanted someone to create a series of sketches of the members playing a skins game and to produce finished paintings for the clubhouse. I suggested Walt Spitzmiller.

Spitzmiller was known for his work in sports, especially golf, and his art was in the collections of some of the legends of the game: Arnold Palmer, Jack Nicklaus, Lee Trevino; and in the World Golf Hall of Fame. He established himself as an iconic golf artist, and he was delighted to hear from me regarding this opportunity.

After coordinating the timing and travel arrangements, Walt agreed to meet in Honolulu on his way to the newly-built golf clubhouse in Okinawa. He was excited at the prospect of this adventure, but knew it would require a lot of work.

His process was to sketch while watching golf matches and then use the sketches to create more painterly and finished studio work. His experience and ability to work under corporate requirements were instrumental in making this project successful.

Walt sent us a painting of Isao Aoki, winner of the Hawaiian Open golf tournament in 1983. It depicts the golfer and the onlookers' gallery as he is hitting a winning shot on the 18th tee. We are not golfers or particularly interested in displaying golf paintings, but appreciated the gesture.

CHAPTER 74

HEADED TO HONG KONG

To reboot my career, I had to go halfway around the world.

If I have learned anything by being in the art business over the decades, it is to stay flexible. Markets and conditions change. I was working with Merrill Chase Galleries during the first Gulf War when the art market took a huge hit in Hawaii. The Pritzker family from Chicago owned the gallery, and I got a call informing me that one of the Pritzkers was on his way to meet with me.

The short version of this part of the story is that all of the galleries were going to close except those in Chicago. They explained that "their people" informed them that the market would be dormant for the next seven years. They turned out to be right about that.

The news came at a particularly difficult time. We had just bought a new place, had three kids at home, two of them under five (four and two years old), and scant prospects for work in the business that we had grown to love. It was going to take belt-tightening and luck to clear this hurdle.

A couple of weeks later, at around six in the morning, the phone rang. It was an old friend and business associate asking if I wanted to go to Hong Kong to work an art show for a week. Boy, did I ever.

After a few discussions with the gallery owner in HK, I was on a plane bound for a new and exciting adventure.

When I landed at night at the old Hong Kong airport, I felt like I was in a sci-fi movie. Seeing Victoria Peak and Central, Hong Kong lit up on a clear night from the Kowloon side was exhilarating. It looked like a megapolis.

A driver picked me up and drove me to a restaurant to meet Vincent Lee, a smart and successful businessman. He had an infectious love for art, energy and enthusiasm.

The Israeli American artist Yankel Ginzburg was at the dinner, along with a former ambassador for John F. Kennedy and his wife. We talked for hours.

Later, Vincent had his driver take us to a flat that he owned in Lan Kwai Fong, the Soho of HK. He lived in a huge house nearby. The apartment was perfect. A great location with a huge ex-pat presence and lots of bars and restaurants. It would become my home away from home.

The next day was the first day of the show. But that night was brutal. I woke up with massive cramps in my legs, felt pretty sick to my stomach, and barely slept. But the adrenalin of being there kept me going. I showed up on time in the morning, and we set up the show in a most unusual place. It was not at Vincent's gallery at the Ritz Carlton in Central, HK but was set up around a fountain that formed the hub of three high-rise buildings populated by successful businessmen and women.

Very International. The foot traffic was brisk, and we went non-stop all day.

It was a bit of a grind, but I sold $88,000 during the week and made a good impression. After the show, Vincent asked that I come back and train his staff for a month. It was the best and only offer on the table for me, and I had mouths to feed and bills to pay, so the answer was a foregone conclusion.

I looked forward to it. The booming Asian art market was blowing my mind, and Vincent made it interesting and fun.

After a trip home to Hawaii to gather what I needed for a longer stay, I gave my beautiful wife and lovely children hugs and kisses and headed back.

Hong Kong was all go. People work and play hard. It was such a contrast to the islands' laid-back pace, but I liked it and appreciated the opportunity. After a month, I was asked if I could stay for the rest of the year. I said yes, and I'm glad that I did.

Vincent Lee was a great mentor. His intelligence and business acumen, coupled with his love of having fun, made him an ideal guy to work with. His father had made a fortune importing Italian electronics to HK before anyone else. They grew their company, the Tung Tai Group, into a diversified powerhouse.

They would buy companies in China and take them public; they had their own guy in the Chicago Stock Exchange and traded stocks every day; they had about seven divisions going all at once. In their office on Connaught Road in Central, HK, they displayed photographs of the senior Lee with all of China's rulers going back decades. They were players.

Vincent's motivation for his gallery was to grow out of his father's shadow and indulge his true passion for art. Specifically, Yankel Ginzburg.

Lee had the most extensive and exclusive Ginzburg collection in the world. His passionate belief that Yankel was the best artist in the world led him to buy everything Ginzburg produced.

But Vincent hedged his bets with an option on Thomas Kinkade's work. He contracted for the SE Asia exclusive rights to market Kinkade. I was not on board with that. Among art whores, Kinkade was slut status. I found his work cloying and saccharin.

In addition to having an elegant gallery at the Ritz Carlton in Central, Hong Kong, Vincent hosted a lavish event/fundraiser for a children's charity. We brought in the bas relief sculptor Bill Mack to participate. Bill holds the world's record for giving away red roses and always wore one on his lapel. Every lady at every show would be given one. In my mind Mack was passé by then, but VL loved the work.

Before the event, we went out to dinner with Yankel Ginzburg and Bill Mack, along with Vincent's lovely wife, Carrie. During dinner, there was light banter about who was the best artist. Vincent challenged them both, at the table, to draw a portrait of his wife. Pencils and paper were provided, and I thought that the results were equally dreadful.

That was the first and only time that I saw two artists challenged to a doodle.

An odd twist to a charity auction illustrates how different things can be in HK and the US. Vincent Lee hosted a lavish fundraising event for a children's hospital with an auction to raise money for their charity. He commissioned Yankel Ginzburg

and Bill Mack to collaborate on a mixed media sculpture as the pièce de résistance, the grand finale, to the auction.

It was a strange hybrid that combined Ginzburg's colorfully abstract Lucite sculpture, with moving parts, and Mack's white bas-relief bonded sand sculpture of a women's face. The two artists' work was so different that putting them together seemed to me to create an artistic Frankenstein. The materials and aesthetics did not harmonize. It was more clash than collaboration.

In addition to that commissioned sculpture, we auctioned various works from both artists. But there was an Asian twist that made the auction unique and incentivized people to participate. It was Vincent's idea to share the difference between the winning bid and the next highest bid with the person who had not bid enough to win. I am not sure if this would be legal in the US. It did get more people to participate. It was a winning idea. The notion of going to an elegant catered art event with some of the most affluent people in HK and making money at the same time was appealing to a lot of attendees. Vincent knew what motivates Hongkongers.

The Ginzburg/Mack collaboration sold for close to $30K. Later, I delivered the art to the winner and was impressed with their lavish house. There must have been twenty maids and a garage full of the most exotic cars with attendants caring for them. A spectacular view overlooking the South China Sea and furniture that included a couch designed after a famous Dali. It was modeled on the large Mae West red lips sofa that Dali designed. The furnishings were exotic, colorful, and over the top.

Before I left I provided detailed cleaning instructions for the sculpture. But two months later I received a call from the lady of the house upset because Bill Mack's part of the sculpture fell off while the maid was cleaning it. I called Ginzburg and asked what he wanted me to do. I was prepared to ship it to his studio. He suggested that I fix it in the gallery and gave me instructions on a special solution that required a powerful glue with a catalyst. It sounded like a viable solution.

I picked up the sculpture and took it back to the gallery. I followed Yankel's instructions. A few days later I took off the binding, anticipating a fix. But it didn't work. The piece fell off again. I called Ginzburg and asked for his advice. He apologized and gave me new instructions. A different material. This time it worked. I delivered the repaired sculpture.

Fortunately, this rigamarole helped children in need. I thought that the sculpture made both artists' work look bad, but it was done for a good cause. The client bid that high because she wanted to stand out in the illustrious crowd while contributing to a good cause.

Fortunately, the oddness of the art fit her offbeat decor.

Eventually, VL proposed that I move my family to Hong Kong and work with him to open galleries throughout Southeast Asia. He had an ambitious, bordering on grandiose, plan to open in seven different countries. He had the resources and connections to make it work.

I was torn. The offer was exciting and I really enjoyed working with Vincent, but my wife was not crazy about living in HK, so I knew that if I accepted the offer, I would not be able to spend time with my wife and kids. It would require traveling and

working all of the time. And selling our place was problematic because the real estate market in Hawaii had tanked. We were upside down and not in a position to sell at a loss.

This was about three years before HK was handed back to China. I asked Vincent what he thought would change, and he said that it would just require more under the table payments.

With mixed emotions, I turned down the offer and headed home. I will never forget Vincent's kindness and generosity, and his upbeat spirit. I wish more people loved art the way that he does.

The last time I saw him was when his daughter and my son were graduating from USC. He invited the family to dinner, and when I asked him what was new, he showed photos of his new 70,000-square-foot home in China.

I think of him more now that China is cracking down in Hong Kong. He is smack dab in the middle of that socio/political bramble and no doubt torn by current events.

I hesitate to contact him because I once sent a jpeg of a painting that I did of Mao Tse-tung to a friend in Beijing. It was titled Miky Mao Klub and was a silkscreen and painting of Mao with big black Micky Mouse ears, but Micky's logo on the hat was more Mao than Micky. My Canadian friend was living in Beijing married to a Chinese woman. He asked me to never to send anything like that again. His reaction made me realize the political ramifications in China.

SWINGING FOR THE FENCES

No one has ever accused me of being the Babe Ruth of art consultants.

While I was writing this, I was reminded of how many swings I took at success and how many foul balls and misses there were. The business can be hard ball, not whiffle ball. If I were a major leaguer, I would probably have been sent down to the minors a few times. But I always believed in what I was doing and my ability to get it done, and I never gave up. I felt like a home-run hitter and reached for the fences, but that grand-slam home run was elusive.

I enjoyed working with people exploring art. Whenever I was training someone new to the gallery, I explained that this is a marathon with sprints. At one point, one of my colleagues dubbed me "Maier-athon man."

It takes endurance to do it day after day. I don't know how many turnarounds (working a night shift and then turning around to work the morning shift) I did, but thousands is probably an underestimate. One year, when we opened a gallery, I worked from bell to bell every day. You have to love it to do that.

Otherwise, it's crazy (I can hear the peanut gallery in my mind snickering in agreement at that).

A gallery floor is a stage. With the chance to write the script and direct the action. The art is the star of the show. On a good day, it can be fun. Retail theatre.

Art is one of the reasons for living, not just a way to make a living.

While art traditionally consists of tangible objects, at their best, those objects are infused with and have an esoteric dimension. It is the closest that material comes to transcending its materiality into an ethereal realm. Art is generational, a visual bridge that connects us.

Despite critics, I have nurtured an egalitarian attitude about the often-snobbish to standoffish art market. The joy and satisfaction that hard-working people get from what they can afford to own makes me happy. That exuberant delight can throw shade on the smugly cool reaction that a wealthy collector might feel when acquiring something impossibly expensive.

When art becomes so expensive that bankers get involved, it's no fun. But for some big shots, that's the point. Those who have it made in spades often want to let it be known to everyone. Showing off is part of the thrill. Maybe most of it.

At the upper echelons of collecting art, while puffing on a fat hand-rolled Cuban cigar, sipping 1937 Glenfiddich Rare Collection Single Malt Scotch with impossibly rich friends, it feels good to boast about your recent Rothko acquisition from Sotheby's. It provides cultural cachet, clearly shouting: "I am fucking rich!"

INSURANCE AGENTS LOVE ART

Art makes things better. For insurance agents in an office all day, it's visual candy.

Hurricane insurance is bigger business than I thought. Especially in Hawaii. A local insurance company that specialized in hurricane insurance gave carte blanche to their various employees to select whatever art they wanted for their individual offices. It was a challenge that I worked to meet.

It took finding the dynamics that worked for each one of seven different agents while maintaining a flow and coherence between offices. It was a budgeted corporate purchase, but everyone had their say.

Art can make everyone feel more successful and cheer up the room. And clients feel more at ease with art that softens an austere fluorescent office—takes their minds off the inevitable monthly premium. Subliminally, the art reflects the company's good taste and values without them having to toot horns or say anything. Art works for everyone.

I had not anticipated being asked to hang the art, but when they asked me to do that, I, against my better judgment, agreed.

It was troublesome. But customer service and satisfaction have always been important.

Everyone had an opinion about how to hang the art in their office. And just getting to the office in a high-rise with tight parking, multiple elevators, and secure rooms was—a pain in the ass. As the expert, you sometimes have to teach them what works best.

Knowing that they were happy made it all worthwhile. My son gave me a helping hand; his good humor and hefting talent helped a lot. And two years later they purchased more art.

The art truly transformed that sterile insurance office environment. It felt like a visual vacation. They now looked like the successful company that they had become. They were blown away.

Intangible rewards last longer than commissions.

THE ARTFUL DRAFT DODGER

We all know about PTSD. You probably have never heard of PTDDSD.

As an 18-year-old college student in 1965, I was in the Air Force ROTC program and stayed for two years. At the time, Arizona State University required this regimen for graduation. Once I had completed the ROTC training and was drafted, I could have gone into the Air Force as a first lieutenant. But that didn't happen.

I had two older brothers, one in the Coast Guard and another in the Navy. My brother in the Navy went to Vietnam. I also had friends fighting in Vietnam, and the more I learned, the more I was against the war. As long as I stayed in school, I would not get drafted, but I wanted to take a year off from school to figure out what I really wanted to do.

Once I dropped out of the university, it didn't take long for my number to come up in the draft. By then, I was staunchly against the war and decided that I wouldn't go. Hell no.

I fasted for two weeks before my draft date and thought about how I would deal with this situation. While reading a

book on American Indians, I came up with the idea of being a Contrary.

Among the Great Plains tribes, a small group intentionally acted opposite from the way other tribal members behaved. They would do things like sitting backward on their horses. Literally, they did things contrarily. That was my plan.

My morning of reckoning came before sunup on a cold day. I was feeling weak from the two-week fast and was nervous, not knowing what would happen. I could be in jail by the end of the day. My friend Terry drove me to the draft board in his old truck, and as I was getting out, he handed me a small ball of hashish and said, "Eat this." I did. What a crazy way to break a two-week fast.

While standing in a long line outside waiting to get in, I was shaking, both from the cold and from nerves, but I was determined not to be part of a war that I felt was inhumane and counterproductive. When the order came to enter the building, with instructions to go to the front and sit in the chairs and wait for further instructions, I went to the back of the room and sat on the floor facing the opposite direction with my legs crossed Indian-style.

A uniformed man came and asked what I was doing. I just looked at him. He took me to an empty room with a few chairs and told me to wait there. It seemed like a long time before someone came in and asked me to take a test. I deliberately spelled my name wrong, put down "the desert" for my address, and answered every question wrong. Except for one; that was an error.

The next thing that I remember was being with three uniformed men asking me questions. One guy got frustrated with me, pounded his fist on the table, and said, "Are you playing a game?" By this point, my nerves had calmed down, and I said in a soft, monotone voice: "You're playing a game, and I am playing a game, but we're not playing the same game." They were pissed. After that there were other tests—eyes, ears, etc. A long day.

Finally, at the end of what felt like a gauntlet of tests and interviews, with lots of waiting in between, I was asked to see a psychologist. He told me that they wanted me to see a psychiatrist. He also said that under no circumstances would I be taken into the United States of America's armed services. He told me that my eyesight was too bad. I went through all of that and was given a medical deferment for my eyes. And I was on a shit list.

For the first time in my life, I felt like an outlaw.

PTSD is no joke, but PTDDSD is: Post Traumatic Draft Dodger Stress Disorder.

PTDDSD is not covered by insurance.

CHAPTER 78

MINTING ERTÉ

For some dealers, publishing art is like printing money.

The late Art Deco-ish designer Erté was trendy at one point in the art business. The publisher Ron Parker was an astute art gallery CEO at the time with Circle Fine Art and Dyansen Galleries. He was the brains behind the bronzes.

Erté's sculpture seemed almost ubiquitous in galleries in the 1980s and '90s, mostly because Parker had figured out the market's mentality.

I remember having a conversation with Ron one night at a bar. He was a thin, wiry guy with glasses and darting eyes. Like he was always scheming. He regaled me with the story of meeting the artist Erté on an island off Majorca. They were on the beach, and Ron approached the artist and wooed him with his sophistication and wit—and the opportunity to make money. Lots of it. That's the abbreviated CliffNotes version of our talk. The crux of the story was that Ron was singularly responsible for Erté becoming a popular artistic phenomenon.

The market for Erté's sculpture eventually petered out after that brisk market run. It was a lesson in great marketing and

execution. Fun while it lasted. The effort generated a small fortune.

Erté made his name in fashion, jewelry, graphic arts, and costume design. His style is best described as Art Deco: bold designs; vibrant kitsch colors; sleek, with sunbursts and decorative flourishes. The Erté Sculpture Collection was Ron's most successful brainchild, but not his last.

Essentially Parker told me that Erté would walk into a room full of the newly-minted bronze sculptures that he literally was seeing for the first time, and bless the collection with his cane.

Take the money and hobble.

The entire enterprise was conceived and executed in the name of the artist. They would take his old design sketches and translate them into elegant signed and numbered limited editions sculptures. Erté endorsed the effort.

Erté, at that time an old, mostly forgotten artist, enjoyed the attention and success. He really had little to do with the production, promotion, or sale of the work.

A signature collection. Contracts were signed, bronzes were stamped. Art alchemy. They turned bronze into gold.

Ron had a successful career in art to go with his impressive academic accomplishments. PhDs to go with BS degrees. I wish that I had taken notes at our casual meetings to capture the convoluted psychological phenomenon that he embodied and some of the dark humor that went with it. One of his projects, and he made a business card for it, was "The Art Thief." A convoluted art business plan that made buyers feel like they were getting a steal.

He epitomized the retail spirit of that time.

That bronze collection reflected the mendacity, raw calculation and manipulativeness that fueled more than a few art business success stories from that era.

A DEBACLE IN OZ

Opening galleries in foreign countries such as Australia can boomerang.

"Wild" Bill Wyland, the whale artist Wyland's stout brother, and at the time his business partner, ran the Wyland galleries in Hawaii. Bill's forte was signing leases. He had a reputation as a good negotiator and seemed to relish running roughshod over the staff.

During one of the business's downturns, when I came back from San Francisco, Bill asked if I would be interested in being the gallery director for one of his locations on Oahu. In my mind, it was a step backwards career-wise, but I had to find work without delay, and that was the only viable option.

The gallery was huge. The rent was $60,000 a month, and there were about twenty art consultants. So the pressure was always on. Bill called several times a day to check our sales numbers, and if there was any hesitation about answering precisely, he would flip out and yell. I loathed getting those calls.

The fact that the gallery was the biggest in the state in those days allowed us to show many different artists, but Wyland's work took center stage and the lion's share of the space.

For years Wyland had represented seascape artist Roy Tabora, but they had a falling out. Roy wasn't in the stable of artists anymore. One afternoon a young family visited the gallery and asked if we carried Tabora's work. They had just built a new house and had an idea of the seascape that they wanted.

I suggested that they look at Walfrido's work. It was in the same genre, luminous Hawaiian seascapes, and a little less expensive. They liked it.

By the end of our meeting, they had put a deposit down on one of the paintings, and we made arrangements for them to wire the balance when they got back home to Australia.

During our conversation, I learned that our new Australian friend was responsible for all of the Sears locations in OZ. Before he left, I explained that Wyland was interested in opening galleries in Australia and was looking for partners to do that. I asked if he might be interested. He was.

I called Bill and explained the situation to him, and he was ecstatic. He wanted to take over immediately. He insisted that he do all of the negotiations. I suggested that that was not the best idea because I had spent hours building rapport with them. But he was the boss, built like the HS wrestler that he was, and he had that take-them-down mentality, so I stepped aside.

It was not really a choice.

One of the first things that Bill did in negotiating with our client was to roll the painting price into the deal. I told Bill that I would have considered that purchase a demonstration of our potential partner's good faith in moving forward with the franchise opportunity in OZ. A separate deal. Glue.

My commission for making that sale was part of what Bill gave away. He assumed that the pot of gold at the end of the rainbow was worth far more than that sale.

Working with the Wyland's was becoming onerous. I decided to move on. When I called to give my month's notice, Bill said that because I had gotten the ball rolling with the Australia deal, he would follow through with the commission. Anyone working for the gallery that put a franchise deal together would get a commission. I felt a lot better about leaving and left on positive terms. I had worked hard for those guys. We all benefitted.

About a year later, I got my Art World News in the mail. A big, I thought too big, glossy magazine that I subscribed to. The headlines were about the Wyland deal. They said that five Wyland galleries were being planned for Australia.

Former associates told me that Bill was frequently traveling to OZ for negotiations. I was also told that when the lady in charge asked about my involvement and compensation, Bill had answered, "Fuck him."

The obscene version of "I will pay you."

Karma can be a bitch. Bill's deal fell apart. Not only did Bill blow the big deal, he blew the original sale.

I am not on a Burning Bridges tour, or tossing boomerangs; I want to maintain good, or at least civil, relations with people in the business. I still see Bill and Wyland from time to time and value the good work that we did together decades ago.

Still, I view that period as the nadir of my art career.

The fact that the Wyland's have sued one another and are not on speaking terms says a lot about the pitfalls of success and doing business with family. The dark side of success.

On the other hand, to be associated with whales was a great career move for Wyland. He was one of the best promoters of his generation.

If he were a nice guy, maybe he would have finished last.

CHAPTER
80

PLEASE DON'T JUDGE THIS BOOK
BY THE COVER

We have all used or heard the dog eared expression "don't judge a book by its cover." It's true, but feel free to judge this book by the cover if you like the cover.

Rejected book cover

A shabby example of the veracity of that old expression: an ordinary, unassuming older guy visited our Maui gallery wearing tennis shoes with holes in them, a t-shirt that looked like it had been washed too many times but needed another wash, and hair that cried out for a brush.

Not wanting to judge him by his cover, I just started talking with him despite, in the back of my mind, wishing for a customer more qualified to buy. He was sailing around the islands and had stopped for the afternoon in Lahaina.

It didn't take long to ascertain that his tastes and his art collection were museum-quality. He was polite about ours.

By the time I finished conversing with Mr. Rockefeller, my commitment to the concept of book covers and judgement had become stauncher the ever. He was on a yacht passing through the islands. If we had had higher-octane art, we might have been able to sell him something. He seemed like a nice guy with a disheveled cover.

When an older homeless woman visited the gallery semi-regularly, I always treated her with respect. She had made the hair on my neck stand up a few times with her extemporaneous banter about aliens on Haleakala and the munitions buried up there. Delusional or dialed in to a different frequency, she was a good person. Despite the crazy talk, she was intelligent and only slightly eccentric. On this visit, she asked about a bronze sculpture that we had on display. After explaining all that I knew about the art, she said, "I'll take it." She pulled out a checkbook from her pants pocket, and wrote me a check.

Without missing a beat, she started to pick up the 32" bronze sculpture. I gently stopped her and explained that our policy

required the check to be cleared before the art was delivered. She wanted it now, so with her permission, I called the bank and put her on. She was cursing the bank and that procedure the whole time.

I was pleasantly surprised when the check cleared. Actually I was blown away. My assumptions had precluded that eventuality. I had judged, but incorrectly. I had been indulging myself.

Even though I offered to deliver, she carried the art out. It felt like a message. I use it as a lesson.

CHAPTER

81

BUILDING A FAUX WESTERN TOWN

B uilding a miniature Western town in a mini-mall was my first big art project.

In the Old West false fronts added a grandiose quality to the rapidly-built saloons, hotels, and banks. We riffed on that for this project.

My friend Mike Smith was a talented artist and intrepid worker. We were both living with single parents. His mother was stringent, and Mike helped her by working and making money. My father was much more generous, and while I didn't have to work, I did.

When Mike was commissioned to build a faux Western town inside a shopping complex in Scottsdale, Arizona, he asked if I was interested in working with him.

It took weeks, but I was impressed by my friend's ability to visualize and construct this project almost extemporaneously. We built faux fronts for a saloon, a bank, a hotel and we created the feeling of walking down a funky Western street. We did all of the carpentry, painted the signs. I was knocked out by how good it looked when we finished. I just followed instructions; Mike was the mastermind. A dynamo, really.

Later he was asked to paint a big mural on an auto parts store in Phoenix, and we worked together on that. He came up with a clever design that looked like abstract auto parts in a color scheme that looked pretty cool from the street.

It was fun working with Mike and being a part of transforming space into art. He was naturally creative. Inspiring.

CHAPTER 82

THE PUBESCENT ART CRITIC

Joe Gatti, my HS art teacher, did not inspire me to pursue art as a career. In fact, I remember him making fun of one of my drawings and my not loving his class, but it was a lot less stressful than biology.

He was a good and revered teacher and got everyone involved in a huge mosaic mural regarded as an important part of Scottsdale's Coronado High School over a half-century later. I imagine that he would get a kick out of the fact that one of his mediocre, C grade, wiseass high school students pursued a long career in art.

One of the few memories I have from those pubescent days in his class was his painting White on White, which also describes the composition, color scheme, and overall impression of the work. I probably should have paid more attention to the whites' subtle tones and realized his art's profundity, but I didn't. I thought that it was lame. Not sure if that would be my assessment now, but as a high schooler, it was.

CHAPTER 83

A SNAPSHOT OF PHOTOGRAPHER
PETER LIK

❝ I'm the world's most famous photographer, most sought after photographer, most awarded photographer." Peter Lik, as quoted in *The NY Times,* Feb. 21, 2015.

Don't be modest.

If you haven't heard the proverbial phrase "hoisted with his own petard," it goes back to Shakespeare's Hamlet and means you fucked up on your own. More literally got blown up by your own bomb, kinda like a terrorist who accidentally self-destructs. Well, Lik's petard was hoisted and blown by his own record-breaking photograph and by Pulitzer prize-winning writer David Segal's withering takedown in The NY Times.

This was a case of Lik's best day becoming his worst nightmare. A $6.5-million sale ended up costing him many tens of millions of dollars over the ensuing years and earned him the sharpest criticism among the chorus of criticisms regularly aimed at him. It was an ironic reversal and, in the minds of many detractors, poetic justice. The article came out in the Sunday edition of the newspaper and covered the business section's entire front page. It blew a hole in Lik's business that

he was not able or willing to repair. Rope-a-dope worked for Ali but not for Lik.

Lik's success was in his timing and his skill in opening cool-looking galleries to showcase his work. Roughhewn sophistication. He created spaces that seemed to bring the outdoors inside to display his work in various sizes and frame styles.

Enough choices, but not too many.

Lik's marketing was impressive: Good locations, well-compensated and motivated art consultants and a fresh Aussie sensibility. His interior gallery designs clicked. His timing was perfect.

When he started, he brought a fresh sensibility to the market when many people were thirsting for pristine images of Nature and big art at affordable prices. His presentation nailed it.

Lik had panache. Kind of like Crocodile Dundee meets Steve Irwin with a Linholf camera. Aussie chutzpah.

And atmosphere: Gallery interiors with stone, wood, and other natural elements coupled with large-scale, highly-resolved limited edition photographs hit it off with the public at a time when collecting art was becoming more pervasive. It was Pete's own field of dreams.

His marketing consisted of good, if not great, locations, a motivated sales staff, and a scalable product with generous profit margins. It was new enough, and no one else was doing it to that degree.

Lik was arguably more skilled at promoting, than taking, his photographs. And he is a good photographer.

I didn't think so at the time, but looking back, Lik became almost cult-like with his staff and some of his loyal collectors. He called the staff "legends." Lik legends.

Dreams gradually morphed into delusions. Marketing eventually overshadowed the art.

The company did nothing to refute the negative message that permeated the Times article. Nothing. Mum was the word. So, I wrote the following response in defense of the artist because this was an attack on my integrity as one of his representatives. I felt that my reputation was impugned by my association with Lik. And he wasn't lifting a glove, or a finger, in defense.

I had already suffered the humiliation of Center Art Galleries Dali fiasco. This was not where I wanted to be nearing the end of a career. Guilty by association.

Because so many people had bought Lik's work in good faith, this was a game-changer that needed a vigorous defense. I was told by the corporate toadies running the company, that I would be fired if I published the letter.

Lik texted that he liked and appreciated what I wrote. His lawyers thought it best to do nothing and probably charged a hefty fee for that minimalist advice.

I felt insulted, baffled, and bummed.

Lik's $6.5-million sales of Phantom, a black and white photo of his previous best-selling color photo Ghost, led to the NY Times article. I estimate that that $6.5-million dollar sale cost Lik many, many, many tens of millions of dollars over the years. Incalculable damage, really. He sold the photo at a loss measured by the negative media backlash.

People visiting the gallery, would fall in love with Lik's work, but before buying, do what they considered "due diligence" online. The first thing that popped up on a Goggle search was that acerbic NY Times hit piece. The potential sale would be jeopardized, along with my credibility and reputation.

As Desi would say to Lucy, there was plenty "'splaining" to do once customers read that article in the newspaper of record. I was mopping up like a janitor after a gooey spill.

The news wasn't fake, but it wasn't balanced.

This is the letter I wanted to send to The NY Times but was told that I would be fired if I did:

"When a writer starts with the line, 'Peter Lik is in awe of himself,' you know that he is ready to write a hit piece. David Segal's bias is not disguised a bit. That first paragraph ends with a description of Lik's Australian accent as 'chummy.' His obvious disdain seems to color everything that he writes.

"To be fair: critics get paid to tear down and belittle—not to be nice. Nice critics retire early—it is a career liability. The best targets for criticism are big. Lik just broke the mark for the most valuable photo without consulting with the art experts, an unforgivable art sin. He received a Lifetime Achievement Award from his peers—not the literati, so he is a prime target. It is the duty of the writer to knock Pete off his perch.

"While the stiffest criticism goes with the territory, we expect an article in The NY Times to be somewhat objective, not vicious character assassination.

"Segal goes on to compare Peter Lik's record-breaking $6.5-million sale of Phantom to [Andreas] Gursky's and [Cindy] Sherman's multi-million-dollar sales with the comment: 'But

Mr. Gursky and Ms. Sherman are titans...Who is Peter Lik?'
The fact that the open market that Lik has been working and
developing for decades (which obviously does not impress the
writer of the business section) takes a back seat to the art elite,
the pooh-bahs and high priests and tastemakers, is indicative
of the elitist mentality of people who look down on collectors
who buy what they love without the imprimatur of an 'expert.'
If it does not bear the stamp of their official approval, it cannot
be worthy.

"The artworld is multi-tiered. To rely on auction results as
somehow THE barometer of the market is dubious. Gallerists
who do not rely on auctions are a force no less viable. They may
represent a much broader spectrum of taste and sensibilities
than the auctions, especially when the auctions are sometimes
set up by dealers and collectors with vested interests. If tens
of thousands of people, with free will, acquire Lik's work, that
has to count for something, even if he has not been ordained
by the high priests of culture and The NY Times. If two or three
collectors vie at auction for a work of art and the price skyrockets,
does that make it a more viable market than a thousand people
buying a limited edition Lik?

"Modern art is more about critical theories than the simple
visual satisfaction of enjoying beauty for beauty's sake. The
contemporary art world is still dominated and controlled by an
insular circle of wealthy collectors, museums, and critics with
remarkable influence. If you go outside of this elite circle, you
risk ridicule and write-ups in The NY Times.

"The same people belittling and disparaging Lik's
accomplishments are the same ones who celebrate and laud
the diamond-studded skull that sold for $100 million and a

shark floating in formaldehyde that sold for $112 million—the art market is broad and varied, and ultimately subjective.

"The fact that Peter Lik has broken with tradition and the standard way of marketing art obviously offends the writer. He decries the fact that Lik has credit card machines in his galleries and calls the device a 'swipe machine.' People prefer using credit cards and enjoy the protections that the cards provide. Segal goes on to point out that checks are preferred in the context of fine art. Lik prefers checks but does not expect or demand them because he is not an elitist poseur.

"As if these jabs were not enough, the writer reloads and attacks the fact that Lik buys and sells homes and had a failed marriage (who hasn't?). He then writes that Lik never studied any other photographer and never took an art class. He makes it seem that Lik puts down Ansel Adams, which is absurd. Of course, if you are a photographer, you look at photographs of all of the greats, and you study composition and all of the elements of style that help shape your vision. This is a preposterous statement meant to impugn the motives and the reputation of a successful artist. He takes things out of context to bolster his bias with innuendo.

"A writer more concerned with the truth and interested in capturing his subject's nuances would have ascertained and reported that Lik has a sense of humor.

When Segal quotes Lik as saying: 'I'm in Caesars. I'm God. Nailed it,' he makes him sound insane, not ironic, or joking. We all know that you can take facts and twist them to suit your purpose. One hopes that a writer would be less inclined to twist all of the facts to his mission of painting a distorted caricature.

"It is a long article, and the writer outlines the established art market and tries to impugn the way that Lik markets his work. He criticizes the fact that Lik's gallery consultants 'will happily discuss the color of your sofa to find a matching frame, an unimaginable topic in other galleries.' He bemoans that the galleries create a welcoming atmosphere and suggest that a real gallery would have white walls and would never speak to a visitor unless spoken to.

"There is a viciousness—a snarkiness, permeating this article that belies an animus deeper than reportorial standards demand. Word grenades thrown with mal intent—a premeditated attack with an agenda. The way the article is crafted makes it seem like the writer is in Peter Lik's head. That he knows him well. But he gives himself away by the one-sided narrative that could have just as easily been a puff piece about a successful fine art photographer.

"It is a matter, as for a photograph, of composition and perspective."

The fact that Lik has done nothing to refute the article, then and even now, is disappointing and still bothers me. If you tried to choose two titles from his oeuvre that shimmer with irony, it would be hard to beat his best sellers, Phantom and Ghost. They even sound like market metaphors.

The NY Times exposé will haunt Lik's market as long as google searches exist. It's embedded: a cyber archeologist might stumble over it long after we stop talking about it.

It also pains me to think that if Lik had focused longer on his career and the business instead of living the life of a rock star and just digging deeper into his old shots, he would have been

able to deliver on his early promises to collectors. Resting on your laurels is not a good career move for a creative. I felt like he ran out of creative gas.

Because he marketed his collection with the expectation that the price goes up as the edition sells out, I think he was obliged to do his best to actually sell out the limited editions. The lack of critical decision-making at the top, especially his picks for CEOs over the last decade stunted his enterprise—an object lesson for aspiring art entrepreneurs.

Success can be one of the worst things that can happen to an artist. The temptation to parody your own work, to repeat and repeat like a chirping birds in a cage, the images that sold, mutilates the creative spirit. I think that it did with Lik.

Selling leftovers as masterworks is a flawed strategy.

After decades the challenges and adventures of a young aspiring photographer can become tiresome. Innovation takes vision and work. Fresh becomes clichéd. The market obscures the vision. Business is challenging. The temptation to enjoy the fruits of your long labor are understandable. Staying relevant and commercially viable while cruising is not a given.

Once you whore out as an artist, dating again is hard.

ON THE EDGE

TV magnifies fame. One of the highlights of working with Lik was the buzz created by his television show on The Weather Channel, From the Edge With Peter Lik. It boosted sales and staff morale.

The medium of TV is powerful and has a long pervasive reach. People would visit the gallery and say, "I know this artist." When asked which of the Lik galleries they had visited, they would respond that this was their first time in a gallery; they had seen the art on TV. It enhances the reality of fame, and validates it.

Before the show aired, before it even had a name, Lik offered a tantalizing prize to anyone in the company who came up with a title for the show.

I submitted On the Edge With Peter Lik. When the show aired with the title From the Edge With Peter Lik, I thought that I might have a claim to the prize. But I had the wrong preposition. "On" nullified my request. Darn, that bleeping pronoun. No one received the prize.

I licked my wounds. "From" was a better choice for the show, but I always felt somehow on edge working with Lik.

CHAPTER 85

THIRD TIME'S AN ALARM, NOT A CHARM

Meeting people from around the world made living on an island thousands of miles away from a continent more continental. And interesting.

I love the art business in many ways, but knowing that everything can change for the better on any given day is near the top of the list.

This meeting started awkwardly. When a good-looking Japanese man visited the gallery. I greeted him in Japanese, and he answered in English, telling me that my Japanese was good. I told him that his English was better, and that my Nihongo/ Japanese was sukoshi dake (limited).

We had a very fluent Korean-American working in the gallery, a consultant who spoke perfect Japanese, and I suggested that he work with this gentleman. It was gallery protocol at that time, but I would have preferred to continue working with the only visitor to the gallery on that slow morning.

After just a few minutes with our Japanese visitor, the consultant slouched to the back of the gallery and folded his arms. Pursed his lips. I said that the prospect looked interested,

and he just shook his head and said, "He's an asshole." So I took over.

By this time, the gentleman was out the door but still looking through the window. I went out and invited him back in. We had couches and a table in the front of the gallery, and I had him sit while I lugged what we called The Big Book, a 95-pound leather-bound book that Lik had recently published, over to the seating area.

For the next fifteen minutes, we went through that book. He was sitting, but I was kneeling on the floor, turning the pages and not saying much. Sometimes less is more. My knees were sore on the wood floor, but I knew that he was interested in the collection. I probably looked like a guy proposing marriage down on one knee.

At one point, he looked at his watch and said that he had to go. He had an appointment for a massage. I suggested that he get the book, which sold for $1,950, and set up an appointment to meet again. He agreed.

The next day he showed up at the appointed time, which doesn't always happen in these situations. We spent hours looking at the collection. I rolled out image after image, trying to see what worked best. Part of his last name translates as "red" in English, and he was focusing on works that were as red as ripe tomatoes. He had excellent taste and kept selecting the most sold out, appreciated, limited editions. We set up another appointment to meet again. He needed to digest all that he had seen.

During the next meeting, he acquired a stellar collection. Lik's greatest hits. It was the largest sale in that gallery up to that

point. He used a credit card to put down a deposit but asked to come back with a check to pay the full six-figure total.

The next night I was eagerly looking forward to seeing him. It was getting late, and closing time came around, but he didn't. I decided not to leave, believing that he would bring the check as promised. I called his room at the Trump International Hotel & Tower Waikiki, where he owned a unit, and his girlfriend said he was in the bar. The hotel was a block away, so I walked over. He was not in the bar. I returned to the gallery and waited.

Finally, near midnight, I saw his smiling face pressed against our glass door and let him in—what a relief.

Before he paid, he said that he had a list of requests. One was to have Lik speak at the design school that bore his name. I told him that that was not likely to happen, but I would ask. Another request was to have him open a Lik gallery in Japan. I explained that Lik doesn't have any partners, but I thought that it was a good idea and a partner would be necessary for a Lik gallery in Japan. I promised him that I would do my best to insure that he would be at the top of the list if that were to happen.

A year passed. The first time we came close to a franchise-like agreement, he put down a deposit on an $800K sale to show good faith. Lik's lawyers drew up an agreement that our client said was one of the worst written and most slanted contracts that he had ever seen. He was a very successful businessman and knew what he was talking about. After almost nine months of back and forth, that deal fell through, and his substantial deposit was returned.

The second time, after Lik fired the guys who were running his company, I was sure that we would be able to make this happen.

We did get close, but again, after getting everyone's hopes up, Lik changed his mind at the last minute.

The third, and last time, was the most promising. Lik's company had a new CEO, a Japanese-American man, and he saw the value of opening in Japan and asked me to reach out to our client one more time. I told him that I was embarrassed to have stood up our client two times and that I needed assurance that we would be able to follow through if we were to proceed. He told me that Lik was on board and assured me that this time was different. I believed him.

Fortunately, our client was still interested and agreed to meet with us. Arrangements were made to fly to the Big Island and spend a few nights at his vacation home. It was a great experience, and he could not have been nicer or more gracious. What a thoughtful host and a truly outstanding person.

By the end of our visit, we had agreed to open multiple galleries in Japan. Finally, I thought, just as the I Ching—the ancient Chinese book of changes—understood: persistence furthers. This was finally happening after almost nine years of trying.

The client had his secretary spend months looking for a suitable location to open the first gallery. During this time, Lik took a long-planned trip to Japan to take photographs. We texted back and forth while he was there, and he said that he loved the country and the people. I tried to get him together with our client, but the client was traveling, and Lik was shooting, so it was not possible, even though he was there for over a month.

It annoyed and amused me that Lik addressed me as "Squire" in his texts. He must have fancied himself as a Knight, the camera his lance.

Then, on a whim, Lik changed his mind again. He said that he was planning to open Pop-Up galleries. That, I thought, was a terrible idea. It was a monumental betrayal.

The utter disregard for the good faith of our client left me appalled. Flabbergasted.

Shell-shocked and disgusted, I didn't know how to convey this news, yet again, to our dear client. I felt like a Peanuts cartoon with Lucy pulling the football away, except this wasn't the comics. This was a professional malpractice. But Pete, like Johnny Crack Corn, didn't care.

I knew that there would be no fourth time. I was bummed and embarrassed, and ashamed of Lik. I did my best to explain the situation in the most genteel way possible to our client. I had come to personally like and admire him. It broke my heart to be the bearer of this regrettable news. Instead of ending my time with Lik on what I had hoped would be a positive note, it wasn't.

The brevity of our client's response spoke volumes. He e-mailed just one word, "Understood." That was it. I have not heard from him since.

The fact that Lik did not personally contact the client to apologize does not surprise me, but it does piss me off. The CEO was fired a long time ago, and the discordant musical chairs continue to move in the Lik corporate headquarters.

Reflecting on this now, it is fortuitous for the client that the deal was aborted. In light of the global pandemic and all that has happened with Peter Lik, the client dodged a falling star. It worked out best for him, given the postponement of the Olympics and the broad economic fallout. Had we opened in

Japan, I might have had to include this story in the "Duck if You See me Open a Gallery" chapter of the book.

CHAPTER

86

A CEO LOOKING FOR CLUES

As the corporate culture stuttered and fumbled with CEOs being replaced like burnt tires on a speedway, the galleries kept changing gears. Policies and people shuffled in and out.

To provide some context, a coda, perhaps an object lesson and the backstory about opening Lik galleries in Japan and my time with Peter Lik USA...

After firing another CEO, Lik hired an outside consultant to help make his company more profitable. The guy that he hired had cut his teeth with the global management consulting firm Bain & Company, famous for firing a bunch of people as soon as they took charge of a company, but he was now working independently. He was recommended by one of Lik's former girlfriends. She had everyone's best interests at heart.

In a short time, he became the new CEO. Lik liked the cut of his jibber-jabber. Our first meeting was in one of the showrooms in the Waikiki gallery. I asked him about his art business experience, and he explained that he didn't need any; he understood business. He wasted little time getting down to the business at hand, namely making me an offer to leave, to retire.

I was dumbfounded. As the oldest employee in the company, not the most tenured, but born earlier than anyone else, I didn't expect to work forever. However, I was still doing well, and having fun, and had a couple of productive years left to save for retirement. I showed up to work everyday. Focused.

It not only blew my mind, but the entire staff had a WTF moment when they found out.

The offer was not ungenerous. I understood that his thinking was to eliminate enough of the more highly compensated people to fatten up the expense/profit report. He was doing it companywide. It wasn't ageist per se, but there were definite hints. I asked for a day to think it over.

The fact that this inexperienced guy was making these rash moves gave me zero confidence in the company. I knew that I would not enjoy working with him if I stayed. It was a clash from the start.

I accepted the offer. Took the money and didn't run. I sat down and went to work from home.

The touching, heartfelt, going away good-byes from the staff meant a lot to me and still do.

It wasn't retirement; I was not ready for that rocking chair fade out yet. I spent the next nine months painting and working on my Sonny Pops, Nu'u Hawaiian Pop project. A fertile and happy time. My wife was glad to have me home and not working until 11 p.m. at the gallery. But we would stay up until 2 a.m.

About ten months later, I got a call from the CEO with an offer to come back. It was a sweeter deal, hard to turn down, and included a tantalizing incentive: He wanted me to help open galleries in Japan.

I took my slippers off, put my work shoes back on, and got back to work in the gallery. I still wanted to save as much as possible toward voluntary retirement, and after months of working alone at home, I missed working with people.

What an odd twist to my career: to be asked to retire and then get rehired with a better offer within a year. This old geezer felt needed.

When Lik finally fired that CEO, he texted me that he had cost him MILLIONS (he put that in caps) of dollars in lost revenue and questionable expenses. In my mind, the damage to the Lik brand was extensive and lasting. I was no longer a fan.

SELLING OUT

S elling out is not a bargain. You pay in the end.

I worked far longer than I anticipated for the Lik Gallery. To summarize my feelings about working with Peter Lik: I really appreciate that I worked in a beautiful gallery with art that so many visitors spontaneously enjoyed, and it was fun and invigorating working with younger people. I appreciated meeting local visitors and people from all over the world in a refreshing space.

The fact that Lik was able to employ so many people was admirable. The gallery systems were efficient, and the customer service was generally good. He did many things well.

Because he was vertically integrated with his own studio/ production, he produced a top-notch product with timely delivery and follow-up. He is the prototype for building out a fleet of galleries and promoting and profiting from your art. People are still drawn to his aesthetic.

What bothers me is the pricing system and the large edition sizes. And Lik's cavalier proclivity to change his mind on a whim. His lack of loyalty.

Prices were on a tiered system roughly based on the concept of supply and demand. As the supply of a limited edition sold out, the prices went up like clockwork. Every 10% of an edition that sold sent the price up. The amount of the increases escalated as more of that the edition sold. Perception of scarcity and higher prices goosed sales.

The difference between the beginning prices and the last price was many tens of thousands of dollars. It sounds logical enough, but it turned inside out the traditional process of letting the open market set the prices. Lik did that programmatically. He controlled the primary market, but not the secondary market. The strategy really does not pass the test of time. It's unsustainable. The art business does not work like clockwork, and it does take a lot of time for prices to rise in the normal course of market events. And often prices fall.

The edition sizes were typically 950, with an additional 45 Artist Proofs, APs. Seasoned collectors bristled at that. With such a large supply, both the long and the short-term marketability are sacrificed.

APs, Artists Proofs, once coveted for their association with the artist because he would save them for the artisans and printmakers who helped with the creation of the limited edition, as well as select collectors, were now just a more expensive option, a way to expand the market and charge more.

Conflating protocols established for limited editions, protocols historically tied to etchings and hand-pulled Bavarian limestone lithography and other multiple art forms, with those for photographic images can create ethical dilemmas.

How do you provide a value proposition that justifies paying substantially more for almost the same image? Lik came up with some things to differentiate the two options to justify the higher prices. The Certificates of Authenticity were black, not white. The signature was inked with a gold pen. The number of prints in the edition shown on the front was 45 instead of 950. They were eventually printed at a higher definition, but most people couldn't tell just by looking. The big selling point was the exclusivity of the APs, but the total number of the majority of the editions was still 995.

Without the driving force of multiple galleries with lots of horns to toot high praises at Lik's photos, the market is sustainable only as long as he is operating on all cylinders. An art god needs followers. The old notion that once an artist dies the work is more valuable only applies to a few exceptional artists. Sheer commercial success probably isn't enough in an era where everyone is famous for fifteen minutes. If you are the sole promoter of your work and you stop promoting, that's the end. A camera needs a tripod, and an artist needs a platform.

Artists need dealers almost as much as dealers need artists—especially AD.

While the specter of price increases definitely provided an incentive to buy now, before the next price tier kicked up the price, I think it was predicated on a false assumption. It also insinuated that art was an investment. Something that the company was careful not to allow anyone to say outright. Everyone had to sign an agreement not to sell Lik's work as an investment, despite a pricing system that suggested that it was. The threat of "termination" was part of the signed document. This provided legal cover for the company in the event of a lawsuit.

Unless the artist sold out the editions and continued to maintain a top-tier status as a respected fine art photographer, there was nothing to sustain the prices. I had witnessed many artists soar in popularity only to become yesterday's news.

Much of the contemporary art business, on the retail level, piggybacks on the assumption that art is an asset class and appreciates. We hope that we get a seat on that well-appointed gravy train because we read stories about landmark art sales and prices going through the roof.

Greed may be a more compelling motivator to collect art than aesthetic appreciation.

Among the most important criteria that define an artist considered investment quality is that he or she is part of the art historical context. Having created something that adds to the evolution of a genre. Originality is one of the keys. Someone whose work bends the arc on the trajectory of art history counts more than the rest.

Also and importantly, an investment-worthy artist is one who did not flood the market with his or her work. Rarity and condition matter.

Lik may lay claim to being the most commercially-successful photographer of his generation, with a record-breaking $6.5-million sale along with staggering sales numbers over many years. He is the photographer who popularized the retail market more than anyone else. But his large edition sizes and prolific output do not bode well for collectors who hoped their purchase would appreciate in, and hold, value over time.

Many purist photographers, the ones who eschew post-production work, i.e., Photoshop, Lightroom, etc. to edit the

camera work, criticize Lik. Others, looking for originality and visual breakthroughs, talk stink because he is just an extension of a movement that is regarded, in critical art circles, as past.

The one timeless piece of advice for collectors that I always emphasize, is essential: Buy what you love. Emotional value is not bankable, but it is rewarding. Art appreciation is like gratitude in love.

Get something that excites you or makes you feel good. Art that you want to share with family and friends, and hopefully the next generation will enjoy it too. That is what collecting art is about once stripped of the profit motive.

That is a genuine art appreciation.

I loved the fact that anyone could visit and was welcomed to the gallery and generally left feeling more upbeat. We prided ourselves on providing a buoyant gallery experience. To lookers and buyers alike. Lik brought the outdoors indoors in a way that was pristine and bright. Up or down markets won't change that fact.

Nonetheless, caveat emptor.

CHAPTER 88

ICE CREAM OR LAHAINA GALLERIES?

Profit-sharing is caring.

One of the good guys in the art business is the owner and operator of Lahaina Galleries.

When Jim Killett moved to Maui in the early 1980s, he wanted to open a business. He wanted to buy an operating business. It came down to an ice cream store or an art gallery. He was not sure which would be best, but the relatively low rent on the space that eventually became his first art gallery swayed the decision. Lahaina Gallery was born, willy-nilly.

Jim was unique among art gallery owners. A former high school football coach from the south, he was a lanky plain-spoken individual who was well-liked by his staff. He drove a scooter to work. I was always impressed that he had one of the most loyal and tenured art gallery staffs in Hawaii. I later learned that people liked him for his down-to-earth nature, ethical business practices, and the fact that he had a profit-sharing agreement with the staff.

His success was steady and, at times, exponential. He was riding the island and worldwide art wave. But he was not

immune from the economy's vicissitudes and weathered some retail storms along the way.

Perhaps the most daunting aspect of the gallery business in Hawaii is the exorbitant rents. They are sky-high, and while Jim started with a five-year lease that in retrospect looks like he won the sweepstakes on Let's Make A Deal, he eventually was held hostage like the rest of us. He had to pay exorbitant rent that made staying in business problematic.

Nonetheless, he is still standing. Still running the galleries, albeit pared down versions. Jim remains a model of how a gallery owner can succeed and remain liked and respected. Kudos.

CHAPTER 89

MAUI'S MARINE MIRO

Originality is precious in art. Free spirits are few and far between. That's why Captain Kenny caught our attention. He was a creative free spirit—an original.

Only a loose coconut that fell on his noggin could make this happen. It sounds apocryphal, but it's true.

Among the life-long friends I made during the 1980s art bubble and one of those I most appreciate knowing was someone who has always made me laugh and think: Eddie Waznis, aka Waz.

Edward Montgomery Waznis carved a unique niche in the art business and is a great representative for artists of an original stripe.

He also took one of the most idiosyncratic, bordering on bizarre, characters from Maui under his wing. He showed his work in a gallery and published it.

I regarded Captain Kenny Neizman as Maui's marine Miro. He was also called the "Picasso of the Pacific" for his zany, subtly sophisticated, primitive artwork. He was an original, and Waz took pains to represent him in a way that gave him stature and an artistic afterlife.

As odd as it sounds, the artist awakened in Captain Kenny when he was literally hit on the head by a falling coconut while napping in a park on Maui. "Character" is not colorful enough to describe Neizman. He would reel around Lahaina singing and making honking sounds, pushing his artist materials-laden shopping cart, creating lasting impressions.

And sometimes scaring tourists.

His art reflected a free spirit unencumbered with influences beyond the deep blue sea.

Many people would judge him as a bit off his rocker. A street artist at best. Waz recognized his genius and originality and continues to represent his work and burnish his legacy. An outsider artist invited in.

The business of art can be hard. It's like a Ferris wheel or a merry-go-round with horses going up and down. Or maybe a more apt analogy is the ride that scared me when I was a kid, the one where the floor drops away after centrifugal force from the rapidly spinning room leaves you stuck on the wall: The Gravitron.

Not everyone can hang on, let alone thrive. Those who do are to be commended. My hats off to my friend that still is, Waz.

CHAPTER

90

SUNSET IS FOLLOWED BY THE DON

Only an optimist or a bullshitter calls our greyest years golden.

The Crossroads of the Pacific directional sign in Honolulu is a recurring theme because paths keep crossing in the islands. A friend from grade school, an old pal, and a speedster whom I had competed against in our younger years, but had not seen for decades, had been living on the Big Island for years before we ran into each other. A fast blast from the past.

Don Hurzeler is still upbeat and really amusing to be around. He enjoys having fun with relationships—a key to our golden-grey years. I realized that our connection is that at heart we are both jesters. Class clowns. Been goofing off since grade school.

Success means different things to different people, but by multiple measures, this old friend defined success. He had the respect of friends and colleagues, a loving wife, and a remarkably long marriage. He had climbed to the top of his field and had carved out a rewarding retirement plan. And then be became an accomplished photographer and gallery owner.

Don literally reinvented himself.

Hurzeler posts his remarkable photographs of trips to the top of Mauna Kea to capture the Milky Way and zooming comets. He trekked for miles across lava fields, night after night, to capture Kilauea volcano as it erupted. He gets up before the crack of dawn to capture surfers and gets tossed by the waves while taking the photos. At 73, it looks like he is speeding up when most of us are slowing down.

He was always a speedster, but now shutter speed takes pride of place.

If it had not been for Don, I would not be writing this. He has published six books, so far. The next to last one, *What's Left of Don*, kept me laughing from beginning to end. It's a fun read. I let him know it in an email.

Later, I sent him a short piece about a mutual friend, "Career Prep," and he wrote back, "That is one great chapter for your own book…loved it. Do some more and see where it leads you."

I responded with a terse, "LOL."

But after a few days, I thought that it would be fun to write about some of my art business experiences. As one story led to another, I started remembering incidents and people I had long forgotten. It was fun and kept me engaged during the Covid-19 quarantine (feels like it should be called Covid-1984 because it goes on and on and has an oddly dystopian feel).

So, if you don't like this book, blame Don. H.

Big respect and shaking shakas (a hand gesture in Hawaii that involves extending the thumb and little finger from a closed fist to say 'hang-loose') to Don, a generous friend who continues to mentor and help people. Don inspires with his energy and enthusiasm.

CHAPTER 91

A MAD RIDE WITH BUDDY HACKETT

"As a child, my family's menu had two choices: take it or leave it." Buddy Hackett

Everyone in the neighborhood was aware of the Hollywood movie being filmed down the street. It was a scenic, out-of-the-way spot along the Pacific Coast Highway and not the first time that it served as a backdrop for a movie. We had watched Rebel Without A Cause, the drag racing scene ending with the car going over the cliff, while it was being filmed there years earlier.

If my parents had known what we were doing, a spanking with a belt would have been the least of my worries. But they didn't know and never found out, at least not in time to stop it.

Hitchhiking as a grade-school student will not win the most-likely-to-succeed award, but that's what my friend Russ and I were doing. The ride from Malaga Cove School to Portuguese Bend, with all of the stops, took about forty-five minutes.

The school bus was late, so we stuck our short thumbs out to see if someone would give us a lift. It didn't take long for a big shiny Mercedes to answer our wish.

Russell sat in the front seat, and I sat in the back, but I could see the driver's face in the rear view mirror. He looked familiar. Russ said, "Hey, aren't you Buddy Hackett?" Buddy, with that funny sideways grin, said "Yeah, and if you didn't recognize me, I was going to let you out here." My friend said that he had just seen him on the Tonight Show Starring Johnny Carson.

It seemed like the drive was shorter than usual, and we got out to the entrance to the old Vanderlip estate on Highway 1 where they were still shooting the movie, It's a Mad Mad Mad Mad World. You almost lose track of the mad's in the title of that star-studded romp.

The walk up the steep hill to our homes was not short. We didn't notice. Energized with the feeling of having a legendary comic buddy.

CHAPTER
92

CAREER PREP

In my early college days, a balanced diet was a beer in both hands.

Doug, Russ, and I were roommates at ASU during our sophomore year. Doug was a drinker, and even then, I thought he needed to moderate his intake. Russ managed to imbibe beyond his limits. I was the wimpy one and really never reveled in it, but willingly participated. I preferred pot. We drank "spoliolies" (spo-lee-o-lees), a combination of beer and wine, often to excess. It was really a nasty combination. But that is not the story.

On one semester break, my dad flew us down to Nogales in a Cessna 150, and Doug and I caught a train for Mazatlán. It was a fun trip, but not without issues. The first was the fact that Doug took the hat of one of the Mexicans who worked on the train, and I was freaking out thinking not only was that nuts, but we could end up being owned by José in the carcel.

I asked him to not take the hat; he finally left it somewhere, and we avoided being a line in "MTA," a once popular Kingston Trio tune—we did return.

At the end of the week, we were almost out of money and needed to get home, but Doug suggested that we get a case of beer and go to the beach. It didn't take much to get me drunk, and I think we shared some of it with new friends on the beach, but by the end of the day, we were both pretty wasted and decided to hitchhike to the border because we were down to loose change.

I literally passed out on the side of the road, but Doug was indomitable and could drink a thirsty horse under the table. Smiling, he kept his thumb out. Around sundown, I heard him yelling, and I came to and saw him running towards a truck used to haul bales of hay that had stopped to give us a ride. Running after him, I managed to climb the tall wooden slats on the truck and fell into the hard bed of that old truck with a thud and a Mexican guy calling me, I think, a gringo dog. I should have paid more attention in Spanish class.

After dark, after what seemed like a very long drive, we came to a little town and a dilemma. How do we get to the border?

We checked our cash, and together we had enough to afford, we hoped, a bus to Nogales. Doug's Spanish was pretty good, and he asked some passersby for directions to the bus station. They said they would take us to the station, and we found ourselves walking through what felt and looked like some pretty sketchy streets. I whispered to Doug that I thought that we would get rolled, but they were actually just good Samaritans and took us to the station. We used our last dinero to get to Nogales, Mexico.

We were hungover and broke and it was a new, Nogales, morning.

After crossing the border, we used our thumbs to hitch a ride, which was scarier than being passed out on the side of the road. I was sure that the driver was a criminal. He opened his glove compartment and some watches fell out; he asked if we wanted to buy one. I told him the reason we were hitchhiking was that we were broke. He asked if we wanted to go with him to Utah because he knew some hookers there. We explained that we were students and needed to get back to school. After a long drive, we were getting close to Tempe, Arizona, and we asked him to stop at the next light so that we could get out. But he seemed to just slow down and it didn't seem like he was going to come to a full stop. So, we jumped out while the car was still on a slow roll towards the red traffic light.

We thanked him as the doors slammed shut.

Drinking can be a big problem…both of my friends gave it up decades ago. Cheers.

ANDY WARHOL SPEAKS,
OR DID HE?

"Art is what you can get away with." Andy Warhol

In the mid-sixties, I attended an art-related event on campus at Arizona State University. Andy Warhol was there to talk. It was a fairly large auditorium, not fully packed. Warhol sat motionless on stage with that white wig mopping down his brow.

I don't remember most of the details but left thinking that it was a vapid event. Many years later, I read in a monograph about Warhol that he had sent a body double to those talks. It wasn't really him. I don't know what actually transpired, and maybe that was part of the point. Perhaps it was a convoluted version of performance art performed without the performer?

Is it ironic that the guy that came up with the statement, "In the future everyone will be world famous for 15 minutes," will be famous forever?

ART POLICE DON'T WEAR BERETS

"**B**adges? We ain't got no badges! We don't need no badges! I don't have to show you any stinkin' badges!" The Treasure of the Sierra Madre

The looting hombres in John Huston's classic film share something with gallerists.

Badge with Beret

Of all the markets that drive economies, the art market has some rogue qualities. For people who chafe at regulation, this business might be for you. It can be like the Wild West, and the art police don't wear berets or carry badges. A lot has been gotten away with.

Postmodernism has been a free-for-all embracing ideas and concepts that turn the world upside down and inside out. The art market reflects it. Retail-ism. A bear market, depending on what the market will bear.

It isn't quite anything goes, but you can get away with a lot. From the outside, as a kid observing the art dealers whom I knew through my mother, there seemed to be more gentility, respect, and honor then. The lure of making easy money in art has affected behavior. Things have gotten more cutthroat and commercial. Or quite possibly I was just naive and unaware of what was happening under the table and behind closed doors. There is just more of it now. More of everything really.

The players who respect the market and follow long-established protocols—ranging from sensible edition sizes that favor the collector and protect the integrity of the artist; to a pricing system that is not rigged or jiggered to create the illusion of value but instead relies on the market to do that; to sensitivity to supply and demand instead of wily-nilly diluting the market—those players will ultimately be well-regarded. Short term gains should never overshadow long term aims.

Now that all of the big art isms are wasms since Postmodernism gave way to Post Neo-Neo, nothing, it seems, is new under the sun. Anything goes. Our appetite for the new is unquenchable. Art market oxygen.

Somewhere, in the imaginations of young artists, the future of art is percolating. We look forward to what he/she/it/they/them (pronouns are dangerous these days) is brewing up. With no beret-wearing art police (but now hounded by pronoun police), with no stinkin' badges to stop 'em—if the sky's not the limit, what is?

The shadow, and artificial intelligence, knows.

CHAPTER 95

ADJUSTING THE REARVIEW MIRROR

In retrospect, a career looks like a fading blip.

These few silhouettes across the dense wall of my dimming memories are just sketches. Partly erased by time. Approximations. But I'm grateful for the afterglow of that slice of life's magic...feeling thankful for the people and places that inspired and animated these events and, most of all, the simplest moments.

With more road behind me than up ahead, I plan to savor the rest of the ride before I unbuckle my seatbelt. I'll keep searching for the new Nu'u.

Keep your eyes on the road ahead.

CHAPTER

96

A PRIMER ON SELLING ART

"...good business is the best art." Andy Warhol One of the most challenging facets for career artists is maintaining a balance between the artistic and commercial aspects of their work. Too often, artists cash in on their popularity and end up devaluing their art, both monetarily and artistically. Selling out is tempting. I may have. Even today, I think that I would sell out for the right price.

For galleries, there are many challenges beyond profitability: maintaining good relations with the artists represented; finding and keeping capable staff; keeping the gallery fresh; finding and keeping collectors; positioning the gallery in the market in a way that makes sense. It is common knowledge that the restaurant business is tough, but so is the gallery business. On the other hand, at the end of the day, good art doesn't spoil.

One phenomenon that proliferated while my art career was unfolding is relatively new—the artist-owned gallery. Traditionally there was an art dealer/artist relationship that played to the strengths of both. Now more artists open their own galleries and cut out the dealer. The difference between an artist singing his or her own praises vs a dealer doing it is significant.

A good dealer is a curator, a connoisseur, a more neutral guide. At best, a creative scout. While dealers can always be suspected of having ulterior motives and perhaps vested interests, I subscribe to the belief that I work for collectors. Even when I am working for a gallery, the client's best interests are paramount. Long-term relationships matter. Feeling good about what you do matters. The best relationships are long-term.

Not all artists can wear two hats—the artist's jaunty beret and the businessman's cocked fedora (or backward baseball cap), and still look professional doing it. It usually looks more like the Mad Hatter in Alice's Adventures in Wonderland. Conflicts are inherent in the process. Fortunate is the artist who has an honorable dealer.

On the other hand, it is hard and sometimes impossible for an artist to find a gallery that will carry the work. And a gallery that will suitably display and sell the work is even harder to find. The rewards for an artist who can find or create a market for his or her work can be enticing. But the artist has to sacrifice time that could otherwise be devoted to creating art.

The 800-pound market gorilla, the INTERNET, is an equalizer that upends some art market tried-and-truisms. Most to-do lists include the internet as a must-do. An entire industry has blossomed around teaching people "How To Make It" in the art biz. And how to use the internet to sell art. It is a great tool, but is it a substitute for the person-to-person art experience? The physical connection with art can be magical; to me, the internet feels remote, disconnected.

Perhaps the most radical impact of the internet on selling art relates to information parity. The old advantage of the dealer

knowing more than the client, information asymmetry, has changed. Information is ubiquitous now, and everyone can access it with a few clicks.

Successful art consultants need to shed the old stereotype of the pushy, sleazy, smarmy salesman and attune themselves to the clients' tastes and desires. One of the reasons women do so well with art sales is that most people think of the pushy sales guy, not the pushy sales gal. That and the stereotype that women are more sensitive to aesthetics.

The essence of being an art consultant is not to sell but rather to serve. It's simple. Treat people the way that you want to be treated. With information so easily available, curate the information you have in ways that help people make satisfying decisions. Show them how the experience of owning and displaying the work at home and sharing it with family and friends will be a joy forever. If you do that well, your expertise and good cheer will be worth their time and money. If we are going to be replaced by robots sooner or later anyway, let's make it as human as possible now. Be real.

I hope that art galleries proliferate again soon, despite the trend toward internet sales. When people can comfortably and confidently congregate to look and talk again, more galleries should open. Waikiki went from having dozens of galleries in the 1980s to just a few today. That is a disturbing trend for a place that is ideal for art galleries. While there are many things to buy online, art is best experienced hands-on, especially on vacation in Hawaii.

CHAPTER 97

THROUGH A LOOKING GLASS (OF WINE)

"You're not the same as you were before," he said. "You were much more...muchier...you've lost your muchness." Lewis Carroll

Pre-cell phone, and pre-internet, no one foresaw how fast that relatively staid art business would change. Post-pandemic, the changes will shift into overdrive.

Before the Covid-19 crisis, it was not unusual for a potential collector to cell phone google the artist while looking at the art in the gallery. It seemed rude, but it was not unusual. It was their way of doing due diligence, on the spot. If a story popped up on google dismissive of the artist, it led to a botched sales opportunity. If the art was on an art brokerage site or eBay for less than the gallery charged, it was a potential sale stopper.

That kind of search could be beneficial, but the point is that to succeed, it is now imperative for an art gallery to take the new media into account. Everyone knows this, but we don't know exactly where and how fast it will change in this wary and wired world.

The physicality of most art is best-experienced by eyes, hands-on, close up and personal. But as social distancing has become necessary, that principle has become more problematic. The old paradigm of the stand-alone brick-and-mortar gallery has given way to that of a robust online presence in support of the gallery. The more cutting-edge the media presence, the better. Entire careers are now virtual.

The pandemic and the need for social distancing has given the art gallery a huge incentive to embrace the digital era. The challenge is that the cost of getting online customers is going up. Inexpensive alternatives are labor-intensive. Art markets are rapidly evolving. Or devolving, depending on your point of view.

The newest wrinkle in the art business are NFTs: Non Fungible Tokens. NFT's are the new WTFs in art. Beeple, aka Mike Winklemann, sold his Everydays, The First Five Thousand Days art for $69.3 million. Through Christy's. Power to the Beeple. That makes the duct taped banana look like a bargain. The buyers of the Beeple said that they expect their purchase to appreciate to become the first billion dollar art. That's a charging bull market chased by a grizzly bear. I now want to create a new persona, Lucky Pixel, to cash in on this craze. When researching this my eyes glazed over. Crypto purists claim that it is not a true NFT, but a JPEG marketing stunt. They allege that the Ethereum Blockchain doesn't conform to norms. It really is a brave new world.

For those of us that prefer the tangible over digital, the physical gallery can still help build an online following. It can serve as a stage and a cost-efficient way of acquiring customers. In a gallery, relationships are galvanized. Once people appreciate the art and your brand's culture, and trust you, they will be comfortable

buying your art online. Calling or texting an art consultant you trust beats buying blind online almost every time.

While the hands-on, 360-degree gallery experience may always be preferable, it won't be long before technology further bridges the gap between a virtual and a physical presence. With AR, augmented reality, and IR, immersive reality, soon the advantages of a physical gallery will lessen. AR can now map textures with vibrations, and people will be able to experience the feel of a piece of art through their computers, phones or tablets. IR can place the art in your home, show you how it looks. Once 5G networks become ubiquitous, the online experience will satisfy many collectors and provide a dynamic alternative to brick-and-mortar galleries. But not for me.

The emotionally-centered art experience won't change; our ways of experiencing it will. Two things, however, will remain paramount—the importance of the story and the central impact of relationships. Without context, a lot of art is more confusing than satisfying. A Jackson Pollock or an Andy Warhol is less compelling if the viewer doesn't know why and how the piece of art became important, and most of us would not be able to intuit that. We need the backstory, what gave rise to the work, and what did it lead to? Why should I consider it important? What makes you so passionate about it?

It's imperative that Galleries create a dynamic in-person experience complemented by an integrated online presence. The future will be hybrid. Successful galleries will get really good at exploiting this combination of approaches to sales. The gallery is a stage, and customers are the most important players. Art Improv. A visual tango.

So, open a gallery, have a show, go to an exhibition, collect art, get out and look and get a feel for the elegant magic that art uniquely provides in a life well-lived.

Write a book: art appreciation for dummies.

CHAPTER

98

GALLERY DIRECTOR OR DAD JOKER?

Things changed. Who expected that? Perhaps the only constant saw it coming.

As I got older in the art gallery business, I went from working with friends and contemporaries to being a father figure to being a grandfather figure. It happened pretty fast.

I now joke that I need to ask the ladies working in the gallery if they have granddaddy issues.

I live to tell dad jokes now.

At the last corporate retreat I attended, everyone else could have been one of my kids. I was happy that they could make fun of me. I had had cataract surgery and wore those huge wrap-around dark glasses that they give you that made me look like a five-and-dime store Mafia boss.

They took a picture of me wearing those oversized glasses and then Photoshopped it to put me on a beach in Hawaii and sent it to all of the gallery directors with the caption: "Don't worry, Steven, you will be home soon." LOL.

The key to longevity is in the levity. I would hate the business if I couldn't make fun of it.

Finding interesting ways to surprise and delight people is one of my goals.

One afternoon a mother and child visited the gallery, and the three-year-old was touching everything. Couldn't keep his hands off. His mother kept telling him, "Don't touch." He was a cute little bugger, but it was getting annoying to hear his mom telling him not to touch while he just ignored her pleas. I finally said to the boy, "You can touch the art with your eyes." He did. He literally went up to the next piece and put his eyeball on it. You gotta be careful what you say to kids. Parents too.

When people visited the gallery driving one of those motorized vehicles for people with disabilities, I would smile and ask them if they had a license to drive it. I followed with, "Don't worry, we're not checking," and then riff into a warm greeting. Doing the unexpected can be effective. I don't remember anyone to whom I said that not smiling. It's all in the way that you do it. Ice breakers work.

Visiting an art gallery is not for everyone. A lot of people have preconceived ideas about the experience. Many people are uncomfortable because they don't know a lot about art, and it feels a bit like not knowing a language with someone that acts like they are fluent. It can be awkward. Especially when a hungry art consultant looms over your shoulder licking, not practicing, his chops.

The worst thing an art consultant can do is to look like they need a sale. The lean and hungry look may work for dramatic theater, but it doesn't work in a gallery. People leave or just don't come in if they see a salesperson ready to pounce.

Creating a welcoming, unpretentious, and open gallery environment is one of the keys to success. I found that breaking the rules, upsetting the expected protocols, works. Getting people to relax and open up is just the start of a relationship. But you have to start somewhere.

Engaging, being in the moment with that person, sensitive to their presence, requires energy and focus. Sensitivity. Collaboration is the goal. How can you help them? They have to be comfortable talking with you to begin a relationship.

Finding your own voice takes time, but it is critical for an art career. If I gave you a script that worked for me, it would not necessarily work for you unless it is heartfelt and personal.

Everyone from comedian George Burns to French intellectuals have said: "If you can fake sincerity, you have it made." As witty as that sounds, if you really want to help people, you aren't faking it.

People want to have fun. By the time they visit the gallery, they have been hit on by and bounced between dozens of salespeople up and down the street. They might feel like retail pinballs on tilt. It would help if you lightened the mood. Create a unique experience for them. Take the pressure off.

Charles Schultz, the Peanuts cartoonist, declared that there's a difference between bumper stickers and philosophy. When they are profound and pithy, bumper stickers are hard to beat. This one was was probably on a car driven by an aspiring artist:

"Earth without art is just eh."

Or, as Canadians might say, "Eh?"

CHAPTER

99

WHAT'S IT ALL ABOUT, ARTIE?

Paul Gauguin's post-impressionist painting in the Boston Museum of Fine Arts titled, "Where Do We Come From? What Are We? Where Are We Going?" asks the deep questions that face us all.

Michael Caine, playing Alfie in the film with that title, in a key line, asked, "What's it all about?" Burt Bacharach wrote the title song, "What's It All About, Alfie?"

Art often asks, and sometimes tries to answer, that question.

We all search for answers to timeless questions. Art helps, with clues and suggestions, but we all grapple to find our own way to the answers.

The answer, for me, is in the struggle, the process, finding a few happy trails. Art gives me hope along the way, and the freedom to stick out my tongue and howl.

It's hard to top Willie the Shake, aka William Shakespeare, in Macbeth, with his tortured soliloquy, life "is a tale, told by an idiot, full of sound and fury, signifying nothing."

Have a nice day Willie...

Shakespeare with Munch mask

There is consolation in art. A way to express deep feelings, celebrate happy moments, doodle the time away, or reinvent it. It's up to you.

CHAPTER 100

ALOHASVILLE

Picture Picasso slipping on a cubist banana peel on the way to his easel, landing flat on his tush. LOL.

A pie in the face and prat falling on a banana peel are slapstick staples. Schtick. We'd be poorer if it weren't for the easy laughs that these stumbling stunts still evoke. From Charlie Chaplin to Chevy Chase, sight gags perform timeless mirthful magic. Who doesn't love an artful fall?

The banana in art has been suggestive and subversive. Sexy and funny. From Warhol's phallic cover for Velvet Underground's first album to Maurizio Cattelan's expensive banana duct-taped to the wall, "Comedian," the art world looks like it has gone bananas. Artists banked on it. Collectors, when not tripping, ate it up. For me, it's a career metaphor.

What is actually funny is the fact that we derive a perverse pleasure from the misfortune of others. Schadenfreude is the sophisticated word for this (apparently, we are too embarrassed to use a word that people understand).

Whether it is someone slipping and falling on a peel or paying a fortune for a 99-cent banana and a strip of duct tape, we enjoy

and are amused. Even grateful. Somehow it makes us feel better about ourselves.

These Confessions of an Art Dealer would not be complete without a full frontal admission and acknowledgement of culpability: A summing up of stumbling's; indiscretions; averted glances; looking the other ways; naiveté's; riding breaking waves; taking advantage of situations. Opportunism. Sell out-ism. Banana slips and loose lips. Total Mea culpability.

No doubt a few old friends and colleagues will be offended by this book. Generally, there are more than two sides to a story. That's why we sometimes get called to jury duty.

Comfort zoned out, too often, I did not live up to my own expectations.

'Nobody's perfect' is an imperfect excuse. I am not going to use it. In spite of being guilty of all of the basest reasons to pursue art, I remain a believer. Art can be redemptive. Mistakes and all. Or at least temporary relief from ennui.

Starting with a bite out of a banana, for fun and context, this narrative ends with banana's for effect and perhaps as a parable. Serious art doesn't have to be heavy; in fact, it doesn't have to be anything. Entire oeuvres have been devoted to this concept.

Unchain your Imagination through art.

Bananas are still the butt of fruit jokes and have sex appeal. That kind of remark killed vaudeville. Old dad jokers still tell it like it's fresh. You are free to express yourself in any way you choose. Love it or hate it. Be corny or contemporary. Stick to the rules or break 'em. That's what's liberating about art. Freedom of expression. Everyone's welcome.

What would a cave man, emerging from a cave, say about Michelangelo's art on the ceiling of the Sistine Chapel? "That's not art, he's using a brush."

Cave man critics aside: do your thing.

Everyone's a critic.

In a play, this is the point where the hooked cane darts out from the curtain and, with a decisive yank, EXIT STAGE LEFT. Shoes falling off. Eyes popping. Still smiling.

If you can't enlighten, please entertain.

Echoing the fade out in a pop tune without a proper ending... here's the slip-sliding- book version:

The font just fades away......

ALOHASVILLE

ABOUT SONNY POPS aka steven maier

The Micky Mouse years,1947, the year that I was born, were magical. I can barely remember what I had for lunch yesterday. I do remember the stories that I was told about my birth and those early days. And old pictures.

Memories are like shadows that grow and shrink with the light and the music. And time.

Post-war Los Angeles was booming. My father worked as a superintendent at Boeing. He met my mother, a secretary at the firm, at that time. They married and, auspiciously, honeymooned in Death Valley. They lived in Hermosa Beach and moved to Manhattan Beach during my first five years. Two brothers, Christopher, four years older, and Kimbrough, two years older, helped me adjust to home life.

In 1952 my childhood memories begin. My folks bought a plot of land in Portuguese Bend, the southernmost tip of Palos Verdes Peninsula. A literal stones throw from Highway 1.

We built a home from the foundation up, and we were all involved in the process. After working all day, my dad would come home, pile us into a station wagon, and drive to the new home site. They built a beautiful, functional home overlooking the Pacific Ocean with a view of Catalina Island in a beach community that seems even more idyllic in retrospect but really was a great place to experience childhood.

There was a draw back: the entire neighborhood began to slide. A slow motion (but gaining speed every year) landslide. The neighborhood was built on shale, and the earth was making its way to the beach. Over a period of years everyone on our side of the hill moved. I watched my neighbors house, a fairly big home, be trucked away in pieces to be relocated. We lived on Cherry Hill Lane, on the hill that is now collapsed, and it's hard to find the lot that the house was on. Earth crumbled and tumbled down to the shore.

That ephemeral experience left a lasting impression.

The family packed up and moved. Arizona, after growing up in California, was jarring. I loved going to Phoenix on Thanksgiving or holidays to visit my beloved grandparents, but I really didn't want to move there. But my grandfather on my mother's side owned Allied Construction Company and offered a VP position to my father. They were building hundreds of homes a year and expanding. And our family was living its own parental landslide, a slow-motion breakup. My folks saw the move as the best chance to keep the family together.

But wherever you go, there you are.

After HS, well, these 100 sketchy stories speak for what happened, more and/or less.

RESUME

brat; process server; house painting contractor; house parent for twelve kids from juvenile hall; manager for Élan Vital Ranch (a treatment alternative for emotionally disturbed juvenile delinquents), swimming and diving coach; dollhouse designer/builder; art consultant; gallery director; gallery owner; publisher; writer; satirist/artist (with a small a): temporary survivor.

Work's not done: If time and circumstance permit, Sonny Pops is planning to provide a light-hearted Hawaiian inspired pop-up gallery experience:

Waikiki will need all hands on deck to thrive again, and I hope to be among a chorus of creative voices to add color and texture to the visitor experience. This is the best opportunity in decades to reshape the retail art landscape.

I am applying for the job of :

HAWAII'S AMBASSADOR OF NU'U POP

Sonny Pops is a point of view, an attitude.

Thirty-two years ago, while evaluating the art in Hawaii Steven Maier realized that Hawaii had talented artists of all stripes, but no one was defining the movement that animated much of what we consider contemporary art, Pop. Sonny Pops was born, perhaps hatched, at that moment.

Becoming the self-appointed Ambassador of Nu'u Hawaiian Pop Art became a passion that still excites me. Sonny's ICON SMILE COLLECTION is the definitive effort to translate the iconic pop idiom in images relevant to Hawaii.

Pop goes the easel.

For Show Updates visit:

www.sonnypops.com

ACKNOWLEDGEMENTS

This motley word parade would not be possible without the entire cast of characters…

Especially you the reader.

Kudos and Kisses to:

- My wife Mihoko for putting the vows "for better or worse" to the test

- And the kids that outgrew me: Emily, Laurence, Scott, and Sara. Lovely people

- Special friends that lent advice and energy: Don, Eddie Waz, The Moon Man - Barry, Ricky B, Ron. Shannon, Terry. And ol' what's his name…

- To father time (put away the hardware) and colleagues over the years for lessons learned, but more for the laughs.

- To failures that make trying worthwhile. And success' that make it all worthwhile

- To Tanya Hayes Lee for her conscientious work editing, fact-checking, and suggesting revisions to this meandering career mosaic

- Thanks to the Authorbytes team

- To the artists and art entrepreneurs that keep this market spinning and fascinating.

- **Most of all,** If you bought this book, I would like to acknowledge and thank you*****!

Pau. Hawaiian: Done

Made in the USA
Las Vegas, NV
03 November 2021

33639893R00177